The Elements of Black-and-White Printing

The Elements of Black-and-White Printing

Carson Graves

Focal Press is an imprint of Butterworth–Heinemann.

Copyright © 1993 by Carson Graves. All rights reserved.

All photographs by the author unless otherwise credited (see page 165).

No part of this publication may be reproduced, stored in a retrieval system, or transmitted, in any form or by any means, electronic, mechanical, photocopying, recording, or otherwise, without the prior written permission of the publisher.

Recognizing the importance of preserving what has been written, it is the policy of Butterworth-Heinemann to have the books it publishes printed on acid-free paper, and we exert our best efforts to that end.

Library of Congress Cataloging-in-Publication Data

Graves, Carson, 1947-

The elements of black-and-white printing/Carson Graves.

p. cm.

Includes index.

ISBN 0-240-51795-4: (pbk.: acid-free)

1. Photography—Printing processes.

TR330.G73 1993

771'.44—dc20

British Library Cataloguing-in-Publication Data

A catalogue record for this book is available from the British Library.

Butterworth–Heinemann 80 Montvale Avenue Stoneham, MA 02180

10 9 8 7 6 5 4 3 2 1

Printed in the United States of America

Contents

	Chemical Safety 1 Burning and Dodging 2 Chemical Capacities 3 Chemical Temperatures 4 Proper Agitation 6 Timing 6 Inspection Lights 7 Enlarger Basics 8 Summary 9	
Chap	ter 2 Exposing for the Highlights 11	
	How Exposure Affects a Print 11 Finding the Correct Exposure 12 Avoiding Safelight Fog 17 Standard Black and White Patches 20	
	The Proper Proof 21 Emulsion Speeds of Printing Paper 23 Summary 24	
Chapt	ter 3 Changing Contrast for the Shadows 26	
	What Contrast Is 26 Shadow Tones 28 Paper Grades and Print Contrast 30 The Ring-Around Test 33 Exposure and Development Variables 35 Summary 37	
Chapt	ter 4 Photographic Chemistry—Creating a Developer 3	8
	Standard Developer Chemicals 38 Obtaining Darkroom Chemicals 40 Measuring Photographic Chemicals 40 Mixing Photographic Chemicals 41 Creating a Print Developer 41 Other Print Processing Chemicals 48 Summary 49	

Preface xi

Chapter 1 Reviewing Darkroom Fundamentals

50 Chapter 5 Choosing a Paper and a Developer

The Physics of Viewing Prints Comparing Print Tones and Color 52 Testing Methods 55 Choosing a Paper and Developer 58 Summary 59

Chapter 6 Special Contrast Solutions 60

60 Printing a Very High Contrast Negative Printing a Low-Contrast Negative **Customizing Print Contrast** Summary 72

Chapter 7 Salvage Techniques 74

Negative Techniques 74 81 Print Techniques 86 Summary

Chapter 8 Toning 87

Toner Types 87 88 Special Safety Precautions for Toners Preparing a Print for Toning **Testing Toners** Notes on Specific Toners 90 Multiple Toning 95 Alternative Coloring Processes 97 97 Summary

Chapter 9 Archival Processing 99

Why Use Archival Processing? 99 Printing for Archival Processing 100 Development 101 Stop Bath 101 102 Fixing for Permanence Rinse and Washing Aid 105 Washing 105 Protective Coating (Toners) 107 Hypo Eliminator 108 Print Drying 109 110 Summary

111 Chapter 10 Preservation and Presentation

Print Finishing 111 Storage 113 Mounting Materials Mounting Techniques 121 Framing Prints 124 125 Summary

Appendix A Enlarger Alignment 127

Checking Alignment 127 Aligning an Enlarger 129

Appendix B Developer Formulas 132

Neutral-Color Developers 133
Warm-Color Developers 134
Cold-Color Developers 136
Low-Contrast Developers 137
High-Contrast Developers 138
Beers Variable-Contrast Developer 139

Appendix C Miscellaneous Formulas 141

Reduction and Intensification 141 Toners 143 Archival Processing 147

Appendix D Supplies 150

Archival Storage 150 Chemicals, General 151 Chemicals, Specialty 151 Darkroom Equipment 151 Frames 152

Appendix E Books 153

General 153
Darkroom Design and Construction 154
Formularies 154
Technical 155
Archival Processing and Preservation 155
Conservation 156
Safety 156

Index 157

*					

Preface

The Elements of Black-and-White Printing is a resource for photographers who already have some experience in the darkroom but who want to understand more about the processes they are using. The benefit of this understanding is the ability to assume a greater control over what appears on the final print.*

In addition to explaining procedures, this book contains exercises to help you calibrate these procedures in your own darkroom and with the materials you prefer using. Use this book to guide your own experience and practice in the darkroom. The reward for this effort will be an understanding of printing that is both practical and flexible.

Two concepts, *print statement* and *expressive print*, help explain the purpose of this book:

- A print statement is the way that an image is crafted. It includes all of the choices that you make about an image in the darkroom, such as the materials you use, the print size, and even the print exposure. These choices, as much as the subject matter, affect how a viewer sees the image. Every image can have many technically correct print statements. Usually, however, only one print statement accurately expresses the content of a negative. In other words, some print statements are appropriate; others are not.
- An expressive print combines carefully seen subject matter
 with an appropriate print statement. The result is a print that
 satisfies a viewer on both an emotional and an intellectual
 level. Such prints radiate energy and luminosity while communicating the feelings and intentions of the photographer.

The Elements of Black-and-White Printing will help you make expressive prints by teaching you the techniques you need to produce appropriate print statements.

HOW TO USE THIS BOOK

There is no need to proceed through this book all at once. There are three points where you can pause, take what you have learned into the darkroom, and then continue only when you feel ready to learn more.

^{*}For readers interested in brushing up on their basics, several useful books are available, including *Into Your Darkroom Step by Step* by Dennis Curtin and Steve Musselman, Focal Press, Boston, MA, 1981.

- The first pause is at the end of Chapter 3, "Changing Contrast for the Shadows." At that point you will have learned how to make correct decisions about exposure and contrast for your prints. These are the foundations of making an intentional print statement rather than an accidental one. If these techniques are new to you, practice them until they feel comfortable before proceeding.
- The second pause is at the end of Chapter 5, "Choosing a Paper and a Developer." This chapter and Chapter 4, "Photographic Chemistry—Creating a Developer," explain how print developers are formulated and how they interact with printing papers. These chapters are the basis of making an informed choice about which papers and developers are best for your print statement.
- The third pause is at the end of Chapter 8, "Toning." This chapter, Chapter 6, "Special Contrast Solutions," and Chapter 7, "Salvage Techniques," describe techniques that you can use to fine-tune your print statement. You may want to use some of these techniques right away. Others, you might want to use in the future. Skim the material first, and concentrate on what interests you.
- Finally, Chapter 9, "Archival Processing," and Chapter 10, "Preservation and Presentation," instruct you on how to give your prints (and negatives) the best chance for long-term survival. This information will be increasingly important as you begin to produce prints that you want to keep and display.

The Elements of Black-and-White Printing concludes with five appendices, which provide information on testing for and correcting enlarger alignment problems; annotated formulas for developers, toners, and other darkroom processes; suppliers for hard-to-find chemicals and darkroom equipment; and books containing additional information about black-and-white printing.

ACKNOWLEDGMENTS

A great number of people have made significant contributions to this book. First and foremost, I would like to thank Karen Speerstra and Sharon Falter for having almost infinite patience in waiting for the finished manuscript, Judith Riotto for a very thorough copy editing and for helping me with my use of hyphens, and LeGwin Associates for their production assistance. In addition, thanks go to Jon Waldron for his helpful critique of my initial drafts, Judith Canty and Nancy Roberts for technical assistance, and to all the photographers who gave their images for illustrations and whose contributions are listed in the back of this book. Also, help and support came from Margo Halverson-Heywood, Paul Callahan, and Lois Lord. Finally, a note of appreciation to Interleaf, Inc., on whose fine software this book was written.

The Elements of Black-and-White Printing

Reviewing Darkroom Fundamentals

Many photographers actually make worse prints after a year or two of darkroom experience than they did when they first started. It is so easy to expose and develop a piece of printing paper that they give in to the temptation to relax and begin taking short cuts without realizing the difference between convenience and bad habit. The resulting loss of print quality can happen so gradually that it isn't even noticed.

In a field as controlled by technology as photography, you need to periodically review your working procedures and discard any bad habits. If you neglect basics, such as developer temperature or enlarger alignment, then no amount of additional effort will produce a truly fine print.

This chapter covers the areas of basic darkroom technique, which is where most people create problems for themselves, and includes suggestions that you can follow to improve your own technique. The areas covered are

- chemical safety
- burning and dodging
- chemical capacities and temperatures
- · proper agitation and print timing
- inspection lights
- · variable-contrast filters
- enlarger alignment

CHEMICAL SAFETY

Every discussion of darkroom procedures should begin with how to handle darkroom chemicals safely.* Although the chemicals for black-and-white processing are reasonably safe, you should always observe common-sense precautions. Some special processes described in this book, such as certain toners and intensifiers, contain dangerous chemicals that require additional precautions. Where appropriate, warnings accompany the descriptions of these processes.

^{*}The best way to protect yourself is by becoming more informed. Arts councils in many states publish safety guidelines for working with arts materials. Another source of information specifically for photographers is *Overexposure: Health Hazards in Photography* by Susan Shaw, Friends of Photography, Carmel, CA, 1983.

Handling Chemicals

Darkroom chemicals are most dangerous to you when they are in their powdered, concentrated state. As you mix them with water, small amounts of the powder escape into the air where they can be inhaled. This could have long-term consequences because developers contain known carcinogens and the acid in powdered fix can eventually lead to respiratory problems.

Even though liquid concentrates are safer to handle than powders, some concentrated acids (such as Kodak Indicator Stop Bath) can cause burns if you spill the stock solution on unprotected skin or can irritate the lining of your sinus passages if you inhale the fumes.

As a general rule, go outside the darkroom where there is good ventilation when mixing powdered or concentrated chemicals. Consider wearing rubber gloves and a hospital particle mask or even a respirator to keep your contact with undiluted chemicals to a minimum.

Handling Prints during Processing

Use print tongs (one per tray) to handle prints during processing. Never use your bare hands to touch prints while they are being processed. Your hands contain many ridges and pores, and handling prints while they are in a chemical solution transfers that chemical from one print to another and from one tray to another. The result is contaminated trays of chemicals and stained prints. Using tongs saves you money by preventing ruined prints and keeping your chemicals fresher for a longer time.

An even more important benefit of using print tongs is protecting your skin from direct contact with darkroom chemicals. Developers are alkaline, and stop bath and fix are acidic. The change in pH caused by dipping your hand in developer and then in stop bath causes your skin to dry out and eventually crack.

Tongs reduce the chance of chemicals being absorbed through your skin and of your developing metol poisoning, which is a common allergic reaction to developers. At best, metol poisoning is a painful rash, and at worst, it can keep you from ever working comfortably in the darkroom again. Rubber gloves and skin preparations, such as barrier creams, are good supplements, but nothing can replace the proper use of tongs.

BURNING AND DODGING

Done correctly, burning and dodging enhance the details in a print. Burning is the adding of exposure to selected areas of a print to make them darker than they would be with only the main exposure. Dodging is the opposite: withholding part of the main exposure from selected print areas to make them lighter. Effective burning and dodging don't call attention to themselves and are invisible parts of the print statement. Unfortunately, most photographers either reveal their burning and dodging technique in the print or waste sheet after sheet of paper in an attempt to make their efforts look natural.

Problems generally occur because most photographers don't think about burning and dodging until they need a salvage technique for a print that is badly exposed or printed on paper of the wrong contrast. One of the goals of this book is to teach you ways to determine the correct print exposure and to select the right paper contrast. This alone will eliminate wholesale burning and dodging and will allow you to concentrate on using these techniques to enhance fine details.

There are as many methods for burning and dodging as there are people working in darkrooms. As long as the technique you use is comfortable and effective in adding exposure or withholding it, there is no reason to change. However, you should keep in mind the following:

- Reflections in the darkroom are a significant problem. Examine the area around your enlarger, and either cover or remove any shiny objects. Any light-colored or reflective object near the enlarger can project stray reflections onto the print. The resulting loss of detail and added fog may not be immediately noticeable, but they have a significant impact on the subtle qualities that separate a good print from an average one.
- · What you use to manipulate the light during burning and dodging is important. Always use a dark-colored, nonreflective, and completely opaque object. Don't use a sheet of typing paper or an old print because light is transmitted through these and will cause fog even if you can't see it happen. Hands are also too reflective to use. If you like to use your hands to burn and dodge, try wearing a pair of black, nonreflective gloves. Inexpensive white cotton gloves sold by most camera stores to handle film can be dyed black with India ink mixed in water.
- Limit the time the print is exposed to any light, even supposedly "safe" light. For example, if you use a red filter over the enlarger lens to determine which areas of the print to burn and dodge, remember that the light from a red filter can cause fog if left on too long.
- With variable-contrast paper, you can burn highlights and shadows through the highest and lowest contrast filters. By burning highlights through the lowest contrast filter, you minimize the "spillover" effect on the adjacent midtones and shadows. Likewise, burning shadows through a high-contrast filter avoids problems with adjacent highlights and midtones. See Chapter 6, "Special Contrast Solutions," for more information on twofilter exposures of variable-contrast paper.

CHEMICAL CAPACITIES

Chemical solutions in the darkroom have short effective lives. As these chemicals are inexpensive relative to the cost of printing paper, it pays to plan your printing sessions around the capacities of your working solutions. The following suggestions are useful for standard print processing. For maximum print life, additional care is needed. See Chapter 9, "Archival Processing," for details.

Developer

For a quart of working solution, develop a maximum of 20 8×10^{-1} inch prints. Be sure to include your test strips. After reaching this maximum, prints will no longer have a full, rich scale of tones. Also remember that once diluted to working strength, a developer oxidizes within a couple of hours even if it hasn't been used. Mix working developer only as you need it.

Stop

Although most commercial stop baths contain a dye that changes color to indicate exhaustion, these indicators change only after the solution is no longer working effectively. This allows developer byproducts to contaminate your fixing bath. To maintain the efficiency of your fix, don't wait for the stop bath's indicator to turn color; replace the stop bath every time you change your developer.

Fix

Used properly, a silver iodide test solution (available commercially from Edwal Scientific Products as Hypo-Chek) gives a good indication of when a fixing bath is exhausted for normal use. A drop or two of the test solution in the fixing tray will indicate by the presence of a milky white precipitate that the fix is no longer usable.

If you use a rapid-type fix, you must remove an ounce or two of the fix from the tray and test that rather than testing the entire tray of solution. Putting drops of the test solution directly in a tray of rapid fix won't indicate exhaustion until well after the fix has gone bad.

Many photographers leave open trays of partially used fix in their darkroom for days at a time. Unfortunately, water and acid evaporate from fixer, upsetting its acid balance and its ability to fix prints properly. Cover the fixing tray between printing sessions, or better yet, pour the fix into an airtight bottle reserved especially for that purpose.

Washing Aid

Most commercial washing aids, such as Heico Chemicals Corporation's Perma Wash or Kodak's Hypo Clearing Agent, contain a chemical that replaces the thiosulfate in a print (left over from the fix) with a more water soluble compound. This shortens the time needed to wash the print. A washing aid doesn't substitute for actually washing the print; the chemicals left in the print after treatment are still harmful to the image.

As you process prints in a washing aid, its effectiveness is decreased. Follow the manufacturer's capacity recommendations for the particular product you are using. Pay special attention to any instructions about the tray life of the product.

CHEMICAL TEMPERATURES

Although photographers are usually very careful about the temperature of their film developer, few pay much attention to the temperature of their print developer. This is a common cause of poor prints.

Chemical reactions, such as development, are temperature sensitive. They are more active at higher temperatures, and less active at lower temperatures. The ideal temperature for most darkroom chemicals is 70° if you are using a Fahrenheit thermometer or 20° if

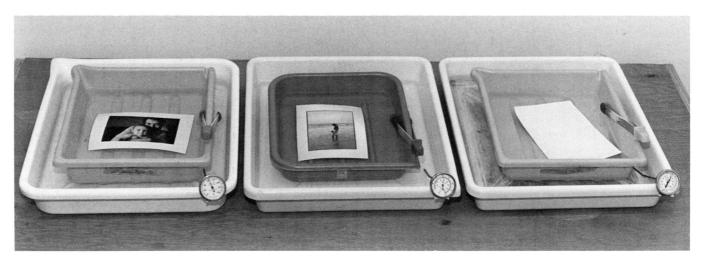

you are using a Celsius thermometer. The two temperatures aren't exactly the same, but each represents a major mark on darkroom thermometers, and thus they are easier to see (and maintain) under normal working conditions.

Most developers contain two active ingredients, called *develop*ing agents, that have different temperature sensitivities. These ingredients are metol (also known as Elon, a Kodak proprietary name) and hydroquinone. Metol develops the midrange and light tones in a print, and hydroquinone develops the dark tones. Together, they produce a full-scale print (one with a complete range of tones), but only under the correct temperature conditions.

Metol reacts in a predictable way to changes in temperature, increasing and decreasing in activity gradually, but hydroquinone is less predictable. For example, at a temperature higher than 75° F, it is aggressively active, overemphasizing the dark tones in a print. On the other hand, as the temperature drops to less than 65° F, hydroquinone loses its ability to develop an image at all.

If you try to compensate for a developer that is too hot or too cold by changing exposure or development times, you often end up with either a dark muddy print or one with chalky white highlights and dense featureless shadows. If you use a developer that is only a little too warm or a little too cool, you affect your prints in a less drastic way, probably without even realizing it.

The other chemicals in a black-and-white darkroom aren't as temperature sensitive as the developer, but it is a good idea to keep them within 5° F of the developer temperature. This is especially true of the wash water. A cold water wash (below 65° F) is almost completely ineffective for removing residual fix. A warm water wash (over 80° F) will actually cause the emulsion of a print to float off the paper base if the print is washed too long.

Maintaining Even Temperatures

Check the temperature of your chemicals frequently. If the air temperature of your darkroom is much higher or lower than the ideal chemical temperature, use a water bath.

You can make a water bath by placing trays containing your processing chemicals inside larger trays of water at the correct tem-

Figure 1-1 Maintaining even temperatures with a water bath. Placing your chemical trays inside a larger tray of water maintains the inside tray's temperature when the air temperature is significantly higher or lower than 70° F. Note the separate print tongs for each tray.

perature (Figure 1-1). The larger mass of water cools down or warms up more slowly than the smaller volume of the chemical. As the temperature of the water bath rises or falls, adjust it by adding more hot or cold water until it is correct again.

Some photographers use their sink as a large water bath, putting a raised lip around the drain so that they can fill the sink with two or three inches of water in which to place the processing trays.

PROPER AGITATION

The purpose of agitation during development is to replace exhausted developer at the surface of the print emulsion with fresh developer. Letting a print sit still in the tray produces unevenly developed tones. This is why it is important to keep the print moving. How you do this is less important than making sure that you do it at regular intervals.

Effective agitation methods include rocking the tray (although in a small sink it is easy to spill developer into the stop bath), turning a print over at regular intervals, holding a print by one corner and moving it back and forth, or any combination of these. The important thing is using a consistent technique.

Regardless of how you agitate the print, pick it up approximately every 30 seconds, and let it drain from the corner for about 5 seconds. Physically removing the print from the developer in this way breaks the surface tension of the liquid and ensures that fresh developer reaches all parts of the emulsion evenly when you place the print back in the tray.

Agitating a print in the stop, fix, and washing aid is equally important. Each step is a chemical process that must occur evenly and completely. It is never acceptable to leave a print in a solution while you are doing something else.

TIMING

Careful timing ensures correct print processing. The chemical reactions that occur as a print moves from developer to stop to fix require a certain amount of time to complete and can actually harm a print if allowed to continue too long. Use the following processing times when you print. Note that all of the times assume a temperature of 70° F.

Developer

Use 2 minutes as a standard for developing a print, even for resincoated paper, which tends to produce a visible image more quickly than conventional fiber paper. Having a standard development time gives you the option of using different development times to produce predictable changes in contrast and density. The usefulness of this is discussed in Chapter 3, "Changing Contrast for the Shadows."

Stop Bath

Agitate a print in stop bath for 1 minute if you are using conventional fiber paper and 30 seconds if you are using resin-coated paper. Most photographers don't keep their prints in the stop bath long enough because they think that the only purpose of a stop bath is to neutralize the alkalinity of the developer. Although it is true that this process takes only a few seconds, another function of the stop bath is to remove the residue of the bromide compounds created in the emulsion of the paper while it is developing. This requires the full recommended time. If any bromide compounds are left in an emulsion when the print goes into the fix, they appear as permanent gray stains.

Fix

Fix a print for 5 minutes in a standard fix (one containing sodium thiosulfate) or for 2 minutes in a rapid-type fix (one containing ammonium thiosulfate). Less than the recommended time incompletely fixes the emulsion, and more than the recommended time can cause the emulsion and paper fibers to reabsorb the chemical residue of the fixing process. If you are developing test strips or work prints that you don't intend to keep, you can remove them from the fix for inspection after only a minute.

Washing Aid

Three minutes in a washing aid is enough for most conventional fiber papers if you agitate the prints properly. Resin-coated papers require only 1 minute.

Washing

After treatment in a washing aid, wash resin-coated paper for 10 minutes and conventional fiber paper for at least 20 minutes. Be sure that prints are kept separate and given adequate agitation.

Washing times assume a system in which there is a complete change of water every 5 minutes. You can check the efficiency of a print washer by adding ½ to 1 ounce of food dye to the wash water and timing to see how long it takes for the color to go away. It should disappear in 5 minutes. Washing efficiency isn't helped by increasing the flow of water beyond this point. You will only waste water.

INSPECTION LIGHTS

A darkroom should contain a white inspection light so that you can evaluate a print as soon as it is fixed. The type and intensity of this inspection light are very important. It should reproduce as closely as possible the light under which you will normally view your prints when they are finished.

If the inspection light is brighter than your normal viewing conditions, you will tend to make prints that are too dark. If the light is too dim, your prints will tend to be too light. If the inspection light is a standard fluorescent tube, the blue rich color spectrum of that light will cause you to make prints with too much contrast.

Now is the time to make some observations about what viewing conditions you prefer for your photographs. In general, the most satisfactory lighting seems to come from tungsten bulbs with perhaps a small mixture of indirect daylight. Take a light meter reading off of a neutral-density gray card in conditions you consider ideal.

Once you discover an optimum intensity for your viewing light, adjust your darkroom inspection light to have the same intensity at the location where you normally examine your prints. Remember, you want to duplicate the intensity of light falling on the print, not the wattage of the bulb itself. A low-wattage bulb at close range will cast as much light as a higher wattage bulb at a greater distance.

ENLARGER BASICS

All but budget-priced enlargers and enlarging lenses produce good results. Each, however, has individual characteristics that you should take into account. The same negative printed on different enlargers will have a different contrast and sharpness.

There are three enlarger types:

- The most common is the *condenser* enlarger. This enlarger uses a tungsten light source, much like an ordinary household light bulb, which is focused by large lenses (condensers) before it passes through the negative.
- A second type is the *diffusion* enlarger. This enlarger uses a
 piece of frosted glass or plastic to scatter light nondirectionally
 before it passes through the negative. A variation of the diffusion enlarger uses a special fluorescent tube as a light source
 and is called a *cold-light* enlarger.
- Less common, but used by many people working with graphic arts materials, is the *point-source* enlarger. This enlarger projects highly focused light from a small, bright filament bulb through the negative.

Each of these enlarger types is capable of producing excellent black-and-white prints, but with certain tradeoffs. A condenser enlarger provides the best sharpness for the least cost. Diffusion enlargers are best at hiding dust spots and negative flaws but have slightly reduced print sharpness. A diffusion enlarger also produces prints with lower contrast than a condenser enlarger, requiring the use of higher contrast enlarging paper to produce equal results. Point-source enlargers produce the sharpest prints but are typically more expensive and more difficult to set up correctly.

You can adapt some enlargers to accept each of these light sources, so it is possible to experiment with two or more enlarger types to determine which is best for you. In spite of some claims to the contrary, no one enlarger type is inherently better than another.

Variable-Contrast Filters

Many photographers appreciate the convenience of variable-contrast paper. This is enlarging paper that has several different contrasts built into the emulsion. Manufacturers of variable-contrast papers supply sets of differently colored filters that change the paper contrast.

If you use variable-contrast paper, try to place the filter above the negative in the enlarger's lamphouse. Whenever you place a filter between the negative and the printing paper, you lose a small amount of sharpness. Not all enlargers permit the use of filters above the negative, however.

Although manufacturers use different numbering systems for their filters, there is no practical difference between them. You can use filter sets from different manufacturers interchangeably. You can also use the filters built into many enlargers designed for color printing. The following table lists color printing filter equivalents for the Kodak Polycontrast filter set:

Contrast	Filtration
Lower than Grade 1	80 Yellow
Grade 1	30 Yellow
Grade 1½	5 Yellow
Grade 2	10 Magenta
Grade 2½	30 Magenta
Grade 3	70 Magenta
Grade 3½	120 Magenta
Grade 4	200 Magenta

Many color heads don't have enough magenta filtration to produce a contrast higher than grade 3. You may have to supplement the built-in filters. Also, variable-contrast filter sets are designed for an incandescent light source. If your enlarger has a light source with a different color spectrum, the final print contrast may be different.

Enlarger Alignment

For a print to be uniformly sharp, the planes of the negative, the lens, and the easel must all be parallel. If you haven't checked your enlarger for proper alignment, you should do so. Even new enlargers are rarely in proper alignment. See Appendix A, "Enlarger Alignment," for instructions on how to check an enlarger for alignment and for suggestions on how to adjust the alignment if necessary.

SUMMARY

- Most darkroom chemicals are not obviously dangerous, but observing some standard safety rules, such as ensuring adequate ventilation and avoiding skin contact, can prevent longterm problems.
- Print tongs reduce the possibility of contaminating a print and eliminate the necessity of bringing your hands into contact with darkroom chemicals.
- Burning and dodging are two techniques that can improve the tones in selected areas of a print. Successful burning and dodging aren't noticeable.
- Processing chemicals are inexpensive relative to the cost of printing paper. Know the capacity of the different chemicals you use, and replace them before they cause problems.
- You can maintain even chemical temperatures by using a water bath. A water bath uses a volume of water surrounding the processing trays to hold them at a constant temperature for a longer time than normal.
- Proper agitation and correct timing ensure even development and prevent stains and other contamination.
- The type and intensity of your inspection light should duplicate as closely as possible the viewing conditions of your finished prints. Too bright or too dim an inspection light can make your prints darker or lighter than you want.

- There are three enlarger types: condenser, diffusion, and pointsource. Each has specific characteristics and produces different print statements, although no one system is inherently better than another.
- Variable-contrast papers, when used with the appropriate filters, are convenient ways to have access to a variety of contrasts at minimal expense. Filters used above the negative stage produce sharper prints than those used between the negative and the printing paper.
- Proper enlarger alignment is critical for making uniformly sharp prints.

Exposing for the Highlights

There are many books and theories to help photographers expose their negatives, but little has been written and even less is generally understood about exposing prints. In a way, this acknowledges the priority that negatives have over prints. You can always make a new print, but you only have one chance to expose a negative.

Today, with the increasing cost of quality printing paper, it makes little sense to use up materials just to find the right print exposure. Knowing how to find an exposure efficiently not only saves money, but also allows you to concentrate your efforts on refining the print statement.

HOW EXPOSURE AFFECTS A PRINT

When you expose a print, the amount of light striking the paper in the lightest areas of the image (the highlights) determines how those areas will appear after development. Nothing else that you do in the darkroom short of badly processing the print can change the appearance of those highlights. This isn't to say that exposure doesn't also affect the darker areas of the print, but it is in the highlights that you first notice the effects of exposure changes. It only takes a small change in exposure to turn a luminous and bright highlight into one that is gray and muddy. This difference doesn't show up as dramatically in the other areas of the print (Figure 2-1).

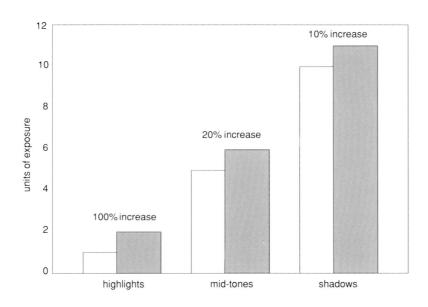

Figure 2-1 Relative effect of exposure increase on different print tones. Changes in exposure affect highlights more than darker print tones. This graph shows the effect of adding one unit of additional exposure to a print that has already received one unit of exposure in the highlights, five units in the gray midtones, and ten units in the dark shadows. The additional exposure unit increases the exposure in the highlights by 100%, the exposure in the middle gray tones by 20%, and the exposure in the shadows by only 10%. The increase affects the highlights ten times more than the shadows.

Readers familiar with the zone system, a method of exposing negatives, will recognize this technique. It is the same as exposing a negative in the camera, where you also determine exposure based on the areas of least density. The only difference is that the areas of least density in a negative are the shadows, while in the print (a positive), these areas are highlights. Since black-and-white photographic film and enlarging paper contain similar light-sensitive emulsions, this fact should not really be surprising.

FINDING THE CORRECT EXPOSURE

The best exposure for a print is one that accurately interprets the highlight tones in the negative. To find this exposure, you first determine which highlight is the most important in the image and then decide how that highlight should look on the print.

The Most Important Highlight

Deciding which highlight in an image is the most important means understanding the significance of that highlight to the print statement. For example, the way that snow in a winter landscape appears is probably critical to a successful print of that scene. Likewise, an accurate rendering of Caucasian skin tone in a portrait is usually important.

When deciding on the most important highlight in an image, ask yourself which one must be rendered accurately for a print of that image to convey the meaning you want. Don't choose a highlight just because it is the lightest or the largest in the image. Unimportant highlights can appear a variety of ways or can be burned and dodged without significantly changing the print statement.

Identifying Highlights

Once you determine the most important highlight, you need to decide how that highlight should look on the print. There are four basic ways that a highlight can appear: as a blank white, as a white with a slight amount of gray, as a textured light gray, and as a tone just lighter than middle gray. Using these terms to describe the highlights in your negative will help you make your decision about how you want them to appear.

Blank White

A blank white highlight is the same as the white base of the photographic paper (Figure 2-2). A highlight can't get any lighter than this in a print. Typically, this highlight appears in a print only when an image contains bright lights shown either directly or in a reflective surface.

First Appearance of Gray

The first appearance of a gray tone in a print is often used to represent a bright object that doesn't have any detail or texture, such as smooth, white painted metal or wood (Figure 2-3). It is difficult to tell the difference between this highlight and a blank white highlight unless they are side by side.

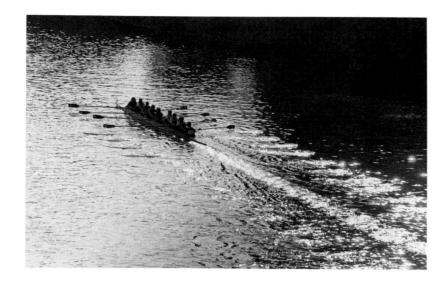

Figure 2-2 An image containing a blank white tone. The sparkles on the water behind the rowers are the lightest tone that a print can produce.

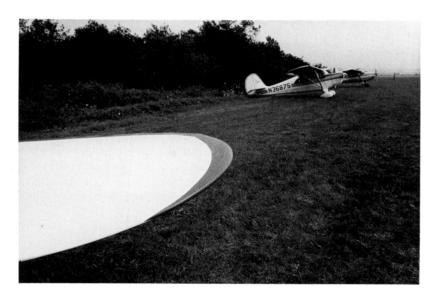

Figure 2-3 An image containing an area with the first appearance of gray. The airplane wing intruding from the left side of this image is a light gray tone that has no detail or texture. Although it is a featureless highlight, the wing has the appearance of a solid object, unlike the specular reflections in Figure 2-2.

Textured Highlight

A textured highlight is normally the tone in which white objects with fine detail appear in prints (Figure 2-4). Examples are weathered white painted wood and white beach sand when you are close enough to see the individual features.

Darker Highlights

Darker highlights are typically the way that concrete sidewalks, the clear north sky, and Caucasian skin appear in prints (Figure 2-5). Especially in portraits, most people notice when white skin tone is rendered correctly.

Making Exposure Tests

After deciding which is the most important highlight in the image and how you want it to look, the next step is making it appear that way on the print. This involves making an exposure test based on

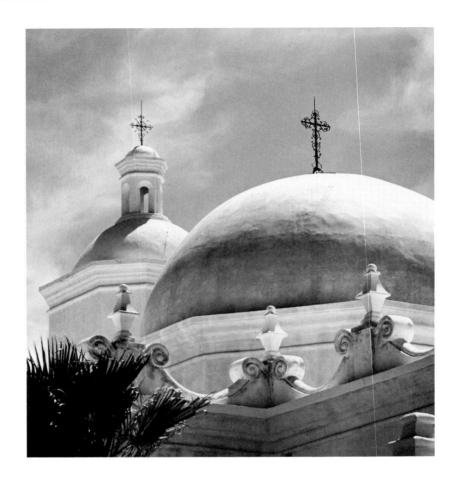

Figure 2-4 An image containing a textured highlight. The church dome shows a full range of highlights from blank white to just lighter than middle gray. The predominant highlight, however, shows the texture and detail of the stucco.

Figure 2-5 An image containing darker highlights. Evenly lit Caucasian skin tone is a good example of a darker highlight on most prints.

your printing paper's ability to produce a highlight that matches your description.

Most photographers make exposure tests by progressively uncovering a single small strip of printing paper while exposing it under an enlarger. The result is what is normally called a test strip because it contains different exposures on a single piece of paper (Figure 2-6).

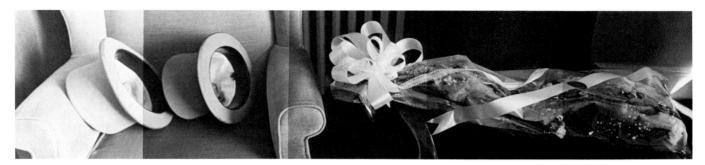

North Addition The

Unfortunately, each exposure is in a different area of the print. Some of these areas might contain highlights, but others might not. It is unlikely that the most important highlight will appear in all areas of the test strip. This prevents you from making accurate comparisons. You can only guess what an exposure in one part of the print will look like in another.

An additional problem with the exposure test shown in Figure 2-6 is that it requires several different exposures on a single piece of paper. A law of physics known as the intermittence effect states that dividing an exposure into several shorter time segments produces a different result than a continuous exposure of the same total duration. In other words, four 5-second exposures won't produce the same print as one 20-second exposure.

An accurate exposure test requires that you compare the same highlight at different exposures and that each exposure be a continuous one. This requires making a series of exposures in which each test strip is exposed to the same highlight. The following is a description of such a method. Follow these steps each time you make a print for one of the exercises in this book.

Preparation

For the exposure test, you need a full sheet of normal-contrast enlarging paper, a pair of scissors, and two light-tight containers, such as old photographic paper boxes.

- 1. Place the negative you want to print in the enlarger, focus it on your easel, and locate the area containing the most important highlight. This isn't necessarily the brightest highlight, but the one that is most visible and meaningful in the image.
- 2. Stop the enlarging lens down two or three stops from its maximum aperture, and set the timer to 5 seconds. Turn the enlarger light off.
- 3. Cut a full 8×10 -inch sheet of normal-contrast enlarging paper into four approximately equal pieces. These are the test strips. Put three test strips in one of the light-tight containers.

Exposing the Test Strips

- 1. Place the first test strip on the easel at the location of the most important highlight, and expose it for 5 seconds. Put this strip in the second light-tight container.
- 2. Reset the timer to 10 seconds. Place a second test strip in the same location as the first, and give it a 10-second exposure. Put it in the box with the first exposed test strip.

Figure 2-6 Exposure test containing different exposures on one piece of paper. This is an example of the kind of exposure test strip most photographers make. The question of which test exposure represents the correct exposure for the print becomes difficult to answer because each exposure is of a different part of the image.

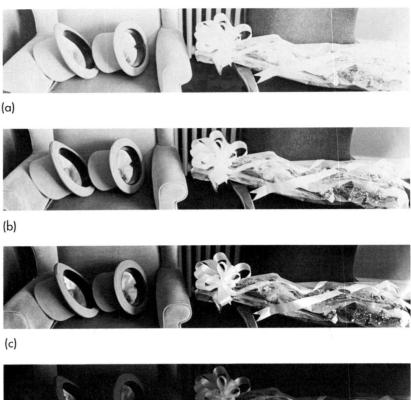

Figure 2-7 A correctly made set of test strips. In this series, each piece of paper was exposed to the same highlight. Knowing ahead of time how a highlight should look makes it easier to decide which test strip represents the correct print exposure (c).

- **3.** Reset the timer to 15 seconds. Place a third test strip in the same location, and give it a 15-second exposure. Put it with the other two exposed test strips.
- 4. Reset the timer to 20 seconds, and expose the fourth test strip for 20 seconds.

Processing the Test Strips

Develop all four test strips together for 2 minutes. After the stop bath, fix the test strips for at least 1 minute.

Evaluating the Results

- 1. Examine the test strips under an inspection light. Arrange the strips in order from lightest to darkest. The 5-second exposure should be too light in the highlights, and the 20-second exposure should be too dark. The results should resemble Figure 2-7. Don't concern yourself with what is happening in the midtones or the shadows.
- **2.** If all of the test strips are too light or if the darkest is the one that looks correct, make a new set of test strips with the enlarger lens opened one stop or with exposure times of 10, 20, 30, and 40 seconds.
- 3. If all of the test strips look too dark or if the lightest is the one

that looks correct, make a new set of test strips with the enlarger lens stopped down one stop.

A valid set of test strips "brackets" the correct exposure. Don't be misled into thinking that an exposure is correct until you have actually produced at least one test strip that you know is too light and one that is too dark.

Determining the Exposure

Once you have a valid set of test strips, pick the one that contains the best highlight rendering. The exposure time of that test strip is the correct exposure. If you can't decide which of two test strips represents the best exposure, choose one halfway between the exposures for those two.

AVOIDING SAFELIGHT FOG

Before you can accurately expose for the highlights, you must first be sure that your safelights aren't causing those highlights to look darker than they should. When this happens, it is called safelight fog. Safelight fog can cause you to underexpose a print if you base the exposure on the highlights.

The word safe in safelight is only a relative term because, despite manufacturers' claims to the contrary, all safelights will fog paper eventually. The goal of a safelight is to provide a maximum

Figure 2-8 The finished print from the test strips in Figure 2-7. The correct rendition of the bridal bouquet (test strip c) determined the exposure for this print.

Figure 2-9 A good image to use for a safelight test. This image contains mostly textured highlights. Any safelight fog will first show up in these highlights. Compare this image to Figure 2-10.

amount of working light without fogging your print during the time it takes to go between the paper box and the fixing tray.

An old photographer's myth is that you can test for safelight fog by removing a piece of enlarging paper from the box, covering half of it for a few minutes, and then developing it. The assumption is that if the uncovered half doesn't turn gray in the developer, the safelights aren't fogging your paper.

This test isn't accurate because it doesn't duplicate the way you actually work. When you are printing, safelight fog is added to any exposure you give a print. Fog occurs much more quickly on exposed paper than on unexposed paper. An accurate test for safelight fog requires testing your safelights after a print has been correctly exposed.

For a safelight test, you need a negative that has a large area of textured highlights. Figure 2-9 is a good example of an image to use.

If you don't have a suitable negative available, photograph a close-up of a white painted house or barn. The more texture in the siding, the better. Don't be tempted to use a negative just because you like the image. You are performing a test of your safelights, and you don't want to be distracted by image qualities that aren't related to the information you are seeking.

The Safelight Test

The following procedure applies only to amber-type safelights intended for use specifically with printing paper. The red safelights that some photographers like to use are intended for orthochromatic materials such as graphic arts film. Red light does not have the correct color spectrum to use with most printing paper.

1. Turn off all of the lights in your darkroom, including the safelights. Wait 2 or 3 minutes to let your eyes adjust to the darkness, and observe whether any light is coming in through cracks in doors, covered windows, or any other locations. Stop and fix any significant light leaks before proceeding.

Figure 2-10 A safelight test showing fog. The left half of this print shows the effect of safelight fog. Notice the line running down the middle of the print. If this had been an unexposed piece of paper or if the image had contained mostly darker tones, the chances of detecting safeliaht fog would have been greatly reduced.

- 2. Working in complete darkness, make a series of test strips of the textured highlight area, and process them.
- 3. Evaluate the test strips, and choose an exposure that renders the highlights accurately. Although it might take several tries before you have a valid set of test strips, it is better not to rush the process. The more care you take at this stage, the more accurate the test will be. Be sure that there is just enough gray in the highlights to show the texture clearly.
- 4. Make a full print in total darkness at the exposure you found. Confirm that it contains the correct highlights, and make a record of the exposure time.
- 5. Again, working in darkness, expose another sheet of printing paper for the same amount of time as the first. Carry the print over to the approximate location of the developing tray, and cover half of the highlight area with an opaque piece of thick paper or cardboard.
- 6. Turn the safelights on, and leave them on for 5 minutes. This should duplicate the maximum amount of time that you handle a piece of paper before putting it into the fix. If you normally have paper out longer than this, adjust the test time accordingly.
- 7. At the end of 5 minutes, turn off the safelights, and develop and fix the print. Don't turn on any lights again until after the print has been in the fix for at least a minute.

Analyzing the Safelight Test

If your safelights are causing fog, the fog will show up on your test print in the area of the highlight. The covered half of the highlight will be noticeably lighter than the uncovered half (Figure 2-10). If there is no difference in either half of the highlight in the test print, your safelights are safe for your normal printing procedures.

If you do have fog, here are some suggestions on how to correct the most common causes.

- 1. Check the safelight filter for cracks, and replace it if you find any. Older or abused safelight filters can develop cracks in their amber coating that let white light through.
- 2. Use a lower wattage bulb in the safelight, or cover a portion of the safelight with black paper to reduce the light intensity.
- 3. Move the safelight farther away from the enlarger and sink where you develop prints. As distance doubles, light intensity decreases by a factor of 4 (the square of the distance.)
- 4. If you are mechanically inclined, you can make a safelight dimmer from a standard household rheostat and an outlet box. Plug your safelights into the dimmer box, and adjust the light intensity until the light output is safe.

Once you adopt one of these solutions, don't assume that you have solved your safelight fog problem until you have rerun the safelight test and gotten the proper results.

STANDARD BLACK AND WHITE PATCHES

Identifying tones on a black-and-white print is highly subjective. What looks like a dark black tone on a wet print can appear gray when the print dries. The difference between a blank white highlight and the first appearance of gray is impossible to distinguish unless one tone is compared directly to the other.

You can prepare small pieces of printing paper with maximum black and maximum white tones to aid in identifying the tones you are producing on your prints. Use these patches as standard references for maximum black shadows and blank white highlights.

Creating Standard Patches

To make a set of standard black and white patches, follow these directions:

- 1. Cut a sheet of normal-contrast enlarging paper in half. Put one half back in the paper box or another light-tight place. Expose the other half under the enlarger for 1 minute with the lens at maximum aperture and no negative in the negative carrier.
- 2. Develop both the exposed and unexposed halves of the print for 2 minutes. Stop and fix as you normally would.
- 3. When the paper is dry, cut each half into two approximately equal pieces. Two inches square is a convenient size. These are your standard black and white patches.

Using Standard Patches

The white standard patch represents the lightest tone that a particular printing paper can produce under your normal processing conditions. The black standard patch represents the maximum black that a particular printing paper can produce under those same conditions.

Use the standard patches by keeping one black and one white patch dry for comparing with tones on finished prints. Keep the other set in a tray of water (like an inspection tray) when you print for comparing with wet print tones. Different brands of paper require different standard patches. You will use the standard black patch in the next test.

THE PROPER PROOF

Most photographers think of a contact proof as a quick and easy way to see small prints of all of their negatives. With only this goal in mind, they tend to make contact prints in any convenient manner. A properly made contact proof, however, also contains information about the exposure and development of film that can save time in the darkroom.

Making a Proper Proof

The secret to gaining this knowledge is to standardize the way you expose a contact proof. This means standardizing the light source as well as the exposure.

Producing a Standard Light Intensity with an Enlarger

- 1. Place a negative in the enlarger, and project the image onto an area of approximately 10×12 inches on the baseboard.
- 2. Focus the image, and mark the position of the enlarger head on the column with a marker or piece of tape.
- 3. Take the negative out of the enlarger, and set the lens at f/8.

This procedure creates a light intensity on the baseboard of your enlarger that you can always duplicate. The actual height of the enlarger or the fact that the negative is in focus isn't as important as the fact that you can return the enlarger head to the mark you made on the column and focus the light in the same way each time you make contact proofs.

Finding a Standard Exposure

Before beginning this test, obtain an unexposed but developed and fixed length of the film you normally use. If you are using roll film, a piece of film 6 to 10 inches long is good. This duplicates the lightest possible areas of your negatives, a density known as film base plus fog.

- 1. Cut a sheet of your usual printing paper into strips slightly larger than the piece of film you are going to use in the test.
- 2. Sandwich the film and paper, emulsions together, in your contact printing frame. If you don't have a contact frame, lay the film and paper sandwich under a sheet of 1/4-inch-thick
- 3. Place the contact frame on the enlarger baseboard, and expose for 5 seconds with your standard intensity light.
- **4.** Repeat steps 2 and 3 at exposures of 10, 15, and 20 seconds.
- 5. Process the test strips, and examine them under your inspection light.

The exposures should produce a range of tones from dark gray to maximum black (Figure 2-11). Use your standard black patch to determine which exposure first produces a maximum black tone. If none of the exposure tests turn the test strip maximum black or if all of them do, repeat the test after first adjusting the exposure time or the lens aperture appropriately.

The minimum exposure time that it takes for the contact print of the clear film base to turn maximum black is the standard expo-

Figure 2-11 Test strips used to determine the exposure for a proper proof. The four illustrations here are "prints" of a length of unexposed but developed and fixed 35mm film. They represent a test to find the exposure necessary to render clear film base as maximum black on a contact proof. Test strip (c) is the correct exposure.

sure you should give all contact proofs made with that film and paper. When you make contact proofs with a different film or on a different brand of paper, you must make a new test for a standard exposure time.

Evaluating a Proper Proof

The standard exposure to use for a proper proof is the exposure time it takes for the lightest possible part of the negative (the film's base) to produce a maximum black tone on the print. When the film base is rendered on the proof as maximum black, any other tones in the negative that are properly exposed and developed will also appear correct on the proof. If there is something wrong with a negative in either exposure or contrast, you can identify the problem in the following manner.

Negative Exposure

A properly exposed negative on a properly made contact proof looks approximately the way you would want the final print to look. If a particular image looks too dark overall, it is underexposed; if it looks too light overall, it is overexposed.

Negative Contrast

Examine the images in the proper proof closely, using a magnifying glass if necessary. If the shadows and midtones of a particular image look correct but the highlights are too light, it indicates greater than normal contrast. If the highlights look too dark, it indicates less than normal contrast.

Using a Proper Proof

A proper proof gives you an indication, in advance of printing, of which negatives should print well on normal-contrast paper and which will require extra work. The fact that the exposure and contrast of a negative aren't optimum doesn't mean that you can't make a satisfactory print. The information simply saves you time and guesswork.

Another use for the proper proof is to spot trends in your working procedures before they create problems. An occasional bad frame on a contact proof isn't a signal of anything wrong, but consistent over- or underexposure can indicate that you either need to change the exposure index you use for that film or that you need to replace the battery in your light meter. Also, if your negatives consistently have too much or too little contrast, it might mean that you need to change your standard film developing time or even that your darkroom thermometer needs recalibration or replacing.

EMULSION SPEEDS OF PRINTING PAPER

Emulsion speed, the light sensitivity of printing paper, is directly related to a paper's ability to render accurate highlight tones. A paper that requires 10 seconds of exposure to produce a textured highlight has a faster emulsion speed than one that requires 12 seconds for the same highlight. Not only do different brands and contrasts of printing paper have different emulsion speeds, but frequently so do different boxes of the same brand and contrast.

This means that if you determine the correct exposure for a print but need to change the contrast, you must rerun the exposure test for the new contrast paper. If you know in advance the exposure change required by the new paper contrast, however, you can save this time and effort. The following test allows you to calibrate the different types and contrasts of paper you normally use so that you can switch between them without having to run new exposure tests.

Testing Different Emulsion Speeds

For the emulsion speed test, use the negative you used for your safelight test or another negative that contains large areas of textured highlights. Since this test requires that you distinguish subtle differ-

Figure 2-12 The proper proof. This detail of a contact sheet shows the different aspects of a proper proof. Notice how the clear film edges have disappeared, leaving only the frame numbers visible. This is the correct exposure for a proper proof. Frames 10 through 12 and 16 show approximately correct tones, indicating that these frames are correctly exposed. Frames 17 and 18 are too light, indicating that they are overexposed.

ences in the highlights of different prints, the larger and more distinct the highlight, the more accurate the test will be. Throughout this test, resist any temptation to burn and dodge.

- 1. Make a print on normal-contrast paper that you feel represents the most accurate rendering of the textured highlights in the image. Don't worry if the midtone and shadow areas don't look the way you want them; you will learn to control these tones in the next chapter. This is the control print. Carefully note the exposure time.
- 2. Using grade 3 paper or a number 3 filter (if you are using variable-contrast paper), make a print that matches the tone, texture, and detail of the highlight in the control print. Again, note the exposure time required.
- 3. Repeat step 2 for all grades of paper or filter numbers you normally use. Take care to match the highlights as closely as possible, each time noting the final exposure time.
- 4. When the prints are dry, examine them, and make sure that the important highlight still matches in all prints. If you have to, remake any prints that don't match.
- 5. Using the control print on normal-contrast paper as a starting point, calculate the percentage difference in exposure for each grade or filter number, and record this exposure factor in your notes and also in large letters on the lid of each paper box. If you are using filters, place a gummed label with this information on the handle of each filter.

For example, if the exposure time for the control print was 10 seconds and the exposure time on grade 3 paper was 15 seconds, the exposure increase for grade 3 is 50%, or 1.5 times the exposure on grade 2.* Once you have this information, all you have to do to switch from grade 2 to grade 3 paper is multiply the correct grade 2 exposure by 1.5. You don't have to run a new exposure test, although you might want to keep a calculator by your enlarger.

Some paper manufacturers claim that different contrast grades of their paper have identical emulsion speeds. Although this is convenient when it is true, don't accept such claims until you test them. Variables in manufacturing and storage conditions can change even the emulsion speed of different boxes with the same emulsion number. Always test a new box of paper before you use it. In fact, running this test again at a later date is a good idea. You might find that as you gain experience, your perception of print tones will change your opinion of what constitutes a matching highlight.

SUMMARY

In this chapter you have learned about the importance of correct exposure in rendering a highlight tone on a print. To help you find the correct highlight exposure, follow these suggestions:

 Always make test strips using separate pieces of paper exposed to the area of the negative containing the most important high-

^{*}You can calculate the exposure factor by dividing the exposure time for the paper you are testing by the exposure for the control print. In the example above, 15 is divided by 10 to obtain 1.5.

- light. Be sure that you give each test strip a single, continuous exposure.
- When evaluating test strips, make sure that you have at least one that is too light and one that is too dark. If the lightest or darkest strip indicates the correct exposure, make a new set of strips at either a longer or shorter exposure.
- Run a safelight test in your darkroom to determine the effect of fog on the highlight of an exposed print. Be sure to correct any problem that the test indicates before you continue with any other tests in this book.
- Make standard black and white patches as references to see if the highlights and shadows in your prints match your expectations.
- Standardize the way you make contact proofs of your negatives by exposing them for the minimum amount of time required to produce a maximum black tone in the area covered by the film's clear base. This gives you information about the exposure and contrast of your negatives before you print them.
- Test the emulsion speeds of the different grades of paper you use so that you can switch from one grade to another without having to rerun an exposure test and without losing the correct highlight rendering of the negative you are printing.

Chapter **3**

Changing Contrast for the Shadows

Finding the correct exposure is only the first half of the printing equation. The essential second half is matching the proper contrast, or paper grade, to the image. The purpose of paper grades in printing is to use changes in contrast to control the appearance of the shadows in the print.

This means that while you are printing you make decisions about exposure and contrast one at a time. First you determine the correct exposure based on the highlights, then you choose a paper grade (or filter number) that best renders the shadow tones. Once the highlights and shadows are correct, the middle tones usually fall into the proper relationship between them.

Thinking of printing as a two-step process enables you to work on the part of the image with the technique that controls it best. Most photographers don't keep the two processes separate and end up burning in highlights or dodging shadows. Working with only one part of the tonal scale at a time eliminates confusion.

WHAT CONTRAST IS

Contrast in photography is the range of tones between the lightest highlight and the darkest shadow (Figure 3-1). Although the concept of contrast is the same for both negatives and prints, it helps to think of them separately because their functions are different.

Negative Contrast

In a negative, contrast is determined by two factors: the range of tones in the original scene and how you develop the film. Some photographers spend a lot of time and effort controlling the contrast of their negatives, and some don't. Usually, however, every photographer ends up with negatives containing a variety of different contrasts.

Although there are precise scientific methods for determining the contrast of a negative, making some generalizations is useful. A negative in which there is a large difference between the highlight and shadow densities is a high-contrast negative. Typical high-contrast scenes are found outdoors on a bright, sunny day. Negatives that are exposed in such situations and are not given special development to compensate for the contrast of the scene produce prints with extremely light highlights and very dark shadows.

A negative that has only a small difference in density between the highlights and shadows is a low-contrast negative. A typical low-contrast scene (indoors in dim light, for example) produces a negative that prints with gray shadows and highlights.

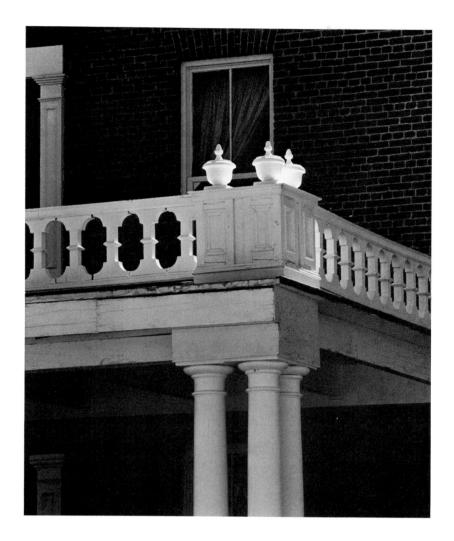

Figure 3-1 How contrast affects image content. The range of tones and how they appear on the print are a major part of an image. In this print, the highlight rendering of the sunlit urns, surrounded by dark shadows, provides the visual focus of the image.

A negative with an average density difference between the highlights and shadows is a normal-contrast negative. Typically, normalcontrast negatives produce prints with a sense of bright highlights and dark shadows without either appearing in extremes.

Print Contrast

Unlike film, which contains no contrast until you expose and develop it, photographic printing paper is manufactured with a specific contrast. When exposed to a negative, printing paper will render the negative tones in a predetermined way.

Some printing papers contain one specific type of contrast. These papers are called graded papers and are usually designated with a contrast number, or grade. Grade 2 paper is normal contrast, grade 1 is low contrast, and grades 3 and higher are high contrast.

Other printing papers contain both high-contrast and low-contrast layers of light-sensitive emulsion. These are variable-contrast papers. When you use variable-contrast paper, you expose negatives through one of a set of filters that control the amount of exposure reaching each light-sensitive layer. The filters are usually numbered in a manner equivalent to paper grades. For example, a number 2 filter produces a contrast that is equivalent to grade 2 paper.

The reason for having so many contrast grades is to allow the photographer to select a paper that matches the contrast range of the negative. The first step in matching paper and negative contrast is deciding how you want the shadows in your print to look.

SHADOW TONES

In a print, a shadow can appear in four basic ways: as maximum black, as a dark gray tone slightly lighter than maximum black, as a dark shadow with the appearance of detail, and as a medium dark tone, just darker than middle gray. Once you have identified the most important shadows, you know how you want them to appear on the print. The following descriptions will help you recognize these shadows.

Maximum Black Shadows

A maximum black shadow is the darkest tone that a print can be made to yield (Figure 3-2). It is the same tone you produced when you made a maximum black patch in Chapter 2. Maximum black

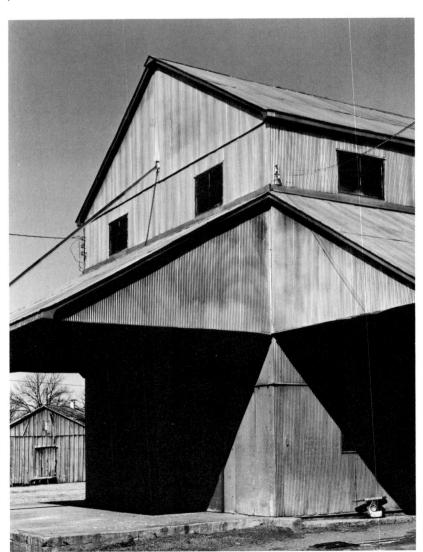

Figure 3-2 An image containing a maximum black tone. The shadows in this print are dark and impenetrable. To see the effect of a maximum black shadow on an image, try looking at this illustration while squinting your eyes. When the image is slightly out of focus, the double triangle of the shadow is the most noticeable shape.

Figure 3-3 An image containing a noticeable area of dark gray shadows. The shadows surrounding the play of light on the wall are too dark to show any detail but are light enough to show that the wall is actually there. The visual appearance of the shadows is substantially different from Figure 3-2.

shadows are typically flat, featureless areas of a print, such as doorways and windows opening into unlit rooms.

How dark maximum black actually is depends on the printing paper you are using. Some brands of paper produce a darker maximum black than others. Whenever you want to determine when a shadow in a print is maximum black, use a standard black patch made from the same brand of paper. If the two tones match, the shadow is maximum black. If the shadow tone on the print is noticeably lighter than the standard black patch, then it is a dark gray.

Dark Gray Shadows

This shadow is the first tone in a print that is noticeably lighter than maximum black (Figure 3-3). Any very dark object in an image for which you want a sense of space or volume should appear in this tone. It is hard to determine the difference between this shadow and

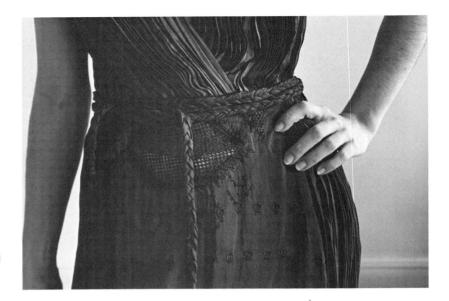

Figure 3-4 An image containing detailed shadows. The form and texture of the black dress are clearly revealed in this image. A darker renderina of this shadow tone would completely change the meaning of the image.

maximum black unless the two are side by side. A standard black patch is useful in making this distinction.

Dark Detailed Shadows

This is the tone of any dark shadow in which you want detail and texture to appear (Figure 3-4). Typical examples of this tone are deep shadows under bushes, black hair, or dark fur on animals. Because you are looking for both a sense of darkness and detail, this shadow is easy to spot.

Medium Dark Shadows

Open shadows in the landscape, average dark foliage, new blue jeans, and brown hair on people are typical values for this shadow tone (Figure 3-5). Details on a print with this shadow are easy to see and obvious to the viewer. Any tone lighter than this will not be a shadow value.

PAPER GRADES AND PRINT CONTRAST

Two factors determine print contrast: the contrast of the negative and the capacity of the printing paper to render contrast. For all practical purposes, once you develop the film, the contrast of your negative is fixed.* Because of all of the possible contrast situations that could exist on developed film, paper manufacturers provide a variety of paper grades (or filters for variable-contrast paper) to let you match a negative's contrast with a particular paper.

^{*}There are exceptions that prove this rule. Chemical intensifiers and reducers and masking techniques can alter the contrast of a developed negative. For the most part, these techniques are complex, aren't completely reliable, and should only be used when all else fails to produce a satisfactory print. Intensifiers and reducers are discussed in Chapter 7, "Salvage Techniques."

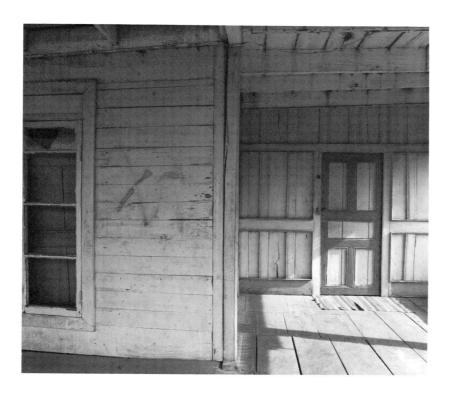

Figure 3-5 An image containing open shadows. The interior of this building is primarily in shadow, but it is light enough to show all of the details of its construction.

Normal-contrast printing paper (grade 2 or number 2 filter) typically renders contrast as it appears in the negative. This means that if a negative has a normal contrast range, the tones in that negative will reproduce correctly on grade 2 paper (Figure 3-6a).

Low-contrast paper (grade 1 or number 1 filter) has the ability to render a greater range of tones than normal-contrast paper. A normal-contrast negative, correctly exposed for the highlights, would look weak and gray in the shadows when printed on grade 1 paper (Figure 3-6b).

High-contrast paper (grade 3, number 3 filter or higher) can render a smaller range of tones than normal- and low-contrast papers. A normal-contrast negative, correctly exposed on grade 3 paper, would look acceptable in the highlights, but the shadows would appear to be dark and without enough detail (Figure 3-6c).

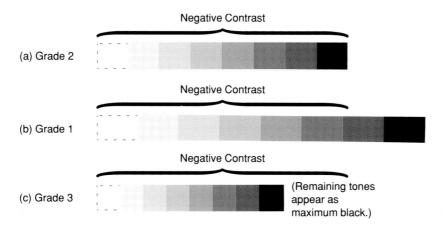

Figure 3-6 Matching negative contrast and paper grades. (a) If the negative contrast matches the paper contrast, then both the highlights and the shadows will be rendered correctly. (b) If the paper contrast is too low for the negative, then exposing for the correct highlights will produce a print in which the darkest shadows will not appear dark enough. (c) If the paper contrast is too great for the negative, then a correct exposure for the highlights will mean that all of the important shadow tones will appear too dark and will probably lose detail.

When to Change Contrast

Knowing what will happen to the tones in an image when you change paper grades allows you to devise a strategy for printing when you are working with new negatives and don't know what contrast to use. The following steps outline a typical approach. This approach combines the steps you learned in Chapter 2 for finding the correct exposure with an approach for discovering the correct contrast. Once you practice and understand their purpose, you can modify these steps to suit your particular needs.

- 1. Make a series of test strips on grade 2 (normal-contrast) paper to find the correct exposure of the most important highlight in the image. Be sure to concentrate only on the highlights; don't be influenced in your judgment of the exposure by how the shadows might look.
- 2. When you have decided on an exposure, make a test print of the whole image on grade 2 paper. This should confirm that the exposure based on the test strips is actually the correct exposure for the whole print. If not, repeat steps 1 and 2.
- 3. Examine the most important shadows in the test print.
 - If the shadows appear as you want them, the contrast is correct. You can use the test print to decide on any finishing steps, such as burning and dodging, for the final print.
 - If the shadows appear too dark, proceed to step 4.
 - If the shadows appear too light, proceed to step 5.
- 4. If the shadows on the test print appear too dark (for example, if the darkest detailed shadow is too dark to show any detail), make another print on grade 1 paper (Figure 3-7). Be sure to adjust the exposure to keep the highlights of the two prints the same.
- 5. If the shadows appear too light (for example, if the darkest shadow looks too gray and the overall appearance of the print is flat), make another print on grade 3 paper (Figure 3-8). Be sure to adjust the exposure to keep the highlights of the two prints the same.

When you begin exposing for the most important highlights and changing contrast for the most important shadows, you will find that the final print requires much less finishing work than you have probably given prints in the past. For example, with the most important highlight and shadow areas controlled by exposure and contrast, burning and dodging is limited to the less important parts of the image. This makes burning and dodging less critical to the success of the print.

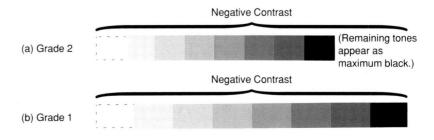

Figure 3-7 Printing a high-contrast negative on grade 1 paper. If you expose a negative for the correct highlights on grade 2 paper and the shadows appear too dark (a), switching to grade 1 paper will make the shadows appear lighter (b).

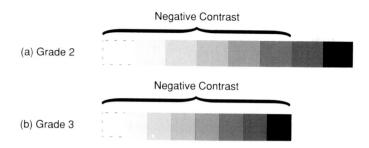

Figure 3-8 Printing a low-contrast negative on grade 3 paper. If you expose a negative for the correct highlights on grade 2 paper and the shadows appear too gray (a), switching to grade 3 paper will make the shadows appear darker (b).

THE RING-AROUND TEST

Even for experienced printers, it can be difficult to decide on the best exposure and contrast for a negative. In fact, for many negatives, more than one exposure and contrast produce a good print. Often, the only way to see and evaluate the choices available for printing a negative is to experiment with the different combinations.

A ring-around test provides a transition from the theory of correct print exposure and contrast to its practice. The ring-around is a technique that quickly and efficiently produces examples of the major exposure and contrast variations for an image. These results show you the different print statements that are possible for a particular image and can even help you gain experience understanding how other negatives might be affected by exposure and contrast changes.

Preparation

For the ring-around test, use a negative that previously has printed well on normal-contrast paper and that has approximately equal amounts of highlights, shadows, and midtones. Figure 3-9 is a good example of such an image. For best results, the test negative should print well without burning or dodging. A convenient and economical print size for the ring-around test is 5×7 inches. As you make each print, be sure to record exposure and contrast information on the back with a soft lead pencil.

Figure 3-9 A good image to use for a ringaround test, such as this one, contains a variety of easy-to-recognize tones.

Procedure

- 1. Using test strips as a guide, make a print of the test negative on normal-contrast paper (grade 2 or number 2 filter), trying to achieve the best possible highlight rendering. Record the exposure time and contrast grade. This is the grade 2 reference print.
- 2. Make two more prints on normal-contrast paper, one with 50% less exposure than the reference print and one with 75% more exposure.
- 3. Using low-contrast paper (grade 1 or number 1 filter) and taking into account any exposure change between the paper grades, make a print that has identical highlights to the grade 2 reference print. Again, record the exposure time and contrast grade. This is the grade 1 reference print.
- 4. Make two more prints on low-contrast paper, one with 50% less exposure than the grade 1 reference print and one with 75% more exposure.
- 5. Repeat steps 3 and 4 using high-contrast paper (grade 3 or number 3 filter and any other higher contrast grades that you normally use. Be sure that for each paper grade you adjust the exposure of the reference print to match the highlights in the grade 2 reference print.*

Evaluating the Test

When the prints from the ring-around test are all washed and dry, lay them out on a flat surface, such as a large table top, or pin them to a bulletin board in the following order:

- 1. Place the grade 2 reference print in the middle, the grade 2 print with 50% less exposure above it, and the grade 2 print with 75% more exposure below it.
- 2. To the right of the grade 2 prints, place the grade 1 prints in the following order: grade 1 reference print in the middle, 50% less exposure above it, and 75% more exposure below it.
- 3. To the left of the grade 2 prints, place the higher contrast prints (grade 3 and above) in the same order as the others: reference print in the middle, 50% less exposure above it and 75% more exposure below it. Figure 3-10 illustrates the order described.

You have created a visual ring around what you have up to now considered the correct way to print the test image. Each print represents a different statement. Some will interest you, others will not. Study the prints carefully, and ask the following questions:

- Is the grade 2 reference print still the best way to print the negative?
- If the grade 2 reference print is not the best, what other prints in the ring-around are better?
- If the grade 2 reference print is still an acceptable print, are there prints in the ring-around that you like just as well?

^{*}During this test you might find that the exposure factors you calculated in Chapter 2 need some adjustment. Be sure that you are sensitive to the actual tones that appear on your prints, and allow for the fact that you have already increased your ability to see small differences in print tones just by performing the printing tests in this book.

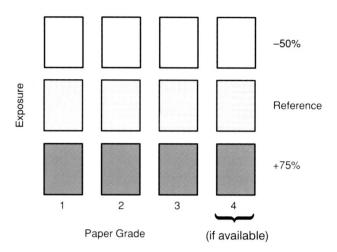

Figure 3-10 Order for arranging the ringaround test.

If there are several prints in the ring-around that you like, try to determine in what ways, other than exposure and contrast, they are different. This means thinking about how the different print statements produce different feelings as you look at them. It is useful to try to describe these differences in writing. A journal in which you keep records of your investigations and examples of your test prints is an invaluable future reference.

The next time you come to a negative that you are having a hard time printing, try performing a ring-around test with it. Sometimes even a partial ring-around (one or two contrast grades or exposures, for example) will help you make decisions about how to print that negative.

EXPOSURE AND DEVELOPMENT VARIABLES

As you increase your awareness of how contrast changes affect a print, you will increasingly encounter situations in which you want to make a contrast change that is less than a full paper grade.

One way some photographers make small changes in contrast is by changing the brand of paper they are using. For example, changing from Ilford's Gallerie grade 2 to Oriental Seagull grade 2 slightly increases a print's contrast. Unfortunately, this approach ignores the many differences that these papers have in overall appearance. Each brand of paper has a distinct color, ability to take toning, and ability to emphasize one part of the tonal scale over another. These differences are the subject of Chapter 5, "Choosing a Paper and a Developer."

In situations in which you need to change contrast by less than a full paper grade and also want to preserve an image's overall appearance, you can use variable-contrast paper (which offers filters in half grade increments), or you can use exposure and development variations with graded paper. This technique takes advantage of the fact that all silver-based emulsions change contrast as you change development time

Using variations in exposure and development to produce small changes in contrast is useful in most situations because it works on any brand and type of printing paper and doesn't require a special darkroom setup.

Your standard developing time is the starting point. An increase in the standard developing time increases contrast, and a decrease in the standard developing time decreases contrast. Although every brand of paper is different, you can alter the development time of most papers from one-half of the standard development time to twice the standard development time without encountering problems of uneven development or fog.

Because changing the development time affects the highlights as well as the contrast, you must compensate for the corresponding increase or decrease in highlight density by changing the exposure. You must increase exposure if you are decreasing development, and decrease exposure if you are increasing development.

The following exercise demonstrates how exposure and development changes alter contrast and offers guidelines for changing both exposure and development that work for most papers.

The Exposure and Development Variables Test

For this exercise, assume that your standard development time is 2 minutes, as recommended in Chapter 1. Use the same negative for this test that you used for the ring-around. If you like, you can save time by doing this exercise when you do the ring-around.

- 1. Using a piece of grade 2 paper, increase the normal exposure time you used for the ring-around test by 20%, and develop that print for 1 minute (one-half the normal development time).
- 2. Using a second piece of grade 2 paper, decrease the normal exposure time by 20%, and develop for 4 minutes (twice the normal development time).
- 3. Using a piece of grade 1 paper, increase the normal exposure time you used for that grade of paper in the ring-around test by 20%, and develop for 1 minute.
- **4.** Using a piece of grade 3 paper, decrease the normal exposure time you used for that grade of paper in the ring-around test by 20%, and develop for 4 minutes.
- 5. If you used grade 4 paper in the ring-around test, repeat step 4. decreasing the normal exposure for that grade and developing for 4 minutes.

Evaluating the Test

Once the prints are dry, examine all of the highlights to make sure that they match. Remake any prints in which the highlights are significantly different, adjusting the exposure appropriately. Then

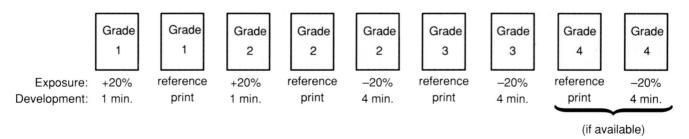

Figure 3-11 Order for arranging the exposure and development variables test.

line the prints up with the reference prints from the ring-around test so that the lowest contrast print (grade 1 paper developed for 1 minute) is on the left and the highest contrast print (grade 3 or 4 paper developed for 4 minutes) is on the right. Figure 3-11 illustrates this order.

You should have a series of prints of the same image in which the contrast varies in subtle steps from very low contrast to very high contrast. Although the highlights in all of the prints are approximately the same, the shadows gradually become darker as the contrast increases. From among these variations you can choose the exact contrast that is appropriate for the image.

The exposure and development suggestions in the test provide a starting point for further experimentation. For most paper and developer combinations, changing the exposure time by 20% and doubling or halving the development time changes the contrast by about one-half grade while matching the highlights of a normally developed print. Even if this isn't true for the materials you are using, understanding the goal of keeping the highlights the same while increasing or decreasing the darkness of the shadows should help vou devise your own procedures.*

SUMMARY

- Printing is a two-step process. It consists of first determining an exposure based on the correct highlight rendering and then adjusting the contrast for the best shadow tones.
- Four general types of shadows can appear in a print: maximum black shadows, dark gray shadows, dark detailed shadows, and medium dark shadows. To determine the correct contrast for a print, first decide which of these types is the most appropriate for the important shadow tones in the image.
- · Change contrast when the highlights look correct, but the shadows don't fit your idea of how they should appear.
 - —If the highlights are correct, but the shadows are too light and gray, change to a lower contrast paper.
 - —If the highlights are correct, but the shadows are too dark and don't have enough detail, change to a higher contrast
- To visualize how exposure and contrast changes affect a print statement, perform a ring-around test to see examples of all of the possible variations. This test is especially useful when you are unsure of which exposure or paper grade to use.
- You can achieve more subtle variations in contrast than is possible with paper grades alone by changing the exposure and development of a print. A rule of thumb is to increase exposure by 20% and cut development time in half to lower the contrast of a given paper by approximately one-half grade and decrease exposure by 20% and double the development time to increase the contrast by approximately one-half grade.

^{*} Some paper developers containing phenidone or pyrazolidone as a reducing agent do not produce as great a contrast difference when you change exposure and development times as do developers containing metol and hydroquinone. Developers containing phenidone or pyrazolidone include Ethol LPD and Sprint Quicksilver. Even with developers like these, you can produce noticeable contrast changes.

Chapter **4**

Photographic Chemistry— Creating a Developer

Watching an image appear in the developer tray should always be a magical event for a photographer. Control of the basic chemical processes that produce that image, however, should not be left to magic. Although few photographers think of chemical formulas when they want to improve their prints, developers can be an additional creative tool when used knowledgeably. All photographers should know why a developer works the way it does and what they can do to change a developer's effect on a print. This means learning something about a developer's chemical makeup.

STANDARD DEVELOPER CHEMICALS

Most developers for film and paper consist of the same five chemicals used in different combinations. Each has a specific and complementary function in a formula. Broken down by function, these five chemicals are two reducing agents, a preservative, an accelerator, and a restrainer.

Reducing Agents

A reducing agent is the active ingredient in a developer. During development, a reducing agent converts the milky white exposed silver halides to black metallic silver. It is this metallic silver that forms the visible image.

Standard paper developers, such as Kodak's Dektol and Ilford's ID-11, contain two reducing agents: metol* and hydroquinone. These two chemicals complement each other; metol controls the overall development of tones, and hydroquinone produces dark shadows.

Some developers contain reducing agents other than metol and hydroquinone. The most common of these alternative reducing agents are phenidone, glycin, and diaminophenol (also known as *amidol*). Phenidone and glycin are usually used in combination with hydroquinone; amidol usually appears by itself in developer formulas.

^{*}Metol (*p*-methylaminophenol sulfate) is also commonly known by its Kodak proprietary name, Elon. Other less-popular trade names for this chemical include Atolo, Monol, Pictol, Rhodol, and Viterol.

Preservative

A preservative prevents the reducing agents in a developer from combining with oxygen molecules in the air, a process known as oxidation. An oxidized reducing agent has released its energy combining with oxygen and can no longer reduce silver halides.

Because it is cheap and efficient, the most popular preservative in photographic developers (as well as many packaged foods) is sodium sulfite. Sodium sulfite is usually sold in one of two forms: anhydrous (sometimes called desiccated) or crystal. Most developer formulas published in the United States specify the anhydrous form of sodium sulfite. Because the chemical activity of the two forms is different, use the conversion table in Appendix B if you have one form of sodium sulfite and a formula specifies the other.

Accelerator

An accelerator enhances the reaction of reducing agents. Most formulas use an accelerator because reducing agents are the most expensive chemicals in a developer. An accelerator allows smaller amounts of a reducing agent to adequately develop an image.

Sodium carbonate is the most commonly used accelerator in photographic developers using metol and hydroquinone. It acts as an accelerator by increasing a developer's alkalinity. The more alkaline the solution, the more active the reducing agents. Sodium carbonate is usually sold in one of two forms: anhydrous or monohydrate. In addition, sodium carbonate is sometimes found in *crystal* form. Be sure that you know which form of sodium carbonate the formula you are using specifies, and use the conversion table in Appendix B if you have a different form.

Restrainer

A restrainer inhibits developer activity. Although it might sound like a contradiction to include a restrainer in a developer that also contains an accelerator, the two work in a complementary fashion. A developer with enough accelerator to develop a strong shadow tone will also reduce some unexposed silver in the highlights where it isn't wanted. This tone is referred to as chemical fog, and it is similar in appearance to safelight fog. A correctly formulated developer contains just enough restrainer to delay the appearance of chemical fog in the highlights until after the other areas of the image are fully developed.

Most developers use the chemical potassium bromide as a restrainer, although there are commercially available anti-foggants that have similar effects. The most popular of these products is Kodak's Anti-Fog No. 1 and Edwal's Liquid Orthazite.

Water

All developers that you mix from dry chemicals are dissolved in water. Even when developers come in concentrated liquid form, you still use water to dilute them. Usually, the slight impurities found in most tap water aren't a significant factor in the activity of a developer.

In some locations, this isn't true. The municipal water supply in many parts of Arizona, for example, contains large amounts of alkaline chemicals that act like accelerators. Prints made in developers mixed with this water often look gray and muddy due to additional chemical fog.

If you have doubts about the quality of the water in your area, run a test using identical developers, one mixed with tap water and the other mixed with distilled water. If you can detect a difference between prints developed in these two developers, then you might want to use distilled water to mix and dilute all of your developers.

OBTAINING DARKROOM CHEMICALS

Obtaining chemicals with which to make a developer is not difficult. One- and five-pound containers of standard developer chemicals are usually common items in photography stores that carry Kodak prepackaged developers, fixers, and stop baths. If a store selling Kodak supplies doesn't stock these chemicals, it can order them for you.

Be sure that when you buy or order chemicals you are specific about what you want. There is a large difference, for example, between sodium sulfite, which you need in quantity, and sodium sulfate, which you will rarely, if ever, need.

For special formulas, mail-order businesses carry hard-to-find chemicals in small quantities. You will find the addresses of some of these businesses in Appendix D.

MEASURING PHOTOGRAPHIC CHEMICALS

Because you must measure precise quantities of chemicals, you should have access to an accurate scale. Triple-beam laboratory scales are very accurate but can cost more than a hundred dollars. Kitchen-type or diet scales are not accurate enough and should not be used anyway if you also use them to weigh food. One scale that is both accurate and inexpensive is a model called the Counter BalanceTM (Figure 4-1).

Whenever you weigh a quantity of a chemical, be sure to place a clean piece of paper on the balance platform and to adjust the scale

Figure 4-1 A triple-beam balance and a Counter BalanceTM scale. The triple-beam balance on the left can measure quantities as small as 0.1 gram. It is more than accurate enough for photographic applications. The inexpensive plastic scale on the right isn't as accurate as the triple-beam balance, but it is useful for most purposes.

to compensate for the extra weight. Creasing the paper in at least two directions can help keep small quantities of a dry powder in the middle of the paper.

Use a clean spoon or thin spatula to remove a small amount of the chemical from the container and place it on the paper. Try to remove a quantity that you estimate is less than you will actually need. Add more gradually until you have the exact amount. If you remove more of a chemical from its container than you need, throw it away instead of putting it back, or you risk contaminating the entire jar.

Never leave a spoon or spatula in a chemical container. This practice can contaminate the container and cover the handle of the utensil with chemical dust. The next time you pick up the spoon or spatula, your skin will come in contact with the dust.

MIXING PHOTOGRAPHIC CHEMICALS

Most photographic formulas list warm water (between 110° and 125° F) as the first ingredient. The warmer the water, the faster chemicals dissolve. Be careful, however, not to increase the temperature of the water beyond what is recommended because too high a temperature causes some chemicals to oxidize prematurely. Reducing agents, in particular, are sensitive to high temperatures.

Always mix chemicals in the order in which they are listed in a formula, and make sure that each chemical is dissolved before adding the next one. The order is important because some chemicals don't dissolve in the presence of other chemicals. For example, metol won't dissolve in a solution containing large amounts of sodium sulfite. Other chemicals prevent the oxidation of a chemical you add later. For example, you should always add sodium sulfite to a solution before (or very shortly after) adding hydroquinone. Hydroquinone oxidizes rapidly when mixed in a solution without sodium sulfite.

Finally, formulas always start with less water than the total volume of the final solution. After mixing the dry chemicals (which add to the volume of the solution), add enough cool water to bring the solution up to its final volume. This ensures that the mixture has the correct volume and helps bring the solution down to its working temperature.

CREATING A PRINT DEVELOPER

The best way to learn about developer formulas is to create your own. This need not be a complex process. You can make a perfectly functional (if not exactly reproducible) paper developer with a few chemicals, some water, and simple measuring spoons.

The following sections describe an experiment in which you create your own developer, make prints during different stages of the process, and then compare the prints. The goal of this experiment is to provide a tangible demonstration of the properties of each chemical component and how they all function together in a developer.

Materials

For this exercise, you should prepare your darkroom for printing. In addition, you need the following:

- a negative that contains an even range of tones and that prints well on grade 2 paper without burning or dodging
- three additional trays for developers (for a total of four)
- a set of inexpensive measuring spoons (not the same measuring spoons that you use to prepare food)
- small quantities of each of the five standard developer chemicals: metol (or Elon), hydroquinone, sodium sulfite, sodium carbonate, and potassium bromide (a one-pound container of each is more than enough)

Setup

Set your enlarger to make an approximately 5×7 inch print of the test negative. Clear some space in the darkroom sink for the additional developer trays. Begin by placing two of the additional trays side by side near your usual developer tray. Place approximately 2 quarts (or 2 liters) of 70° F (20° C) water in each (Figure 4-2).

Procedure

- 1. Run an exposure test to find the correct exposure for a print on grade 2 paper developed normally in your usual paper developer. Label this print the control print. You can remove the tray containing your normal paper developer from your sink at this time if you need the extra space. Remember to stop, fix, and wash each print in this experiment in your normal manner.
- 2. Expose nine more pieces of grade 2 paper for the same amount of time as the control print, and place them in a light-tight container, such as an old paper box.
- 3. Stir the following chemicals into the two developer trays filled with water:
 - a. In the left tray, add 2 level teaspoons of hydroguinone and 2 heaping tablespoons of sodium sulfite. (Add a pinch of the sodium sulfite before stirring in the hydroquinone.)
 - b. In the right tray, add 2 level teaspoons of metol (Elon) and 2 heaping tablespoons of sodium sulfite.
- **4. a.** Label one piece of exposed paper *L1* (on the back), and develop it in the left tray for 4 minutes.

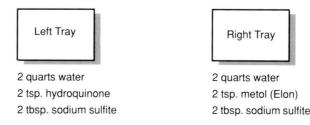

b. Label a second piece of exposed paper R1, and develop it in the right tray for 2 to 3 minutes.

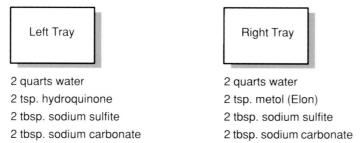

- 5. Stir 2 tablespoons of sodium carbonate into each tray. Not all of the sodium carbonate will dissolve; this is normal.
- **6. a.** Label a piece of exposed paper *L2*, and develop it in the left tray for 2 minutes.
 - **b.** Label a piece of exposed paper R2, and develop it in the right tray for 2 minutes.
- 7. Stir $\frac{1}{4}$ teaspoon of potassium bromide into each tray.

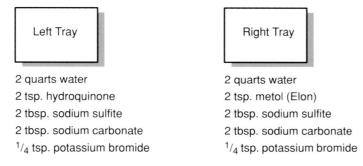

- **8.** a. Label a piece of exposed paper L3, and develop it in the left tray for 4 minutes.
 - **b.** Label a piece of exposed paper R3, and develop it in the right tray for 2 minutes.
- 9. Place a third developer tray between the right and left trays. In the third tray, combine 16 ounces (or 500 ml) of the mixture from each tray.

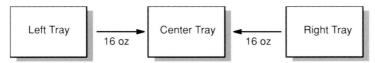

- **10.** Label a piece of exposed paper *C1*, and develop it in the center tray for 2 minutes.
- 11. To the center tray, add 1 quart (or 1000 ml) of the mixture from the left tray.

- **12.** Label a piece of exposed paper *C2*, and develop it in the center tray for 2 minutes.
- **13.** To the remaining contents of the left tray (16 ounces or 500 ml), add the remaining contents of the right tray (1½ quarts or 1500 ml).

14. Label a piece of exposed paper *C3*, and develop it in the left tray for 2 minutes.

Evaluating the Test

When all of the prints have been washed and are dry, study them, starting with the control print, to learn what has happened as you added each chemical to your developer. The figures that accompany the following descriptions illustrate prints that were processed in the manner described in the experiment. Use these illustrations to compare with the results from your own test. Your results may vary from the illustrations, but they should be similar.

The Control Print

The control print (Figure 4-3) should have a normal contrast and an even range of tones since you selected a negative with those qualities. Each of the tones should appear fully developed with bright and luminous highlights and dark, detailed shadows.

As you examine each of the test prints, compare them with the tones in the control print. The differences you observe should indicate how each chemical in the developer affects the image.

Figure 4-3 The control print. This print has a full range of tones from the texture of the snow in the foreground to the detail in the bark in the tree trunks.

(a) L1: hydroquinone and sodium sulfite

(b) R1: metal (Elon) and sodium sulfite

Figure 4-4 Prints developed in a reducing agent and preservative. The L1 print is blank. The R1 print has no texture in the brightest highlights, and the tree trunks are lighter than they are in the control print.

Prints Developed in Reducing Agent and Preservative

Depending on your test image, the L1 print (Figure 4-4a), developed in hydroquinone and sodium sulfite, might have a trace of an image, or it might be completely blank. Hydroquinone is a very weak reducing agent by itself. A hydroquinone and sodium sulfite solution doesn't have enough strength, or reduction potential, to produce a usable image.

The R1 print (Figure 4-4b), developed in metol and sodium sulfite, contains an image, although the shadows are not as dark as in the control print and some of the highlights are missing texture. In relation to hydroquinone, metol has 20 times the reduction potential. In fact, it is possible to have a fully functional developer containing just metol and sodium sulfite. An example of this kind of developer is D-23, a Kodak film developer available as a published formula only. D-23 is a low-contrast developer, useful when film is shot in high-contrast lighting.

Prints Developed in Reducing Agent, Preservative, and Accelerator

The L2 print (Figure 4-5a) should show traces of an image, indicating that the addition of sodium carbonate has increased the ability of hydroquinone to develop an image. This image, however, has little detail in the highlights and, overall, lacks much of the tonality of the control print. Although the hydroquinone solution is still very weak, you can see how hydroquinone primarily affects the darker tones in the image.

The R2 print (Figure 4-5b) shows a much more fully developed image than L2. If you compare the highlights of R2 to the control print, you should notice that the highlights appear darker in R2. The addition of sodium carbonate to the metol and sodium sulfite increases the activity of metol to the point that chemical fog begins to appear in the highlights.

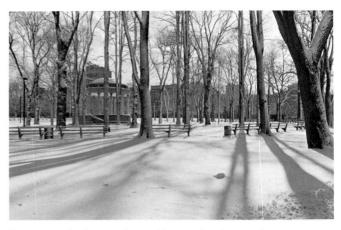

(b) R2: metal (Elan), sodium sulfite, and sodium carbonate

Figure 4-5 Prints developed in a reducing agent, preservative, and accelerator. The L2 print shows detail in the tree trunks and the middle tones, although the overall print is lighter than the control print. The R2 print is fully developed and appears darker in the highlights than the control print.

(a) L3: hydroquinone, sodium sulfite, sodium carbonate, and potassium bromide

(b) R3: metol (Elon), sodium sulfite, sodium carbonate, and potassium bromide

Figure 4-6 Prints developed in a reducing agent, preservative, accelerator, and restrainer. The L3 print has lost most of its detail except in the darker shadows, which now appear as a light gray tone. The R3 print has "cleaner"-looking highlights than the R2 print. The shadow tone in the tree trunks is lighter than in the control print.

Prints Developed in Reducing Agent, Preservative, Accelerator, and Restrainer

The image in the L3 print (Figure 4-6a) is noticeably lighter and fainter than it was in the L2 print. The addition of potassium bromide has greatly reduced the ability of the hydroquinone solution to develop an image.

The *R3* print (Figure 4-6b) has changed in a subtle way compared to the *R2* print. Notice how the highlights in *R3* appear brighter and "cleaner" than they do in *R2*. The addition of potassium bromide has removed the chemical fog and increased the appearance of contrast. Potassium bromide complements the sodium carbonate in a developer to produce relatively dark shadows and bright, clear highlights.

Figure 4-7 Print C1 developed in equal quantities of hydroquinone and metol solutions. This print has a full range of tones from highlights to shadows. These tones are similar to the control print, although the image color (not visible in this reproduction) is not.

Print Developed in Equal Amounts of Metol and Hydroquinone

Compare the *C1* print (Figure 4-7) to the control print. The overall tone and contrast of *C1* and the control print should be similar. Next, compare the *C1* print to the *L3* and *R3* prints. The overall range of tones from bright highlights to dark shadows in *C1* is greater than the tones in either the *L3* and *R3* prints.

The combination of metol, hydroquinone, a preservative, an accelerator, and a restrainer produces a solution that closely matches a standard print developer. The combined solution produces as much detail as the metol-only solution and adds richness in the shadows through what is called the *superadditivity effect*. Superadditivity means that the reduction potential of a combined metol and hydroquinone developer is greater than the individual reduction potentials of metol and hydroquinone added together. Superadditivity in a developer occurs only when you mix metol and hydroquinone or phenidone and hydroquinone.

Print Developed in More Hydroquinone than Metol

Compare the C2 print (Figure 4-8) with the C1 print. Look closely at the highlights and then at the shadows. C2 should appear both brighter in the highlights and slightly darker in the shadows, indicating that it has more contrast than C1. A developer containing significantly more hydroquinone than metol will produce a higher contrast print than a developer that has each in approximately equal quantities.

Print Developed in More Metal than Hydroquinone

Compare the *C3* print (Figure 4-9) with both *C1* and *C2*. *C3* should appear to have less contrast than either *C1* or *C2*. A developer containing significantly more metol than hydroquinone will produce a lower contrast print than a developer that has each in approximately equal quantities.

Changing the concentration of metol and hydroquinone in a developer changes the contrast of prints developed in that solution.

Figure 4-8 Print C2 developed in $\frac{3}{4}$ hydroquinone and $\frac{1}{4}$ metol solutions. This print has darker shadows than the C1 print. The detail in some of the tree trunks has become a solid black tone.

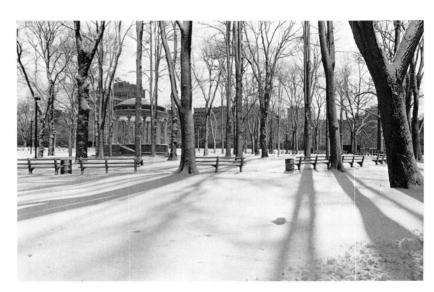

Figure 4-9 Print C3 developed in ¼ hydroquinone and ¾ metol solutions. This print has lighter shadows than the C1 print. The overall appearance of the print is flatter and grayer than the control print.

Several developer formulas take advantage of this fact. The most popular, the Beers formula (named after Dr. Roland F. Beers, who first published it), is mixed as two solutions. One solution contains only metol, a preservative, an accelerator, and a restrainer. The second solution contains only hydroquinone, a preservative, an accelerator, and a restrainer. When you use Beers developer, you mix different quantities of each solution to produce developers with different contrasts. The Beers formula and mixing instructions are found in Appendix B.

OTHER PRINT PROCESSING CHEMICALS

Developer chemistry has perhaps the most dramatic effect on the appearance of a photographic print, but developers are by no means the only chemical tool creative photographers have available. In addition to toners, intensifiers, and reducers, which are described in later chapters, the stop bath, fixer, and washing aid all have impor-

tant effects on the overall appearance and life of a print. Chapter 9, "Archival Processing," describes the proper mixing and use of these chemicals in more detail.

SUMMARY

- Most photographic developers consist of the same five chemicals used in different combinations: two reducing agents, a preservative, an accelerator, and a restrainer.
- Always mix chemicals in the order in which they are listed in a formula, and make sure that each chemical is dissolved before adding the next one.
- A reducing agent creates the visible image in a print by converting exposed silver halides to black metallic silver. The two most commonly used reducing agents are metol (also known as Elon) and hydroquinone.
- A preservative keeps reducing agents from oxidizing too rapidly. Sodium sulfite is the most commonly used preservative.
- An accelerator enhances the reaction of reducing agents by increasing the alkalinity of the developer solution. Sodium carbonate is normally used as an accelerator.
- A restrainer complements the accelerator by preventing chemical fog in the highlights caused by an overly active developer. Potassium bromide is a commonly used restrainer.
- When metol and hydroquinone are mixed together, their ability to reduce exposed silver halides is increased beyond their individual abilities added together. This is due to the superadditivity effect.
- A developer containing proportionally more metol than hydroquinone produces a low-contrast image. A developer containing proportionally more hydroquinone than metol produces a highcontrast image.

Chapter **5**

Choosing a Paper and a Developer

Next to the image on the negative, the printing paper you choose has the greatest influence on the look of the final product. A single negative may have different print statements on different printing papers. Some of these differences can be very noticeable; others can be subtle, but no less significant.

In addition, the choice of a developer can have its own unique effect on a print. Although the effects of the developer are less obvious than the choice of paper, developers can either enhance a print statement or work against it.

The goal is to match the paper and developer to the image. The right match is more than luck or trial and error. It involves learning to see subtle differences in prints and knowing how these differences affect an image. Published descriptions of paper and developer characteristics aren't much help because they are often subjective and quickly rendered obsolete by periodic manufacturing changes. You should rely on your own ability to see variations in materials and should create a library of test results to which you can refer when making decisions.

THE PHYSICS OF VIEWING PRINTS

Learning to see differences in papers and developers starts with understanding the mechanics of how the eye sees the image on a print. You may have noticed that details clearly visible in a negative are often obscured in a print of that negative. At first, this may seem puzzling because photographic paper and film have similar light-sensitive emulsions. The difference, however, is that you see a negative by transmitted light and a print by reflected light.

Viewing Negatives by Transmitted Light

When you look at a negative, you see the image on it because of the light that passes through the emulsion and film base to your eye. As light passes through the negative, a certain amount is absorbed by the developed silver in the emulsion (Figure 5-1). This light absorption is known as *density*.

The relationship of the tones in a negative is in direct proportion to the density in the emulsion. For example, if a particular density has 50% absorption, almost 50% of the viewing light is transmitted through it (allowing for a small amount absorbed by the film base). If a density has 25% absorption, almost 75% of the viewing light is transmitted. If a density has 75% absorption, almost 25% of the light is transmitted.

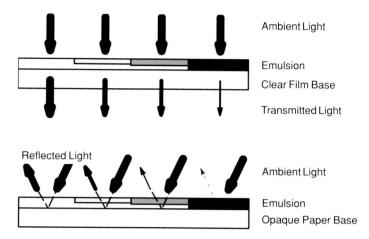

Figure 5-1 Transmission densities of negatives.

Figure 5-2 Reflection densities of prints.

Viewing Prints by Reflected Light

When you look at an image on a print, you see that image by reflected light. Light striking the print passes through the emulsion. reflects off the paper base (where about 10% of the light is absorbed), and then passes back through the emulsion to the eye (Figure 5-2).

The fact that reflected light is absorbed twice by the density in the emulsion changes the relationship of the tones. High densities in a print absorb a greater percentage of light than do the same densities in a negative. For example, a density that transmits 50% of the light passing through a negative reflects less than 25% of the same light when it is in a print. A density that transmits 75% of the viewing light will reflect only about 50%; and a density that transmits 25% will reflect less than 7%.

The result is that even though a negative and a print might have the same densities in their emulsions, the print will appear to have fewer and more tightly compressed tones than the negative. This difference is almost entirely the result of how you view the images. Try holding a print in front of a bright light, for example. Viewed this way, the shadows will usually reveal the same details and shades of dark gray that are visible in the negative.

The Effect of Paper Surface

The discussion of print tones assumes that all printing papers have a similar surface. In fact, some printing papers are made with a smooth surface, and others are made with a textured, or matte, surface. The kind of surface a paper has affects the way that light is reflected even before it passes through the image.

Smooth-surface papers reflect light like a mirror. When viewed at the wrong angle, light sources in the viewing room are reflected in the print. A matte-surface paper has an uneven surface that prevents mirrorlike reflections by scattering light in all directions (Figure 5-3).

When you encounter the reflection of a light source in a smoothsurface print, you can change the viewing angle slightly to avoid it. Because of the way matte-surface prints scatter light in all directions, there is no angle at which you do not see a small amount of reflection. As a result, tones tend to become even more compressed on matte surface paper than they do when you print the same image on smooth surface paper. This is especially true in the darkest shadow tones.

Figure 5-3 Paper surface affects how light is reflected.

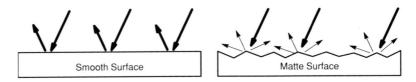

COMPARING PRINT TONES AND COLOR

Before you can objectively compare different print statements, you must learn to compare the two aspects of an image that are most affected by changes in papers and developers. These are tonal separation and print color. Once you can see these differences, you can begin to relate them to your own prints.

Separation of Print Tones

In earlier chapters, separation of print tones was discussed in terms of highlights and shadows. In addition to this overall contrast, more subtle tonal relationships can affect a print statement. Two prints that have the same contrast can look quite different because of the way that the tones between the highlights and shadows relate to each other.

For example, a print made on Agfa's Brovira paper will have a greater separation of tones in the highlights than the same image printed on Agfa's Portriga Rapid, even when the prints have the same overall contrast. The Portriga Rapid print, on the other hand, will have a much greater separation of tones in the shadows, and the separation of tones overall will be more evenly spaced (Figure 5-4).

Print developers can cause similar changes in tonal relationships. A print developed in Sprint Quicksilver tends to have compressed shadow tones compared to the same image printed on the same paper and developed in Kodak Dektol. Again, this difference appears even when the overall contrast of the prints is the same.

When examining tonal separation in prints, it is useful to divide print tones into three general areas: highlights, midtones, and shadows. The differences in most materials are apparent within these broad groups and are easier to recognize than trying to compare widely separated tones. The following sections describe how you can see the effects of different tonal separation in each of these areas. Each description assumes that the prints being compared have the same overall contrast.

Highlights

When comparing the highlights in two prints, look at the most textured highlights first. Compressed highlight tones seem visually flat and lacking in detail. If details are more clearly defined in one print than another, it indicates greater separation. If the highlights in the image are reflections off smooth, shiny objects, the print that shows those highlights with the most appearance of depth also has greater highlight separation.

Middle Tones

The standard reference for a middle gray tone is the Kodak 18% reflectance card, also known as a gray card. The tone of this card defines the midpoint of all print tones. Tones that fall slightly above

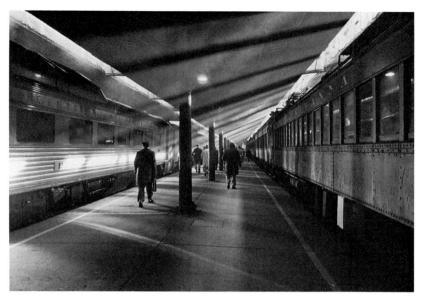

(a) Portriga Rapid paper

(b) Brovira paper

and below this value define the midtones of a print. Common examples of midtones range from the tones normally seen in the clear north sky and average Caucasian skin to sunlit grass and light brown hair.

The midtones in a print typically have the most influence on the viewer's perception of the image. It is in these tones that our eyes are most sensitive to small differences. As with highlights, a compressed midtone region in a print seems to lack sharp detail. By comparison, a print with greater separation in the midtones appears to have more "depth."

Shadows

When comparing the separation of shadow tones in two prints, look at the shadow areas containing the most detail. Compressed shadows seem to have dark murky details. Clearly separated shadows ap-

Figure 5-4 The same image printed on different papers. The Portriga Rapid print developed in Gevaert G.262 (a) shows greater detail and contrast in the shadows than the same image printed on Brovira and developed in Dektol (b). This is an example of the differences in print statement caused by choices of paper and developer.

pear to be more open, even lighter than compressed shadows. Also, in the print with more shadow separation, the area of darkest tone will be smaller and distinct from the slightly lighter shadows around it.

Print Color

Although the color of a negative is rarely a factor in black-and-white photography,* print color does have a genuine, if subtle, effect on the viewer. Most viewers do not consciously see any color in an untoned black-and-white print, even though prints are rarely a neutral gray. Instead, prints range in color from slightly warm (ivory or buff) to cold (bluish). This color is the result of the way the print's paper base and emulsion are manufactured and the way that you develop it.

Paper Color

The primary source of print color is the paper base. This color is usually part of the coating that is placed between the paper itself and the gelatin emulsion. Fiber paper has a clay or bayarta coating intended to smooth out the texture of the fibers on the paper surface. Resin-coated paper has a plastic, polyethylene coating.

Some manufacturers purposely pigment the coating to produce a specific coloration. Many times, however, the color of the coating layer is a by-product of its chemical composition, which includes brighteners and fluorescent chemicals added to increase the amount of light reflected from the surface. The result is that what one manufacturer claims is a neutral white is usually different from what another manufacturer claims that it is.

Unfortunately, in some papers the brightening layer is water soluble and dissolves if a print is washed too long. A paper with a white-looking paper base will appear darker and sometimes even cream colored if the brightener is washed out. The washing test in Chapter 9, "Archival Processing," indicates the practical limit for print washing. Usually, this amount of washing will not remove the brightening layer.

Image Color

More subtle than the color of the paper base is the color of the image formed in the emulsion. The silver density in a print has a particular coloration affected by its grain structure and the chemical composition of the developer used to create it. Fine-grain emulsions, such as Kodak's Polycontrast, tend to have a warm (reddish) color. Coarsegrained, bromide emulsions, such as Kodabromide and Agfa's Brovira, tend to have a cool (bluish) color.

Image color is also affected by development. In Chapter 4, you might have noticed that the color of the test prints changed slightly as you changed the combination and concentration of chemicals in the developer you created. Each developer formula produces its own image color.

^{*}The exception is film developed in a pyro-based developer. A pyro-developed negative has an excessively red-stained image that reacts with the color sensitivity of most printing paper.

The developer formulas listed in Appendix B are grouped by their effect on print color. There are formulas that develop neutralcolor images, warm-color images, and cool-color images. How noticeable this effect is depends on the paper you use. A cool-color developer will not noticeably affect the image of a warm-color paper.

Another way to change a print's color is through toning, which is the subject of Chapter 8.

Seeing Print Color

Although any statement about the psychology of print color runs the risk of being too general to be accurate, warm prints tend to engage a viewer emotionally, and cool prints tend to enforce an emotional distance. For example, you might print portraits on a warm-color paper to increase the viewer's emotional response to the subject, or you might print abstractions on a cool-color paper to produce an intellectual distance and thus reinforce the image's geometry. The important point is that print color can either enhance an image or detract from it.

You can see relative color differences by comparing two prints made on different brands of paper or developed in different developers. You can also compare a print to a gray card to determine if the print is warmer or cooler than the neutral color of the card. It is easier to look in the midtones because highlights are often too light and shadows are too dark to reflect a print's color accurately.

TESTING METHODS

It is nice to know that a photographer whose work you admire uses a particular type of printing paper. Ansel Adams, for example, made no secret of preferring a cold white paper with a neutral to cool emulsion color and a smooth surface when he printed.* This information, however, should not be the basis for choosing your printing paper and developer. Personal testing and evaluation are the only guides for determining which materials are best for you.

The following sections describe procedures for testing different papers and developers. These procedures will not provide the ultimate answer to the question of which paper and developer to use because there is no such answer. Instead, they involve creating a matrix of test results in which you can compare the effects of different combinations of papers and developers on your own images.

The tests are not difficult to perform, but they are time consuming, and there is no shortcut that can give you the same information and experience. Don't feel that you must test all possible paper and developer combinations at once; you can test three or four initially and continue to test as you find time.

Negatives for the Printing Tests

For all of the printing tests, choose three negatives that print well on normal-contrast paper but that emphasize different tones:

• One negative should have a varied and approximately equal

^{*}The Print by Ansel Adams, Little, Brown, Boston, 1983.

- range of tones. The negative you used for your ring-around test should work well. Call this the standard negative.
- A second negative should have mostly shadow tones. Call this the low-key negative.
- A third negative should have mostly highlight tones. Call this the high-key negative.

Each of the images you choose should give you a clear idea of how a paper and developer combination affects a particular tonal area.

Testing Papers

Because the choice of printing paper affects a print statement more than the choice of developer, begin by testing papers. The following test provides information about how your test negatives look printed on different papers with a variety of exposures and contrasts.

Materials

Select at least three different brands of printing paper. These papers should be brands you normally use or papers you are interested in working with. You should have at least one normal-, high-, and lowcontrast grade of each paper. As a suggestion, try to select as wide a variety as possible from among conventional fiber papers, resincoated papers, and variable-contrast papers. The greater the variety you include in the test, the more you will learn about how different papers affect your images.

Use the paper developer you normally use. If you have no preference, use Kodak's Dektol or another widely available print developer designed for normal use.

Procedure

- 1. Select the standard negative, and print a ring-around on the first brand of paper you want to test. Follow the directions for the ring-around test in Chapter 3. You do not need to repeat this test on the paper you used for the ring-around in Chapter 3 if you are using the same negative you used for that test. If you were not satisfied with the ring-around the first time, however, you might want to repeat it.
- 2. Prepare a fresh tray of developer, select the low-key negative, and print a ring-around with the same brand of paper you used in step 1.
- **3.** Repeat step 2 with the high-key negative.
- **4.** Repeat steps 1 through 3 with a different brand of printing paper. Continue repeating steps 1 through 3 until you have printed a ring-around of the three negatives with all of the different paper brands you are testing.

Evaluation

- 1. Lay out the finished prints in the same order you used to evaluate the ring-around test in Chapter 3.
- 2. Select the print (or prints) that have the most appropriate print statement for each image.
- 3. Look carefully at the prints you selected for differences in tonal separation. Look at the highlights in the prints made from the high-key negative, then look at the shadows in the prints made

- from the low-key negative. Finally, compare the midtones and the overall tonal range in the prints made from the standard negative.
- 4. Decide which of the papers you tested has the greatest highlight separation and which has the least.
- 5. Decide which paper has the greatest shadow separation and which has the least.
- 6. Decide which paper has the greatest midtone separation and which has the least.
- 7. Decide which paper has the most even separation of tones from highlights to shadows.
- 8. Finally, decide which papers have a warm color and which have a cool color. Compare the prints to each other and to a neutral gray card.

Keep notes of all of your findings. Be sure to save your test prints, and record the appropriate identifying information on the back of each.

Testing Developers

This test provides information about how developers affect printing paper. When choosing developers to test, do not feel limited to the ones available in camera stores. You might want to consult the formulas in Appendix B for developers you can mix yourself.

Materials

For the developer test, use the paper brand you selected as most appropriate for each of the three test negatives. If you selected more than one paper brand as appropriate for a particular negative, choose between them for your initial tests. If you were satisfied with the accuracy of the exposure for the reference print in the paper test, you don't need to repeat that developer and paper combination.

Choose at least three different paper developers designed to yield normal contrast results (consult the manufacturer's literature if you aren't sure about a particular developer).

Procedure

- 1. Select the standard negative and the paper brand you chose as most appropriate for it, and print a ring-around. Develop the prints in the first developer you are testing.
- 2. Prepare a tray of the next developer you want to test, and print another ring-around using the same negative and paper as in step 1.
- 3. Repeat step 2 with a tray of the third developer you want to test.
- 4. Select the low-key negative, and repeat steps 1 through 3. You may choose to do this part of the test at a later time.
- 5. Select the high-key negative, and repeat steps 1 through 3. You may also choose to do this part of the test at a later time.

Evaluation

- 1. Lay out the ring-around tests for the standard negative in the same way you evaluated the ring-around test in Chapter 3.
- 2. Select the print or prints from each developer you tested that have the most appropriate print statement for that image, and

Figure 5-5 Ordering prints by tonal separation.

- put away the rest. Look carefully at the prints you selected for differences in tonal separation and color.
- 3. Order the prints from the most widely separated tones to the most compressed tones (Figure 5-5). This order may be subjective when a print has widely separated tones in one area (like the highlights) and compressed tones in another (such as the shadows). Don't worry that you might change your mind about the order at a later date.
- 4. Decide which range of tones seems best for the image, which is second best, and so on.
- 5. Rearrange the same prints in order from the warmest color to the coolest color. Compare the prints to a neutral gray card to see which are warm and which are cool (Figure 5-6).
- 6. Decide which of the print colors seems best for the image, which is second best, and so on.
- 7. Repeat steps 1 though 6 for the prints from the low-key negative and from the high-key negative.

As with the paper test, keep careful notes of all of your findings. Be sure to save your test prints, and record the appropriate identifying information on the back of each.

Working though the paper and developer tests is exhaustive and potentially frustrating. Although it is possible that the tests have identified a specific paper and developer combination that is best for your images, it is more likely that it has only narrowed the field down from among the many possibilities and that no clear "winner" is evident.

Don't be concerned if you are temporarily undecided. The point of these exercises is to train your eyes to recognize subtle differences between prints made with different materials. The benefit is to systematize and compress the experience that thoughtful photographers gain through years of working intuitively. Your efforts will give you a library of prints that you can use to make informed decisions when choosing paper and developer combinations.

CHOOSING A PAPER AND DEVELOPER

In many cases, the needs of your negatives dictate the materials you use. If shadow detail is of primary importance, then the print and developer combination that yields the most separation in the shadow tones is probably the best choice. Likewise, if highlight texture is

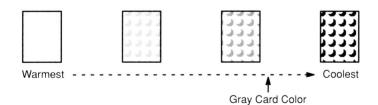

Figure 5-6 Ordering prints by print color.

more important than shadow detail, you should consider using materials that emphasize highlight tones. Keep in mind that the color of the paper and developer combination you choose should also be appropriate to the image.

If you are undecided about how to print an image, make a "working" print on the paper and developer combination that produced the most even overall separation of tones and was closest to a neutral color. After it is fully processed and dry, study that print, and decide which tones you want to emphasize and what color is appropriate. Then use your test prints as a reference in choosing the best paper and developer for the final print.

If uniform print color is important, as it might be for images you plan to display together, you might be limited to papers and developers that produce similar colors. If an image requires a tonal scale only produced by a paper and developer that have a color inconsistent with the other prints in the series, you can modify the color of all your prints by toning, a process described in Chapter 8.

As a final note, some photographers advocate working with only one paper and developer combination. In theory, working exclusively with one paper and developer is a way to understand the subtleties of those materials. This is good advice for the beginning photographer.

As you become used to how a particular combination performs, however, you might tend to limit your photography to just the images that work well with these materials. It is better to have experience working with several paper and developer combinations so that the materials you use don't limit the way that you see.

SUMMARY

- A print appears to have fewer tones than a negative because when you view a print by reflected light, the density in the print emulsion absorbs the reflected light twice before your eye can see it.
- A high-key image is one that contains a predominance of highlights. In these images, the rendering of the highlight tones is usually the most important.
- A low-key image is one that contains a predominance of shadows. In a low-key image, the rendering of the shadow tones is usually the most important.
- In an image that contains approximately equal areas of highlights, shadows, and midtones, the best rendering is usually when all of the tones have even separation.
- The color of a print is affected primarily by the paper base and the color of the developed silver in the emulsion.
- Personal testing and evaluation, in which you compare the effects of different combinations of papers and developers on your images, are the best guides for determining which materials are appropriate for your work.
- Build a library of test results for making choices about which paper and developer to use. For example, if you are undecided about how to print an image, study a work print to decide which tones in the image are most important. Choose a paper and developer combination from among the test prints in your library that emphasizes those tones and has an appropriate print color.

Chapter **6**

Special Contrast Solutions

Occasionally you will have to print a negative with contrast problems that can't be solved by your usual darkroom techniques.* Such problem negatives usually fall into one of three categories:

- The negative has too much contrast for grade 1 paper even if you increase the print exposure and reduce the print development time.
- The negative has too little contrast for grade 3 paper. Although most paper brands offer higher contrast grades, these grades usually do not tone with the same exact color as the lower grades. In a series of prints where toning and uniform color are important, you need alternate high-contrast options.
- The negative has localized contrast problems. For example, when printing some very high contrast negatives, correcting the overall contrast means that the highest and lowest tones appear compressed and dull. In these cases, if you want to show detail in both bright highlights and dark shadows and retain the brilliance of the print, you need a way to control the contrast of the highlights and shadows separately.

This chapter describes different methods you can use to solve these problems. Because each negative with a contrast problem is different, use these descriptions as a guide to adapting these techniques to your own needs.

PRINTING A VERY HIGH CONTRAST NEGATIVE

Certain scenes naturally yield very high contrast negatives. For example, almost any scene photographed in bright sunlight or with strongly directional artificial light will produce a negative with extreme contrast.

Some high-contrast negatives won't make satisfactory prints no matter what you do to print them. Before trying to print any negative, look at it carefully, using a magnifying glass if necessary. To print well, even a very high contrast negative must have visible details in the important shadow areas as well as in the highlights and middle tones (Figure 6-1).

The following sections describe ways that you can print the negative shown in Figure 6-1. As you work with your own high-con-

^{*}If your negatives frequently do not have the correct contrast to print on normal paper grades, you should consider changing the way you expose and develop your film. It is worth studying such techniques as the zone system to help you gain more control over the contrast of your negatives.

Figure 6-1 A high-contrast negative with adequate shadow detail. You can successfully print a very high contrast negative if, like the one shown here, it has adequate shadow detail. Figure 6-2 shows what this negative looks like printed for the correct highlight detail on normalcontrast paper.

trast negatives, expect to obtain results similar to those in the illustrations.

The Control Print

To gauge your progress as you print a difficult negative, make a control print on grade 2 paper developed in your normal paper developer. When you expose for the correct highlights, a very high contrast negative will produce a print with some highlight details and few additional tones other than maximum black (Figure 6-2). The control print will tell you how you are progressing as your prints approach the contrast you want.

Low-Contrast Paper and Decreased Development

The first technique to try when printing a very high contrast negative is to combine grade 1 paper developed in your normal developer with approximately 20% more exposure and half your normal devel-

Figure 6-2 The control print. This is how the negative illustrated in Figure 6-1 looks printed on grade 2 paper so that the sunlit grass is correctly exposed. Although the highlights are correct, the rest of the print is almost completely black. The highlights in this print (Figure 6-3) should match those of the control print.

Figure 6-3 Grade 1 paper with increased exposure and decreased development. When the negative in Figure 6-1 is printed on grade 1 paper with a 1-minute development time, some detail is visible in the midtones (around the sunlit grass in the foreground), but overall the print is still very dark.

opment time. This is a technique you learned about in Chapter 3 to gain a finer degree of control over the contrast of a print. Although this technique is both convenient and effective for negatives that are slightly high in contrast, it usually is not enough to print a very high contrast negative successfully.

Low-Contrast Developers

Developers formulated specially to produce low-contrast results can effectively lower the contrast of a print by more than one contrast grade. Because there are few commercially available developers designed to produce low-contrast prints, most must be mixed from formulas. Appendix B lists a variety of the most useful formulas.

If you don't want to mix a formula from bulk chemicals, a commercially available low-contrast developer is Kodak's Selectol-Soft. This is an excellent warm-color developer. The major drawback with Selectol-Soft is the relatively short life of the working solution; it lasts only about an hour once it is diluted.

Figure 6-4 Grade 1 paper developed in a lowcontrast developer for 1 minute. When the negative in Figure 6-1 is printed on grade 1 paper and developed in GAF 120 (a low-contrast developer) for 1 minute, the print shows detail in the midtone areas and begins to show detail in the shadowed grassy areas of the foreground. Overall, however, the print is still too dark and has too much contrast.

You should be aware that changing from a normal-contrast to a low-contrast developer usually means changing the print color slightly. Most low-contrast developers produce warm colors. However, you can choose a formula from those listed in Appendix B that closely matches the color of the standard developer you are using.

Print Flashing

Flashing is a contrast reducing technique that pre-exposes the printing paper before it is exposed to the negative. This technique increases highlight densities without visibly affecting midtones and shadows.

Flashing works because of the inertia that all light-sensitive silver emulsions have to exposure. What this means is that you can expose a piece of printing paper to a small amount of light without producing a visible density after it is developed. The amount of exposure necessary to produce a visible tone on printing paper is called the exposure threshold. When you flash a print, you expose a piece of paper to white light up to, but not exceeding its exposure threshold. This is the flash exposure. Next you expose the paper to the negative you are printing, calculating the exposure time, as always. for the correct rendering of the highlights. This is the main exposure.

Because flashed printing paper needs less main exposure to correctly render the highlights, the shadow densities of that image will appear lighter than on paper that hasn't been flashed. The result is lower contrast. When correctly done, flashing increases the density of the highlights in a print without noticeably affecting the midtones and shadows (Figure 6-5).

To flash printing paper, you need a low-intensity, controllable light source. In most darkrooms, there are three ways to create this type of light:

Raise the head of your enlarger to its maximum height, and close the enlarging lens to its minimum aperture. This produces a low-intensity light that you can control through the

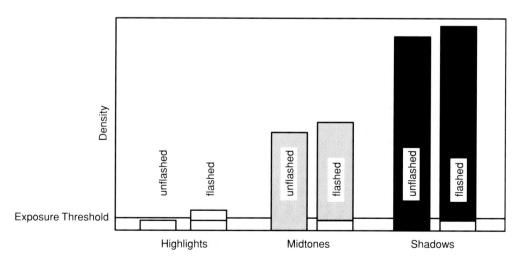

Figure 6-5 Comparison of flashed and unflashed tones in a print. Flashing a print raises the densities of all of the tones in the image equally. The effect, however, is most noticeable in the highlights where the difference is between what is visible and what is not.

- enlarger timer. If you are in the middle of printing a negative, however, you must take the negative out of the enlarger and change its height to make the flash exposure. If you discover later that you flashed incorrectly or you didn't flash enough paper, then you must repeat the process all over again.
- Suspend a small incandescent bulb from the darkroom ceiling. You can temporarily connect the bulb to the enlarger timer and flash paper without having to alter the enlarger's setting.
- Place a diffusing filter over the enlarging lens and make the flash exposure without removing the negative from the enlarger or changing the enlarger's settings. You can use a small piece of 1/8-inch white Plexiglass for the diffusing filter and add neutraldensity filters, if necessary, to reduce the light intensity.

Calculating the Flash Exposure

Once you have decided how you are going to produce the flash exposure, use the following steps to calculate its duration:

- 1. Cut a full sheet of printing paper into test strips.
- 2. Expose the test strips to flash exposures of 5, 10, 15, and 20 seconds.
- 3. Develop the test strips in the same manner that you are planning to develop the final print. For example, if you are planning to use a special developer or a nonstandard development time for the final print, use these for developing the flash exposure test.
- 4. Once fixed, compare the test strips to a standard white patch for the paper you are using.
- 5. If all of the strips are visibly darker than the white patch, reduce the intensity of the light source, and repeat the exposure test at the same time intervals.
- **6.** If none of the test strips shows any density compared to the standard white patch, repeat the exposure test with longer time intervals, such as 20, 30, 40, and 50 seconds.

Once you have a set of test strips in which at least one strip shows some noticeable density and at least one strip shows no den-

Figure 6-6 Grade 1 paper with reduced development time and flash exposure. When the negative in Figure 6-1 is printed on grade 1 paper, developed in a low-contrast developer for 1 minute, and flashed, the print shows appropriate detail in both the sunlit grass and the darkest shadows on the tree trunks.

sity, choose the longest exposure that shows no density as the flash exposure time.

Calculating the Main Exposure

Calculate the main exposure in the same manner that you calculate the exposure for an unflashed print, but use flashed paper for your test strips. Once you have determined the correct main exposure. use full sheets of flashed paper to make the final print. You can burn and dodge on flashed paper just as you would on unflashed paper.

Print flashing works in many situations, but it is not a universal solution. Flashing is most appropriate for prints that have textured highlight areas, and it is less convincing if the highlights in the image are smooth and without detail. When this is the case, a flashed print can end up looking muddy and gray.

Water Bath Development

Water bath development is a technique in which you lower the contrast of a print by alternately agitating the printing paper in a tray of developer and then letting it sit still in a tray of water. The water retards the development of the shadows while allowing the highlights to develop at a near normal rate.

When you agitate printing paper in developer, the emulsion absorbs enough solution to continue producing an image even after the paper is removed from it. When you place the paper in water, the developer absorbed by the emulsion is able to continue working until it is exhausted. Because the developer is working harder and is exhausted more rapidly in the shadows than in the highlights, the shadows stop developing shortly after the print goes into the water, and the highlights continue developing.

Procedure

The following steps outline a general working procedure for water bath development.

1. Place a tray of room temperature water next to the developer tray in your darkroom sink. Because you are using a water bath to print an extremely high-contrast negative, consider using a low-contrast developer.

2. After exposure, agitate the print in the developer for approximately 15 seconds. Agitating the print in the developer saturates the emulsion with developer.

3. Carefully transfer the print to the water tray. Place it face down, making sure that no air bubbles are trapped under the print so that the emulsion contacts the water evenly. Leave the print in the water bath for 1 minute without agitation. In the water bath, developer is rapidly exhausted in the shadows and continues to produce an image in the highlights.

4. Return the print to the developer tray, and agitate for 10 seconds. The print emulsion is resaturated with developer.

5. Transfer the print a second time to the water tray, and let it sit emulsion side down without agitation for 1 minute. The developer is again rapidly exhausted in the shadows and continues to produce an image in the highlights.

- 6. Continue alternating agitation in the developer with still time in the water bath until the total time in the developer equals approximately two-thirds of your normal development time for that developer.
- 7. Stop and fix the print.

The number of times you alternate the print between the developer and the water bath depends primarily on how much contrast the negative has. You must experiment with the following variables:

- Print Exposure—Water bath development affects print exposure. Be sure to prepare test strips and give them the same amount of water bath development that you plan for the full print.
- *Development Time*—Consider the suggested time in the developer of two-thirds normal development time to be only a starting point that you should confirm by testing.
- Safelight Fog—Because the total time that the paper will be exposed to your darkroom's safelights before going into the stop bath will be considerably longer than normal, you should

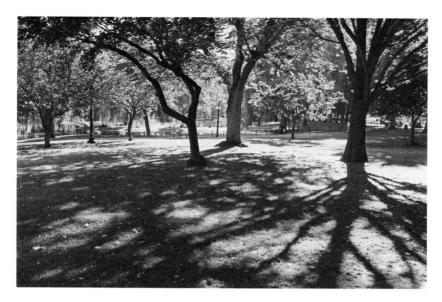

Figure 6-7 Grade 1 paper in a low-contrast developer combined with a water bath development. A water bath is an alternative to flashing for producing a low-contrast print. This print (on grade 1 paper, developed in a low-contrast developer combined with a water bath) is similar to the one in Figure 6-6. Although the procedure is somewhat tedious and susceptible to safelight fog, you can combine flashing and water bath development for even lower contrast results.

consider the possibility of safelight fog. In fact, safelight fog can easily be mistaken for lower contrast. If you suspect safelight fog, perform water bath development under reduced-intensity safelights or in the dark.

- Developer Dilution—If you are using a very active developer and the print develops too rapidly to control, try diluting the developer more than usual. For example, dilute Dektol 1:3 instead of 1:1 or 1:2.
- Uneven Development—If certain areas of the print appear uneven, or "mottled," try rocking the water bath tray once every 30 seconds by lifting a corner slightly and setting it back down.

Combining Low-Contrast Techniques

You can use the techniques for producing low-contrast prints individually or in combination. If a single technique doesn't produce a low enough contrast, you can combine it with another technique.

There is no specific way in which one low-contrast technique naturally follows another. In general, you should test the techniques both individually and in different combinations to understand their effects. Then, when you come across a negative that requires it, you can combine the techniques that are the most appropriate. The figures in this section illustrate possible combinations to try.

PRINTING A LOW-CONTRAST NEGATIVE

Although most paper brands offer contrast grades that permit you to print almost any low-contrast negative, there are times when additional solutions are needed. For example, if toning and matching print color are important in a series of prints, you might want to use the same grade of paper and increase contrast by altering the developer. The result will be a print that tones in the same manner as all of the others in the series.

Figure 6-8 illustrates a control print of a low-contrast negative. A control print allows you to gauge the effect of different high-contrast techniques as you experiment with them.

Figure 6-8 The control print for high-contrast techniques. This print was made on grade 2 paper developed in a normal-contrast paper developer. The ferns appear as a soft gray tone, and the details in them are hard to see, meaning that the print contrast is probably too low.

High-Contrast Developers

Developers formulated specially to produce high-contrast results can raise the contrast of a print by more than the equivalent of a contrast grade. Appendix B lists some useful high-contrast developer formulas.

If you don't want to mix a developer from a formula, one packaged developer that you can use for high-contrast work is Edwal T.S.T. This is a two-solution developer that you mix in different proportions for different contrasts. Mix one part T.S.T. solution A to seven parts water to make a working-strength high-contrast developer. Another alternative is to increase the contrast of a standard developer by increasing the concentration of its working solution. For example, you can use Kodak's Dektol diluted 1:1 or even without dilution, instead of diluting it 1:2.

Changing from a normal-contrast developer to a high-contrast developer usually means that the print color will change slightly according to the formula you use. Try the different high-contrast for-

Figure 6-9 Grade 2 paper developed in a high-contrast developer with twice the normal development time. This print was made on grade 2 paper and developed in Beers high-contrast formula for 4 minutes. Compared to the print in Figure 6-8, not only are the shadows darker, but the ferns appear to have more detail.

mulas in Appendix B to find one that matches the color of the standard developer you are using as closely as possible.

Increasing the Restrainer Content of a Developer

Increasing the amount of restrainer in a developer increases its contrast. When you increase the restrainer, you increase the exposure necessary before the highlights in a print will develop with a visible density. As you saw when you created your own developer in Chapter 4, the restrainer primarily affects the highlights, so the additional exposure makes the shadows darker and gives the print more contrast.

Procedure

When adding restrainer to a working solution of developer, it is useful to prepare a stock solution of 10% potassium bromide ahead of time. A convenient amount of solution can be made by adding 10 grams of potassium bromide to 100 milliliters (ml) of water.

Add the stock solution 5 ml at a time, and test the modified developer by making a print. The contrast of the print will increase as the amount of restrainer increases. Eventually, you will add so much restrainer that it is difficult to obtain a satisfactory print.

Adding potassium bromide increases the green-black color of prints developed in that developer (something you can't see in the reproduction of Figure 6-10). If this color is objectionable, you can tone the print in selenium toner (see Chapter 8 for instructions) or use a synthetic restrainer, such as Kodak's Anti-Fog No. 1 or Edwal's Liquid Orthazite. These restrainers produce a blue-black print color instead of green-black.

CUSTOMIZING PRINT CONTRAST

To print successfully, some negatives require separate contrasts for the highlights and the shadows. For example, a negative with brightly lit subject matter and important details in deep shadow

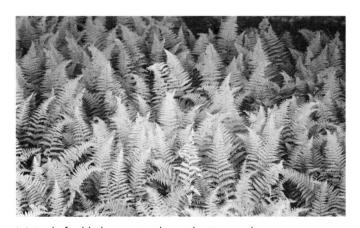

(a) 5 ml of added potassium bromide, 8-second exposure

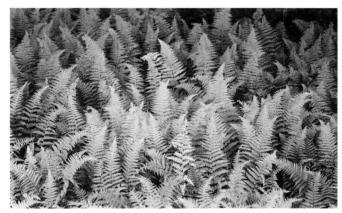

(b) 15 ml of added potassium bromide, 10-second exposure

Figure 6-10 Comparison of prints made with different amounts of restrainer. These prints were made on grade 2 paper and developed in Beers high-contrast formula with added restrainer. The additional restrainer had the effect of increasing the print contrast. Up to a point (which varies by developer), adding more restrainer adds to the developer contrast.

should be printed so that details appear in both areas without making either look dull and gray. Normally, this is impossible if you print the negative with a single contrast range low enough to show the detail in both areas.

The solution for such negatives is to customize the print contrast so that it is optimum for each area. You can do this by either splitting the print development between two different developers or splitting the exposure between two different filters if you are using variable-contrast paper.

Split Tray Development

Split tray development allows you to develop any printing paper for one contrast range in the highlights and another in the shadows. It is a technique that requires two trays of developer: one containing a low-contrast formula and one containing a normal- or a high-contrast formula.

The different trays of developer affect the highlights and shadows of the print differently. The low-contrast formula causes an even, gradual separation of tones in the print. The higher contrast formula produces dark, vigorous shadows.

You alternate the print between the two trays until the image is fully developed. By controlling the amount of time that the print spends in each tray, you control the effect that each developer has on it. With some experimentation, you can find the correct contrast balance for each negative you print.

Split tray development is especially effective for producing a print with a lot of tonal separation in both the highlights and the shadows. This can be a problem, however, if the contrast range in the highlights doesn't work well with the contrast range in the shadows. If you do a clumsy job with split tray development, it will show.

Procedure

Even though the essence of split tray development is experimentation, these general principles can guide you:

- The greatest effect on the overall contrast of the print is from the developer that the print spends the most time in.
- If the development times are equal, the developer you use first will have the stronger effect on the contrast of the print.

For example, a print that requires an overall low contrast but needs dark shadows and good shadow separation should spend most of its development time in the low-contrast tray, with only the final 10 to 15 seconds in the normal-contrast tray.

Following are two different development plans: one for very high contrast negatives and the other for very low contrast negatives. Use these as starting points for your own tests.

Figure 6-11 Split tray development. Alternating the print between two trays of developer controls the contrast of the highlights and shadows separately.

Development Plan for a Very High Contrast Image

- 1. Agitate the print for 1 minute in the low-contrast developer
- **2.** Transfer the print to the normal- or high-contrast tray.
- **3.** Agitate the print for 10 seconds.
- **4.** Stop and fix the print.

The result is a low-contrast print that still has strong shadow separation and black, rather than gray, shadows.

Development Plan for a Low-Contrast Image

- 1. Agitate the print for 3 minutes in the high-contrast developer trav.
- **2.** Transfer the print to the low-contrast tray.
- 3. Agitate the print for an additional minute in the low-contrast tray.
- **4.** Stop and fix the print.

The result is a print that has a full range of tones and that doesn't lose the subtlety or separation of tones in the highlights.

It is possible to use split tray development to print a negative with practically any contrast. Experience is the best guide for deciding how to use this technique.

Split Filter Exposure on Variable-Contrast Paper

Variable-contrast papers contain two layers of light-sensitive emulsion: one is a high-contrast layer sensitive to yellow light; the other is a low-contrast layer sensitive to blue light. The filter sets supplied with variable-contrast papers regulate the amount of each color that the paper receives, balancing the exposure of the two layers to control the overall contrast between moderately low and moderately high.

Variable-contrast paper is intended for exposure through a single filter, but you can take advantage of the two different emulsion layers to use separate exposures for each. Expose the low-contrast layer for the highlights and general details of the image, and expose the high-contrast layer to increase the density of the shadows.

Materials

You can use the lowest and highest contrast filters in your variablecontrast filter set even though these filters do not exclusively expose a single layer of the paper's emulsion.*

^{*}Variable-contrast filters typically range in color from yellow (low contrast) to magenta (high contrast), which contains a large amount of blue. These filters balance the color of light reaching the paper between yellow and blue.

Figure 6-12 With variable-contrast paper, yellow light exposes the low-contrast layer of the emulsion, and blue light exposes the high-contrast layer.

A more effective alternative to the supplied filters is to use the following:

- yellow filter, Kodak Wratten 8 (also known as K-2) or equivalent
- blue filter, Kodak Wratten 47-B or equivalent

You can purchase thin gelatin filters in the appropriate Wratten numbers and place them under the enlarging lens. The thinness of the gelatin filter produces minimum distortion of the projected image. Wratten filters are available from Kodak in various sizes and prices. If you use gelatin filters, handle them carefully because they scratch easily.

Procedure

- 1. Place the yellow (or low-contrast) filter in the path of the enlarger light.
- 2. Run a series of test strips to determine the correct low-contrast exposure. The correct low-contrast exposure is the one that produces the best highlight tones.
- 3. Once you determine the correct low-contrast exposure, expose a full sheet of paper for that time, and cut it into test strips.
- 4. Replace the low-contrast filter with the high-contrast filter, and run an exposure test for the most important shadows. The correct high-contrast exposure is the one that produces the darkest shadows possible without obscuring detail.
- 5. Once you determine the correct low-contrast and high-contrast exposures, expose a full sheet of paper, first to the low-contrast filter and then to the high-contrast filter.

After you make the first print, you can make small adjustments to the overall contrast by changing the balance of the two exposures. reducing one and increasing the other by the same percentage. For example, to reduce the contrast of a print slightly, reduce the exposure of the high-contrast filter by 5%, and add 5% to the exposure of the low-contrast filter. To increase contrast, do the opposite.

Just as with split tray development, split filter exposure can make all the tones in a negative equally visible on the print, so you should use this technique with discretion.

SUMMARY

- Negatives with contrast problems that prevent you from making acceptable prints using normal darkroom techniques generally fall into one of three categories: negatives with extremely high contrast; negatives that are low in contrast but that, for aesthetic reasons, you cannot print on grade 3, 4, or 5 papers: and negatives that must be printed with separate contrast ranges for the highlights and the shadows.
- Negatives that contain extreme high contrast can be printed by using one of the following techniques:
 - —Combine grade 1 paper with 20% more exposure than normal and half of your normal development time if the negative is only slightly high in contrast.
 - —Develop in a low-contrast developer formula, or use a commercially available low-contrast developer, such as Kodak's Selectol-Soft.

- —Flash the printing paper by pre-exposing it before making the main exposure.
- —Alternate the print between a tray of developer and a tray of plain water. Agitate the print for a few seconds in the developer, and let it sit in the water for a full minute. Repeat the process until the image is fully developed.
- You can combine low-contrast techniques to increase the amount of contrast reduction in a print.
- Negatives that have a low contrast and for certain reasons can't be printed on high-contrast paper can be printed by using one of the following techniques:
 - —Develop in a high-contrast developer formula, or use a commercially available developer in a greater concentration than the manufacturer recommends.
 - -Increase the amount of restrainer in a developer. Prints developed in a formula with added restrainer require additional exposure to correctly render the highlights and therefore have darker shadows than those developed in an unmodified formula.
- You can customize the contrast of a print so that it is optimum in both the highlights and the shadows, even when these areas require different contrasts, by using one of the following techniques:
 - —Split tray development divides the development time of a print between a tray of low-contrast developer and a tray of normal- or even high-contrast developer. The low-contrast tray allows even separation in the highlight tones, and the normal contrast tray produces vigorous shadow tones.
 - -Split filter exposure with variable-contrast paper permits you to expose each layer of the print emulsion differently. The low-contrast filter allows even separation in the highlight tones, and the high-contrast filter produces dark shadows.

Chapter **7**

Salvage Techniques

No one likes to anticipate printing a problem negative. It is only prudent, however, to make some preparations for the inevitable day when an essential image is on a hopeless negative. This chapter covers some useful ways to make a satisfactory print when otherwise it would be difficult, if not impossible.

Choosing a Technique

The image salvage techniques in this chapter are organized by their application to the negative or to the print. Improving a negative has the advantage of producing repeatable prints once you have made the necessary improvements. The disadvantage of working on the negative is that any mistake is likely to be permanent and may mean a lost image.

Working with a poor print has the advantage that mistakes are not fatal to the original image. You can discard a print if an experiment doesn't work and perfect your technique on duplicate prints. Working with prints, however, means that it is hard to achieve repeatable results. An edition of matching prints, for example, may be impossible.

Once a negative is developed, it is usually best to concentrate on making the best possible print from it, compensating for any flaws in the negative by changes in exposure and contrast or through burning and dodging. Occasionally, when there are so many problems associated with a negative that no printing technique works, you are justified in trying to improve the negative. Otherwise, the image is useless.

NEGATIVE TECHNIQUES

You improve a poor negative by altering its image density. If a negative doesn't have enough density, you can chemically add to that density through a process called *intensification*. If a negative has too much density, you can remove the excess through a process called *reduction*.

The following techniques for intensification and reduction work only on conventional negative film in which the image density is made of silver. Some black-and-white film, such as Ilford's XP2, is chromogenic, which means that the image is formed by the same dyes used in color negative film. If you use a chromogenic film, try the print techniques in this chapter to improve the image; reduction and intensification of the negative won't work.

Negative Intensifiers

Intensification adds density to an underexposed or underdeveloped negative by combining a metal with the silver in the image or by changing the image color. There are many formulas for intensifiers using metals, such as mercury, copper, silver, and even uranium. Other intensifier formulas tone the negative to a warm brown or red color so that light projected through it appears to have greater density to the printing paper.

You shouldn't attempt to use most classic intensifier formulas because they are unpredictable or even dangerous. Two intensification methods are safe to use if reasonable precautions are taken and work well on contemporary films. These are selenium toner used as an intensifier and a chromium bleach-and-redevelop formula.

These intensifiers increase the densities of the negative in proportion to the amount of silver present and so are called proportional intensifiers. The darker highlight densities in the image intensify more than the lighter midtone and shadow densities. The result is an increase in contrast similar to increasing a negative's development.

Preparing for Intensification

Proper fixing and handling are essential to avoid stains that can ruin the negative. The intensifying metal can bond with unfixed silver halides or unwashed silver sulfide compounds, making them visible as stains. To avoid these stains, fix for the correct amount of time with fresh fixer, and wash a negative thoroughly before you attempt to intensify it.

Contamination from external sources, such as the containers and equipment you use for mixing and storing solutions, can also cause stains. Be sure to thoroughly clean everything you use during the intensification process. Wear rubber gloves while handling the solutions to prevent contamination and to protect your skin.

To avoid damaging the negative during intensification, place the strip it is on back on the processing reel (for roll film) or in a hanger (for sheet film). Intensification softens film emulsion, so the less physical contact, the less chance for scratching. If after taking these precautions you still find your negatives damaged, consider treating future negatives with a Formalin supplementary hardener (Kodak SH-1) before intensification. The formula for SH-1 is given in Appendix C.

Selenium Intensification

Using selenium toner as an intensifier for negatives is a useful way to achieve a slight amount of intensification. Because the procedure has fewer steps than chromium intensification, there is less risk of damaging the negative.

One drawback is that the time of intensification in selenium toner varies greatly depending on the type of film with which you are working. Films with slow emulsion speeds generally intensify more rapidly than fast films. Testing each film type is the only way to establish the correct intensification time.

You can make an intensifier solution by mixing one part Kodak's Rapid Selenium Toner with three parts of a working solution washing aid at 70° F. If during your testing you find that you are overintensifying, try a dilution of one part toner to five parts washing aid. If necessary, you can even increase this dilution to one part toner to ten parts washing aid.

Intensifying for too long in selenium toner causes an image to turn a purple-red color and eventually fade. A certain amount of red coloration increases the apparent density of the negative to printing paper, but after that point, the actual loss of density appears in the print as less contrast.

General Selenium Intensification Procedure

- 1. Prewet the negative in room-temperature water for 1 minute. Agitate for the first 30 seconds to be sure that the emulsion absorbs the water evenly. A few drops of Photo-Flo added to the water helps ensure the even wetting of the emulsion.
- **2.** Transfer the negative to the intensification solution. Agitate constantly for 5 to 10 minutes as needed.
- 3. Rinse the negative, and place it in a working solution of a washing aid for 3 minutes.
- **4.** Wash the negative as you normally wash film.

Selenium Intensification Test

- 1. With your camera on a tripod in front of a scene containing a wide range of tones, shoot a roll of the film you want to test. If you are using sheet film, expose four sheets.
- 2. Develop the film for 60% of the normal development time for that film.
- 3. After processing, cut off about one-quarter of the roll (or take one sheet), and set it aside.
- 4. Agitate the remaining film in the selenium toning solution for 3 minutes.
- 5. Rinse the film, cut off another quarter of the roll (or take another sheet), and set it aside.
- 6. Agitate the remaining film in the selenium toning solution for another 3 minutes.
- 7. Rinse the film, cut off another quarter of the roll (or take another sheet), and set it aside.
- 8. Agitate the final segment (or sheet) of the film in the selenium toning solution for 6 more minutes. Wash all of the film.
- 9. When the film is dry, print one frame from each segment (or each sheet) of film on normal-contrast paper for the best possible highlight value.

When the prints are dry, compare them to determine how much intensification you achieved during each of the tested times. Try to determine the point at which further toning no longer produces any intensification or even reduces the contrast of the image.

Chromium Intensification

Chromium intensifier is a bleach-and-redevelopment formula that changes the silver in the image to a more opaque combination of silver and chromium. Warning: The main component of chromium intensifier is potassium dichromate, a chemical to which many people develop an allergic reaction. Avoid breathing the dust as you mix

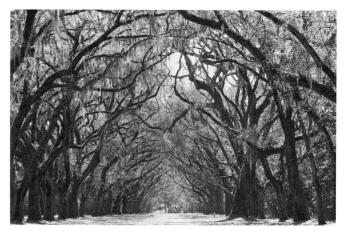

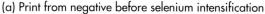

(b) Print from negative after selenium intensification

the formula, and wear rubber gloves when you handle the solution to prevent direct contact with your skin.

You can prepare chromium intensifier from formulas such as the one provided in Appendix C. This has the advantage of allowing you to alter the amount of intensification by changing the mixture of the formula. Photographers who do only occasional intensification, however, usually find that it is convenient to use Kodak's chromium intensifier, which is sold in small, easy-to-use packets.

General Chromium Intensification Procedure

Note: Room lights may be on during the entire process.

- 1. Prewet the negative in room-temperature water for 3 minutes. Agitate for the first minute to be sure that the emulsion absorbs the water evenly. A few drops of Photo-Flo added to the water helps ensure the even wetting of the emulsion.
- 2. Transfer the negative to the bleach bath (part A if you are using Kodak's packaged formula). Agitate constantly for 3 to 5 minutes or until the image on the negative has completely lightened to yellow.
- 3. Rinse the negative in running water for 1 minute or until the rinse water no longer has a yellow color.
- 4. If you are using the Kodak packaged intensifier, transfer the negative to the clearing bath (part B), and agitate for 2 minutes or until the image appears as a faint milky white. If you are using the single-solution formula given in Appendix C, continue the rinse until all of the yellow is gone from the negative, approximately 5 minutes.
- 5. If you used part B of the Kodak formula, rinse for 1 minute.
- 6. Redevelop the negative with a paper developer.* Develop to completion, which for most films is less than a minute. You cannot overdevelop, although you should not leave the film in the developer longer than 5 minutes.
- 7. Wash the redeveloped film for 5 to 10 minutes. No fix or washing aid is necessary.

Figure 7-1 Using selenium toner to intensify a negative. (a)The slight amount of intensification provided by toning the negative for 3 minutes changes the relationship between the live oak tree trunks and the Spanish moss. Note that toning time depends on the film type and the amount of intensification needed.

^{*}Don't use a film developer for redevelopment because the long development time required, combined with the large amount of sulfites that most film developers contain, tends to dissolve the silver image before it is completely redeveloped.

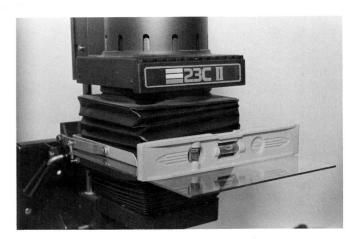

(b) Print from negative after chromium intensification

Figure 7-2 Using chromium intensifier on a negative. Before intensification, the negative yields a print with gray shadows. After intensifying the negative two times, a negative from the same roll of film yields a print with darker shadows when printed for the same highlight tones. Chromium intensification also increases the size of the grain in the negative.

You can repeat chromium intensification three times. Each time, the intensification effect will be less. After three intensifications, the increased density obtained is not great enough to warrant the additional risk of damage to the film emulsion.

Chromium Intensification Test

Follow the same procedure outlined for the selenium intensification test:

- 1. Expose and process one roll (or four sheets) of the film you want to test.
- **2.** Leave one-quarter of the roll (or one sheet) unintensified. Intensify the rest of the film.
- 3. Set aside another quarter of the roll (or another sheet).
- **4.** Intensify the remaining film a second time.
- **5.** Set aside a third quarter of the roll (or a third sheet).
- 6. Intensify the final quarter of the roll (or the final sheet) a third time.
- 7. Wash the film. When it is dry, print one frame from each segment (or each sheet) of film on normal-contrast paper for the best possible highlight value.

When the prints are dry, compare them to determine how much intensification you achieved during each step.

Negative Reducers

When a negative is too dense, either because of overexposure or overdevelopment, the excess density can be removed by a chemical bleaching process. This process is commonly called reduction, although it bears no resemblance to the reduction that occurs during negative development.

There are two primary reducer types: subtractive, which removes density equally from all tones in the image, and proportional, which removes density in proportion to the current density of the

image tones.* Reduction works approximately the same for negatives and for prints.

The reducer formula most often used is Farmer's reducer, named after Howard Farmer who popularized it in 1884. This formula combines potassium ferricyanide, a bleaching agent, with sodium thiosulfate, the major component of most fixing baths. When you use Farmer's reducer, the potassium ferricyanide bleaches the silver in the image back to a silver salt, and the fixing action of the sodium thiosulfate dissolves it.

Reduction is best accomplished in small steps. You can always repeat the reduction process if the initial attempt doesn't remove enough density, but the negative is ruined if too much is reduced.

Subtractive Reducers

Farmer's reducer can be either subtractive or proportional, depending on how you mix it. Appendix C provides two Farmer's reducer formulas: one subtractive, the other proportional. Each is made from the same two stock solutions.

When the potassium ferricyanide stock solution and the sodium thiosulfate stock solution are mixed together, Farmer's reducer is subtractive. Because the effects of a subtractive reducer are greatest in the shadows, this process is most useful for correcting an overexposed negative in which the excess shadow density is most obvious.

General Subtractive Reduction Procedure

Note: Room lights may be on during the entire process.

- 1. Mix 30 ml of Farmer's reducer stock solution A and 120 ml of Farmer's reducer stock solution B with enough room-temperature water to make 1 liter of working solution. Once the solution is mixed, it has a useful life of less than 10 minutes. When exhausted, the solution turns from yellow to green.
- 2. Agitate the negative in the reducer for 1 minute. The image will turn vellow.
- 3. Rinse the negative with running water until all of the yellow has disappeared from the wash water. Inspect the image. You can repeat steps 1, 2, and 3 if more reduction is necessary.
- 4. Fix the negative for 1 minute, then wash (after using a washing aid), and dry normally.

Subtractive Reduction Test

- 1. With your camera on a tripod in front of an evenly lit scene. shoot a roll of the film you want to test, overexposing by three stops. If you are testing sheet film, expose four sheets the same way.
- **2.** Develop the film for its normal development time.
- 3. After processing, cut off about one-quarter of the roll (or take one sheet), and set it aside.
- **4.** Agitate the remaining film in the reducer for 1 minute.
- 5. Rinse the film, cut off another quarter of the roll (or take another sheet), and set it aside.

^{*}There is a third reducer type, superproportional, which removes density by a greater percentage than the proportion of densities in the negative. Superproportional formulas are not in common use anymore.

- **6.** Agitate the remaining film in freshly mixed reducer for 1 minute.
- 7. Rinse the film, cut off another quarter of the roll (or take another sheet), and set it aside.
- 8. Agitate the final segment (or sheet) of the film in another bath of freshly mixed reducer for 1 minute. Wash all of the film.
- 9. When the film is dry, make a print from each segment (or each sheet) of film on normal-contrast paper for the best possible highlights.

When the prints are dry, compare them to see examples of what you can achieve with a subtractive reducer. Try to determine the point at which further reduction no longer produces any improvement in the printed image or actually begins to lower the contrast of the image. This indicates the point at which useful reduction is no longer possible.

Proportional Reducers

When the potassium ferricyanide stock solution and the sodium thiosulfate stock solution are kept separate and the image being reduced is alternated between the two, Farmer's reducer acts as a proportional reducer. Because a proportional reducer removes more density from the darker areas of the negative, this process is useful for overdeveloped negatives that have too much contrast.

General Proportional Reduction Procedure

- 1. Mix 100 ml of stock solution A with water to make 1 liter of working solution A. Mix 210 ml of stock solution B with water to make 1 liter of working solution B.
- **2.** Agitate the negative in working solution A for 1 to 4 minutes. The longer the negative stays in solution A, the more reduction will take place. It is better to have too little reduction take place during this step than too much.
- 3. Transfer the negative to working solution B, and agitate for 5 minutes.
- **4.** Rinse and inspect the negative. If more reduction is needed, repeat steps 2 and 3.
- **5.** When you have achieved the desired amount of reduction, wash the negative thoroughly using a washing aid before the final wash.

Working solutions A and B can be used over again until solution A turns from yellow to green.

Proportional Reduction Test

- 1. Following the same procedure you used for testing Farmer's reducer as a subtractive formula, shoot one roll (or four sheets) of film of an evenly lit scene at a normal exposure.
- **2.** Develop the film for twice its normal development time.
- 3. After processing, cut off about one-quarter of the roll (or take one sheet), and set it aside.
- 4. Agitate the remaining film in solution A for 1 minute, and transfer it to solution B for 5 minutes.
- 5. Rinse the film, cut off another quarter of the roll (or take another sheet), and set it aside.

- **6.** Agitate the remaining film in working solution A for 1 minute. and transfer it to working solution B for 5 minutes.
- 7. Rinse the film, cut off another quarter of the roll (or take another sheet), and set it aside.
- 8. Agitate the final segment (or sheet) of the film in solution A for 1 minute, and transfer it to solution B for 5 minutes. Wash all of the film.
- 9. When the film is dry, make a print from each segment (or each sheet) of film on normal-contrast paper for the best possible highlight value.

When the prints are dry, compare them to see examples of what you can achieve with a proportional reducer. Try to determine the point at which further reduction reduces detail in the shadow tones. This indicates the point at which useful reduction is no longer possible.

PRINT TECHNIQUES

With many available techniques that produce repeatable results, it is hard to justify printing solutions that require custom handling. There are times, however, when certain print problems require careful treatment of each print individually. These techniques include those you can apply to a print during development and those that you can apply after the print has been processed.

Photographic folklore is full of magic recipes for printing. Entire books have been written describing special development techniques, such as hot developer, rubbing and breathing on a print, and even holding a print partially out of the developer, all of which are intended to alter the tones of selected areas of the image from what they would be if development had proceeded normally. At best, these techniques are an inconsistent way of achieving a local increase of density or contrast. What is more likely is that all of the rubbing and chemical coercion will damage the print.

Locally Applied Developer

If you are determined to try any alteration of consistent print developing practices, one process is worth experimentation. This process involves applying small amounts of concentrated reducing agent directly to the print surface to increase the density and contrast of that area. This works best for highlights and shadows that otherwise would appear weak and flat.

The best reducing agent for this purpose is phenidone. Phenidone is similar to metol in its ability to produce an image, but it is about ten times stronger. Ilford sells small containers of phenidone that are convenient for mixing a small amount of a concentrated phenidone solution.

Procedure

1. Mix 10 grams of phenidone in 100 ml of water. If you plan to keep the solution longer than a day, add a gram or two (the measurement need not be precise) of sodium sulfite and hydroquinone, and store the solution in an airtight bottle. It should last about a week.

- 2. Give the print you want to work with a normal exposure, and begin to develop it.
- 3. After a minute, take the print out of the developer, drain it by the corner for 10 seconds, and lay it on a flat surface.
- 4. Using a swab dipped in the phenidone solution, gently wipe over the area you want to darken.
- 5. Wait 15 seconds, replace the print in the developer, and continue with normal development.
- 6. Repeat this process in 30 seconds if you want additional density.

This procedure will slightly increase the activity of your print developer, a potential problem if you are using a low-contrast formula. As an alternative, try waiting until 30 seconds before the end of development to remove the print. After applying the phenidone solution, wait an additional 30 seconds, and then place the print directly into the stop bath.

Print Intensifier

You can intensify a print in the same manner that you intensify a negative. Intensification will help restore contrast to a flat print with gray shadows. Since it is usually easier to make another print on a higher contrast paper, this procedure is described primarily for information purposes. Should you some day be faced with a situation in which you have no choice but to try to intensify a print, you can use the chromium intensifier formula given in Appendix C with the following procedure.

Procedure

Note: Room lights may be on during the entire process.

- 1. Prewet the print for 1 minute in a tray of water.
- 2. Mix the working solution intensifier from 200 ml of chromium

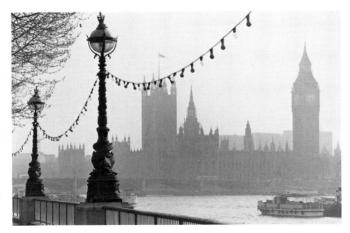

(a) Print before treatment

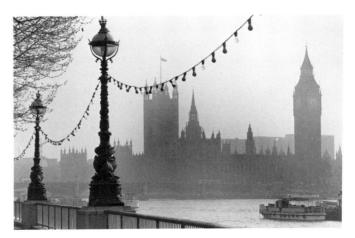

(b) Print after treatment

Figure 7-3 Effect of applying concentrated phenidone to a print. London's Parliament building in the background is darker and shows greater contrast after painting the print with hot, concentrated developer. Note that it is often hard to make this technique look "natural."

- intensifier stock solution A, 650 ml water, and 150 ml of chromium intensifier stock solution B.
- 3. Place a wet print that needs intensification into the working solution.
- 4. Agitate for 4 to 5 minutes. If the image does not disappear at this point, add an additional 100 ml of stock solution A. Some prints fixed in a hardening fixer can take longer to bleach.
- 5. Wash for 20 minutes.
- 6. Redevelop the print in your normal paper developer for 2 to 5 minutes or until strong, rich shadows develop.

It is possible to repeat the intensification process, but the print emulsion tends to soften, so be careful. If the process damages the print emulsion, try using the Formalin supplementary hardener given in Appendix C before intensifying another print.

Print Reducer

You can reduce an overly dense print with Farmer's reducer in much the same way that you reduce the density of a negative. You can also reduce selected areas of a print, something you normally can't do with a negative. This section covers only the proportional reduction of prints. It is generally not necessary to use a subtractive reducer on a print because it is much easier to make another print with less exposure.

Reducing a Print

A print made from a flat negative is a likely candidate for overall reduction if you expose it so that the highlights appear dark and lifeless. The shadows should also be slightly darker than normal.

When such a print is bleached with a proportional reducer, the effect is to increase the contrast and the detail visible in the highlights. This happens because the additional exposure given the print increases the highlight details beyond what you can see in the highlights of a normally exposed print from the same negative.

General Procedure for Reducing a Print

- 1. Mix 500 ml of Farmer's reducer stock solution B with 500 ml of water to make a tray of working solution B. Mix 100 ml of Farmer's reducer stock solution A with 900 ml of water to make a tray of working solution A. If you need more contrast, you can increase the concentration of working solution A by mixing 400 ml of stock solution A with 600 ml of water.
- 2. Agitate the print in the tray of working solution B for 1 minute so that the emulsion completely absorbs the sodium thiosulfate.
- 3. Transfer the print to the tray of working solution A, and agitate it for 15 seconds.
- 4. Remove the print from working solution A, and drain it by one corner for 10 seconds.
- 5. Return the print to working solution B, agitate it for 15 seconds, and examine the result.
- **6.** If you need more reduction, repeat steps 3, 4, and 5.
- 7. Fix, wash, and dry the print in the normal manner.

Testing a Proportional Reducer on a Print

- 1. Using a negative that prints well on high-contrast paper, make four prints on grade 2 paper, exposing so that the shadows are correct and the highlights are gray and flat.
- 2. Set one print aside, and bleach the remaining three prints for 15 seconds.
- 3. Set a second print aside, and bleach the remaining two prints an additional 15 seconds.
- **4.** Set one more print aside, and bleach the final print for 30 more seconds.

Once the prints have been fixed, washed, and dried, compare all four with a correctly printed version on high-contrast paper. Look carefully at the highlights, shadows, and print color. Determine which of the test prints has the best range of tones and highlight details. In comparison with the print made on higher contrast paper, decide if the bleached print has a better range of tones, particularly in the highlights. This will give you an indication of the usefulness of this technique for your work.

Local Reduction of Prints

Occasionally, you will make a print that has one or more areas that you can't successfully dodge during exposure. Chemically bleaching these areas is a useful alternative. Local reduction has the advantage over dodging of allowing you to work under room light and without time pressure.

A small brush or a cotton swab is a good tool to use to apply the bleach to the surface of the print. If you use a brush that has a metal ferrule, you risk getting blue stains on the print unless you prevent the ferricyanide solution from touching the bare metal. Protect the ferrule by coating it with clear nail polish. Let a drop of polish soak in at the point where the bristles contact the metal (to seal off the inside), and then apply a thin coating to the outside of the ferrule.

Whenever iron compounds, either from an uncoated metal ferrule brush or from tap water, contaminate the bleaching solution, you will get blue stains on your print. Remove these stains by plac-

(b) Print after reduction

Figure 7-4 Using Farmer's reducer on a print. Farmer's reducer lightens the overall tones and slightly increases the contrast of the print of the vegetable stand.

ing the affected print in a tray of print developer for 1 minute, followed by the usual fixing and washing.

General Procedure for Local Reduction

- 1. If the print you plan to reduce is dry, soak it for 1 minute in plain water. Then remove the wet print, and blot off the surface water.
- 2. Just before use, mix 10 ml of Farmer's reducer stock solution A and 20 ml of Farmer's reducer stock solution B with water to make 100 ml of working solution. Add two or three drops of a wetting agent (Photo-Flo) to help the solution penetrate evenly. The working solution will be effective for about 10 minutes.
- 3. Using either a small brush or a cotton swab, depending on the size of the area to be lightened, lightly brush the solution on the area. The reducer will exhaust itself rapidly on the surface of the print. Use a paper towel to blot up any excess.
- **4.** Repeat step 3 until the area is as light as you want it.
- **5.** Fix and wash the print as you normally would.
- **6.** If there are any yellow stains around the bleached area after washing, agitate the print in a tray of 50 grams of sodium sulfite mixed with a liter of water for 5 minutes, and then rewash.

Local bleaching is also a useful way to remove black spots, such as those caused by negative pinholes (a common problem with black-and-white infrared and some graphic arts films. Use either a very fine brush or the point of a toothpick to apply the bleach until the spot is completely removed. You can then use spotting dyes to blend the bleached area with the surrounding tones of the print. (See Chapter 10, "Preservation and Presentation," for a description of using spotting dyes.)

Testing Local Reduction on a Print

Take a number of scrap prints and decide which areas of each print you would like to lighten. Try a variety of applicators, from spotting brushes to cotton balls, to lighten those areas. Make notes about

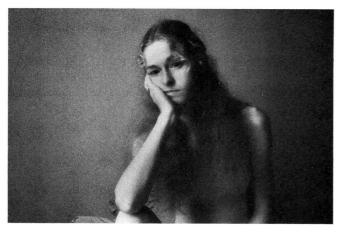

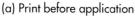

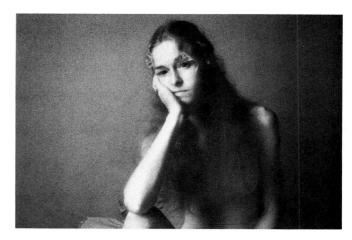

(b) Print after application

Figure 7-5 Effect of local application of Farmer's reducer. The right arm and face of the model in print (b) were "painted" with Farmer's reducer, increasing the contrast between the figure and the background.

which techniques worked best for you. Save the test prints for future reference.

SUMMARY

- In attempting to print a poor negative, you can try to improve either the negative or the print. Improving a poor negative makes it easier to produce an edition of matched prints. Improving a poor print allows you to perfect your technique on work prints before you apply it to the final print.
- Intensification is an appropriate technique for underexposed or underdeveloped negatives. It increases the density of the image where there is already some silver, but it cannot add density where isn't any.
- Using selenium toner for intensification is a useful way to achieve a slight increase in contrast without increasing the grain of the negative.
- Chromium intensifier is a bleach and redevelop formula that can be used up to three times to achieve a significant increase in negative contrast.
- Reduction is a technique that can correct an overly dense negative. Subtractive reduction removes density equally from all areas of the image and is useful when a negative is overexposed. Proportional reduction lowers the contrast of an image and is useful when a negative is overdeveloped.
- You can increase the contrast and the density of tones in a particular area on a print by applying a concentrated reducing agent to that area with a brush or a swab while the print develops.
- Although it is not a recommended technique, it is possible to increase the contrast of a print by using chromium intensifier
- You can increase the contrast of a print with overexposed highlights and normally exposed shadows by using a proportional reducer.
- You can lighten specific areas of a print by applying a reducer to those areas with a brush or a swab.

Toning

For many photographers, toning is the final step in making an exhibition-quality print. This step might be a protective coating with little or no visual effect, or it might be an obvious and intentional color change. As the final step in a planned process, toning can enhance a print statement. As a salvage attempt for a poor image, toning is usually ineffective.

This chapter discusses the uses of print toning for visual effect. Chapter 9, "Archival Processing," discusses the use of toning for print protection.

TONER TYPES

All true toners affect only the image silver and produce a color in proportion to it. Highlights and other print areas that contain little or no silver (such as the borders) retain their original color. Some coloring processes are advertised as toners when, in fact, they actually stain the emulsion and give the print an overall color. Toners can be grouped into three categories: *direct toners*, *silver conversion toners*, and *dye toners*.

Direct Toners

Direct toners bond an inorganic compound directly to the image silver, in effect coating it. The final image color is determined by the nature of the compound used in the toner and is usually modified by diluting the toning solution and varying the time that the print is toned. The direct toners described in this chapter are selenium, gold, selenium/sulfide, and polysulfide toners.

Silver Conversion Toners

Silver conversion toners bleach an image and redevelop it with a new color. During the bleaching step, these toners convert image silver to a silver salt (usually a creamy white silver bromide or silver iodide) in a fashion similar to Farmer's reducer. The toning agent then redevelops the silver salt to form a new compound with a new color. For this reason, silver conversion toners are also called *bleach-and-redevelop toners*.

Some silver conversion toners are two-step toners; the bleach and redevelopment steps occur in separate baths. The final image color depends on the amount of bleaching that takes place in the first step. Redevelopment is usually rapid and continues to completion.

Other silver conversion toners combine bleach and redevelopment in a single bath. In these formulas, the image silver is bleached and redeveloped progressively. The longer the print stays in the toning bath, the more the image is toned. The silver conversion toners mentioned in this chapter are sepia, iron blue, copper brown, and red toners.

Dye Toners

Normally, organic (carbon-based) dyes do not combine with inorganic compounds like silver. They will, however, combine with certain silver salts. Dye toners use a special bleach, called a mordant, to convert the image silver in a print to either silver iodide or silver ferricyanide so that an organic dye will adhere to it. The greater the amount of silver that is mordanted, the stronger the color.

The appeal of organic dye toners is the many colors that are available. By comparison, inorganic direct and silver conversion toners produce few color variations.

Formulas for two-step and single-step dye toners are given in Appendix C. The color produced depends on the dye used in the formula and the amount of silver that is converted by the mordant.

SPECIAL SAFETY PRECAUTIONS FOR TONERS

Chapter 1, "Reviewing Darkroom Fundamentals," discussed general safety precautions you should follow for all photographic work. Because toners present greater health hazards than do more typical darkroom chemicals, three cautions are worth emphasizing:

- Proper ventilation during toning is essential. Even a darkroom that has adequate ventilation for normal black-and-white processes may not be adequate for toning. Because you can use toners under normal working lights, there is no reason to use them in a poorly ventilated darkroom.
- Avoid skin contact with toning solutions. Wear rubber gloves, and use print tongs. Some photographers cite the fact that they have been working with certain toners for years as proof that exposure to these chemicals is not harmful. This sort of anecdotal evidence doesn't account for people with unknown allergic reactions or with small cuts or abrasions on their hands. It is better to be safe than sorry at a later date.
- Be cautious when using a toner containing potassium ferricyanide around strong acids, such as concentrated stop bath. Although normally a stable compound, potassium ferricyanide can decompose and release highly toxic hydrogen cyanide gas if it is exposed to heated, concentrated acid. The same caution applies to selenium toners; as equally toxic hydrogen selenide gas is released if the toner is mixed with heated acid.

PREPARING A PRINT FOR TONING

Because toning represents an additional chemical step, processing errors or sloppy procedures that might not otherwise be visible can show up on a toned print. When processing a print for toning, be sure that you do the following:

- Fix the print completely. This means using fresh fix for the correct amount of time. Residual (undeveloped but incompletely fixed) silver tones the same color as the image silver, causing stains.
- Use a nonhardening fixer. Hardening a print can prevent complete toning. If hardening is needed later, you can use the Formalin supplementary hardener (Kodak SH-1) formula provided in Appendix C.
- Use the dehardening formula given in Appendix C if you need to tone a print that you have inadvertently hardened.
- Some toners, especially silver conversion toners, reduce a print's density. Be sure to print darker than you would normally if the toner you plan to use is one of these.

TESTING TONERS

Toners react to different papers with different effects. Some paper brands and types of papers, even different grades of the same paper. accept toning well, and others do not accept it at all. In addition, the paper developer you use and the mineral content of the water with which you mix the toner can modify a toner's color. The only way to predict how a paper will react with a toner is to perform tests.

General Toner Testing Procedure

The following is a general-purpose exercise that will provide the information you need to predict how a particular paper and developer combination will react with a toner.

- 1. Select a negative with a variety of tones that prints well on grade 2 paper.
- **2.** Find the correct exposure for a 5×7 -inch print.*
- 3. Calculate exposures that are approximately 25% less, 10% less, 20% more, and 50% more than the correct exposure.
- **4.** Expose and process a print for each of the exposures.
- 5. Repeat steps 2 through 4 for any other paper you want to test.
- **6.** Cut each print into four approximately equal test strips. Label each piece with the paper type, relative exposure, and the toner you are planning to test.
- 7. Place one test strip from each print in the toner you are testing for the minimum time recommended for that toner. For a twostep toner, this time applies only to the first (bleach) bath. Toning in the second bath should be to completion.
- 8. Place a second test strip from each print in the toner, and time how long it takes to completely tone or, in the case of a twostep toner, completely bleach the image silver.
- 9. Divide the difference between the minimum toning time and the maximum toning time into thirds. Tone the remaining test strips for those times. For example, if the minimum toning time was 5 minutes and the maximum toning time was 20 minutes,

 $[\]star$ The test recommends a 5 × 7-inch print for the sake of economy. You may use any size print that is convenient for you.

[†] To get the best comparison, tone test strips from the same part of the image together.

Figure 8-1 Order for arranging toning test.

the remaining test strips would be toned for 10 and 15 minutes. This formula is approximate; the idea is to evenly space the toning times between the minimum and the maximum.

When the test strips are all toned and dry, compare the test strips that were toned for the minimum time. Place them side by side with the least exposure on the top (or to the left) and the greatest exposure on the bottom (or to the right). Note the effect of the toner on the shadows, highlights, and midtones at different print exposures. Compare the other test strips in the same manner (Figure 8-1.) For reference, glue or tape the test strips on a piece of cardboard or in a notebook, and record the test data and your observations next to them.

NOTES ON SPECIFIC TONERS

The following sections discuss specific toner types and offer general working advice to supplement the instructions that come with the commercially available toners or the published formulas. The toners are listed in the order of their general popularity.

Selenium Toner

Selenium toner is commercially available as a liquid concentrate from Kodak (Rapid Selenium Toner) and from some other manufacturers. No formula for compounding selenium toner from dry chemicals appears in Appendix C because the powdered form of selenium is highly toxic when inhaled.

Selenium toners produce color changes that range from a mild deepening of the shadows to a strong reddish purple. For most papers, selenium is the easiest and quickest way to enrich shadows and to provide a slight color shift, usually toward a warmer color.

Many photographers have a favorite way to use selenium toner. Although most of these methods work well, almost all ignore the instructions packaged with the product, which are geared to produce a strong reddish purple.

Procedure

With the caution that all toning methods should be tested before they are used on a final print, the following method is recommended because it allows a high degree of control over the amount of color change and it minimizes stains.

- 1. Prepare two trays of a working-strength washing aid.
- **2.** Add between 35 ml and 175 ml of toner concentrate per liter of solution to the second tray.
- 3. Agitate the print for 3 minutes in the first tray (washing aid only), then transfer it to the second tray (washing aid plus toner).
- **4.** Agitate the print in the second tray, watching very carefully for the beginning of a color change to red in the shadows. Use a bright tungsten incandescent bulb for an inspection light to exaggerate the red color so that you can remove the print from the toner before the color change becomes too great.
- 5. When the print reaches the desired color, wash it in cool water. Wash water that is hotter than 85° F can remove the selenium from the print.
- **6.** Air-dry the print. Using heat to dry a selenium-toned print can drastically alter its color.

How fast a print tones and the color produced depend on how much toner concentrate you add to the toning solution and the type of paper you are using. Toning times range from 5 to 20 minutes.

If you encounter red splotches during toning, they are stains caused by the print having an acid pH when it reached the toner. Acid can be carried over from the fix or even from tap water, which in many communities is becoming increasingly acid. Agitating the print in a washing aid before toning neutralizes acidity.

When toning with selenium, remember that there is residual activity that continues to change the color of the print after you remove it from the solution. Rinse a print with plenty of water to be sure that toning has stopped.

Split Toning with Selenium

Certain chloride-based papers, such as Kodak AZO (a contact speed paper) and Agfa Portriga Rapid (a combination chloride- and bro-mide-based enlarging paper), produce an interesting effect when toned in selenium. The shadows tone first with a warm red color. For a short time after this occurs, the highlights and midtones remain unaffected. If you stop the toning process at this point, the print has a split tone. Darker shadows and midtones are warm red, and the remaining midtones and highlights, while retaining their original color, effectively look cooler or even whiter than before. Color Plate 8-4 illustrates a print split toned with selenium toner.

There is little consensus about the proper procedures to use when split toning chloride-based papers. Some photographers believe that the print developer temperature is critical (between 73° and 77° F) and that unknown impurities in the water contribute to the toning effect. Other photographers find that, aside from using a fairly high concentration of selenium toner, such as 175 ml of concentrate per liter of working solution, few factors radically change the toning effect.

Sepia Toner

Sepia toner is available commercially as Kodak Sepia Toner and in a wide variety of published formulas, one of which is reproduced in Appendix C. Sepia toner is a two-step silver conversion process. The first step is a bleach that converts the image silver to silver bromide. The

second step is a solution of sodium sulfide that reacts with silver bromide to precipitate a brown silver sulfide. The result is a warm brown image. Color Plate 8-1 illustrates a print toned with sepia toner.

Procedure

Because they are easier to handle, most photographers use Kodak's Sepia Toner packets in preference to mixing the toner from a formula. Also, when used in areas with soft water, the Kodak packets seem to stain less frequently than toner prepared from a formula.

- 1. Agitate the print to be toned in solution A (the bleach) until you have bleached as much of the image silver as you want. Bleaching until all traces of black silver have gone can take up to 10 minutes, depending on how fresh the bleach is. Partially bleaching a print produces a blacker brown.
- 2. Rinse the print for about 2 minutes or until all of the yellow is gone from the highlights and the print border.
- 3. Place the print in the tray of solution B (the toner). Full toning takes place in approximately 30 seconds. You cannot overtone.
- 4. Wash the print long enough to remove all traces of toning solution (5 to 10 minutes).

Alternative Procedure

For a darker brown, agitate the print in solution B for up to 3 minutes before bleaching in solution A. Rinse the print for 1 minute between the initial toning bath and the bleach. After bleaching, return the print to solution B for final toning.

Selenium/Sulfide Toner

A toner containing both selenium and sulfide compounds is commercially available as Kodak Polytoner. There is no published formula for a similar toner because of the toxic nature of powdered selenium.

The most interesting feature of a combination selenium/sulfide toner is that, depending on the dilution, the toner produces a wide range of warm tones, ranging from brown-black to a reddish brown. This is because the effect of the selenium in the toner is most noticeable at higher concentrations, and the effect of the sulfide is most noticeable at lower concentrations.

On many papers, you can achieve a brown-black at a 1:4 dilution and a warm brown at a 1:50 dilution. Using a combination toner at a 1:50 dilution on a chloride-based paper, such as Portriga Rapid, gives an interesting pink-brown. For testing, consider dilutions of 1:4, 1:24, and 1:50 as separate toners.

Polysulfide Toner

A single-solution polysulfide toner is available commercially in liquid concentrate form as Kodak Brown Toner. The polysulfide toner formula (Kodak T-8) in Appendix C produces results similar to the commercial package.

To use, mix as directed by the package or the formula you are using, and tone prints from 3 to 10 minutes. Because the toning action is relatively slow at room temperature, many photographers use a warm solution (up to 100° F). This requires careful handling because the surface of a warm print is soft and easy to scratch; and good ventilation because the volume of sulfur fumes released by the toner is greater when it is warm. The print color tends to be uneven until the toning process reaches completion.

The colors produced by a polysulfide toner are darker than those obtained with a bleach-and-redevelop sepia toner.

Iron Blue and Copper Brown Toners

Iron-based blue toners are available commercially as Edwal Blue Toner and Berg Brilliant Blue Toning Solution. The formula for iron blue toner in Appendix C is inexpensive and easy to prepare and produces results equal to the commercial packages.

To use, immerse the print in the prepared toning solution until the image silver turns the desired color. There will be some yellow staining in the highlights. After toning, wash the print until the yellow stain has cleared from the highlights. Be careful not to overwash because the blue can wash out.

For most papers, the color produced is a bright cyan blue. If you want to intensify the color slightly, rinse the washed print in a weak solution of ammonia or chlorine bleach (about five drops of household bleach or nonsudsing ammonia to a liter of water).

A copper-based toner is available commercially as Berg Brown/ Copper Toning Solution. Like the iron blue formula, the formula for copper toner in Appendix C is easy to prepare and use. Color Plate 8-2 illustrates a print toned with copper brown toner. A variation of the copper formula that produces red colors is listed in Appendix C.

Use copper toner in the same manner as iron blue toner. On most papers, the color produced is a dark reddish brown.

Gold Toners

A variety of gold toner formulas have been published. The two most popular are listed in Appendix C: Gold Protective Toner (Kodak GP-1) and Nelson Gold Toner (Kodak T-21). Another gold toner is available commercially as Kodak Blue Toner.* These formulas produce colors ranging from warm brown to cool blue. All produce a very stable image because gold is inert to most forms of chemical reaction.

Many people assume that gold toning is expensive. In fact, a gram of gold chloride can tone up to 80 8 × 10-inch prints, depending on the formula you use. If you plan your toning sessions carefully to maximize the number of prints, the cost is minimal, especially compared to the cost of printing paper.

Gold Protective Toner (Kodak GP-1)

Kodak GP-1 is the classic gold protective toning formula that many photographers use as a final step in archivally processing their prints (see Chapter 9 for a discussion of archival processing). This toner also produces a slight blue color that can be used to create a neutral tone on warm-color papers. Tone prints in GP-1 for 10 minutes or until a slight color change occurs.

^{*}There is no published formula for a similar toner in Appendix C because of the toxic nature of the thiourea contained in the formula.

In addition, you can combine the GP-1 formula with other toners to produce strong color statements. Color Plate 8-3 shows an example of what happens when you combine sepia toner with GP-1.

Nelson Gold Toner (Kodak T-21)

Nelson Gold Toner produces warm colors on paper without causing the image to turn brown the way it does with sulfide and polysulfide toners. This toner is used at temperatures between 100° and 110° F. Vary the toning time from 5 to 20 minutes to control the amount of toning and the degree of warmth that the print color takes.

Kodak Blue Toner

Kodak sells a packaged gold toner as Kodak Blue Toner. It produces a subtle blue color on most warm-color printing papers. This color is not as extreme as that produced by iron blue toners, but it is much more permanent. The intensity of blue is determined by the length of time a print stays in the toning solution; 15 to 30 minutes is considered normal.

Dye Toners

Two companies make commercially packaged dye toners: Edwal Scientific Products and Berg Color-Tone. The Edwal toners are single-step dye toners;* the Berg formulas are two-step toners.

Appendix C lists two different formulas for dye toners as well as a formula for removing iodine stains in gelatin. One formula, Kodak Dye Toner T-20, combines the mordant and the dye. The other formula uses separate mordant and dye solutions. The single-step formula is more convenient to use, but the two-step formula offers greater control over the process. For example, when using a two-step dye toner, the print can be transferred back and forth (after rinsing) between the two solutions to increase the amount of toning.

Procedure Notes

Dye toners can be used in a variety of ways. In general, follow the instructions given with the formulas or the packaged toners, being careful to avoid contamination of the solutions or the prints. The following notes are guides for experimentation:

- The longer the print is in the mordant solution, the greater the amount of dye that will be accepted into the print.
- You can mix different dyes or transfer a print to different toner baths to produce new colors.
- Highlights and midtones show the effect of the dyes more dramatically than shadows.
- If you get too much color from a dye bath, you can reduce the color by placing the print in a weak solution of ammonia. Add five to ten drops of nonsudsing household ammonia to a liter of
- The color of a dye-toned print can wash out. Wash the print only until the excess color is gone from the highlights.

^{*}Edwal sells five color toners in identical packaging. The Edwal blue toner, however, is an iron-based toner, not a dye toner.

 Although permanent for most purposes, a dye-toned image is not archivally stable. The color in a dye-toned print will eventually fade, especially when exposed to strong light.

MULTIPLE TONING

Selenium- and sulfide-based toners create a permanent change in the image, one that can't be altered through later processing. Toners like iron blue and the various dye toners can still be manipulated after the toner is applied. You can exploit these properties to tone your prints a variety of colors and to produce a variety of effects.

In choosing toners for multiple toning, you should be aware of their color relationships. For example, a strong color like iron blue makes the color from a less intense toner, such as Polytoner, less noticeable. You can play with this psychological effect by using Polytoner on the parts of an image that you want to remain "natural" and letting the rest of the image be altered by the addition of a bright color.

Two techniques that are especially useful when multiple toning are hand-applied toner and masking.

Hand-Applied Toner

Toners such as selenium and combination selenium/sulfide leave a print inert to change by other toners. When you apply these toners to selected areas of a print, they act as a resist, preventing those areas from being altered further.

You can apply toner by hand in a variety of ways. Cotton swabs and cotton balls are useful because cotton doesn't react with the toning chemistry. For very fine work, you can use a small brush. If the brush has a metal ferrule, be sure to take the precautions noted in Chapter 7 in the section on the local reduction of prints because metal contamination can ruin the toning effect. Once you use a brush to apply a toner, do not use it for any other purpose.

Procedure

- Remove all of the surface water from a washed print with a squeegee or paper towel, and place it on a flat surface and under good light.
- **2.** Apply the toner with a cotton swab or a small brush. You can add a drop or two of a wetting agent (such as Photo-Flo) to the toner to make it spread more evenly. For better color control, use multiple applications of dilute toner.
- **3.** To inspect the effect of the toner or to apply a different toner, rinse the print, and blot off the surface water again.

Masking

You can do multiple toning by masking parts of a print while working with one toner and then removing the mask for additional toning. A common masking material is rubber cement. Another material that works well is a product called *Maskoid*. Both products are available in most art supply stores along with appropriate thinning agents to make their application easier.

Masking works best on resin-coated papers. The waterproof base prevents the toner from migrating through the back of the print and toning the image under the mask.

Procedure

- 1. Select a dry print, and thin a small quantity of rubber cement or Maskoid until it is the consistency of paint.
- 2. Using an appropriately small brush, begin painting the area that you want to mask. After the first coat is dry, apply a second to be sure that you haven't left any gaps.
- 3. Tone the print. If you are using two toners, the first should be a selenium, sulfide, or polysulfide toner.
- **4.** After rinsing the toned print, dry it, and then carefully remove the mask by rubbing lightly with your fingers.
- **5.** If you plan to use a second toner, do it now.

Careful workers can mask a print, tone it, apply a mask to a different area, and tone again, building up several layers of color. For your initial experiments, attempt only a single mask.

Experiments with Multiple Toning

The large number of toners available and the different ways that they work suggest a rich avenue for experimentation. The following experiments are offered as starting points. From these you may find methods and ideas for further exploration.

One reminder: reserve print spotting and retouching until all toning is complete. Toners do not affect spotting dyes and even a subtle color change will highlight the retouched areas.

Experiment: Using Selenium/Sulfide Toners as a Resist

Brush concentrated Polytoner on the area of a print that you want to protect from additional toning, wait one minute, and then wash for 3 to 5 minutes. The areas touched by the toner will appear dark brown. Then transfer the print to a tray of iron blue toner and agitate until the areas that were not affected by the Polytoner turn a bright blue.

Alternative 1

In the above experiment, substitute selenium toner, a polysulfide toner (such as Kodak Brown Toner), or Kodak Blue Toner for Polytoner.

Alternative 2

Substitute copper brown toner or red toner for the iron blue toner.

Experiment: Removing the Silver from a Toned Print

Selenium tone a print and then place it in a tray of subtractive formula Farmer's reducer following the instructions in Chapter 7. The untoned silver is removed, leaving only the color of the selenium left in the print. Vary the amount of time the print is in the selenium toner to vary the final color of the print. The range is from a bright red to a dark purple.

Alternative

Substitute Kodak Polytoner, Kodak Brown Toner, or Kodak Blue Toner for the selenium toner.

Experiment: Partially Redeveloping a Toned Print

Tone a print with iron blue toner and wash. Under a good light. place the print in a tray of diluted developer, such as Dektol 1:5 (one part stock solution to five parts water). Agitate until the midtones have returned to the original print color. Quickly transfer to a stop bath, and then wash. The shadows and midtones have a normal print color, and the highlights remain blue. Alter the effects by varying the amount of toning and the amount of redevelopment.

Alternative 1

Tone the print, wash, and then squeegee or blot off all the surface water. Place the print on a flat surface under good light. Paint undiluted print developer on selected areas of the print.

Alternative 2

Substitute copper toner or red toner for iron blue toner.

Experiment: Using a Dye Toner on a Toned and Partially Redeveloped Print

Using a toned and partially redeveloped print, follow the suggestions in the previous experiment. Place the print in a dye toner. Remove the print from the dye toner when the desired color is reached, and wash.

ALTERNATIVE COLORING PROCESSES

Toning is not the only way to add color to a black-and-white print. Many photographers also apply colored paints and pencils by hand to black-and-white photographs. The most popular of these methods is using Marshall's Photo-Oil Colors and Photo Painting Pencils. Sets of oils and pencils can be found in many camera stores or purchased by mail order from Light Impressions (see Appendix D for address). Each set contains helpful instructions.

You can also use dye sets to "paint" colors onto a print. The organic dyes from dye toners (without the mordant), batik dyes, and even vegetable dyes mixed with a little Photo-Flo have also proved effective. At least one photographer has been successful using modeler's enamels. (To make the colors transparent, mix small amounts of a color with clear enamel.) Color Plate 8-5 shows an example of a print that has been toned and then painted with an air-brush.

SUMMARY

- Toning is often the final step in producing an exhibition-quality print. Toning works best when it is part of a planned process.
- True toners affect only the silver in the image. Highlights and other print areas that have little or no silver are not affected.
- There are three broad categories of toners: direct toners that bond an inorganic compound with the image silver, silver conversion toners that convert silver to a salt and then combine it

- with an inorganic compound, and dye toners that use a mordant to attach an organic dye to the image silver.
- Toning chemicals present greater health risks than standard black-and-white processing chemicals. Be sure that you have adequate ventilation and that you avoid any contact of the toning chemicals with your skin.
- To prepare a print for toning, be sure to expose and develop the print to the appropriate density. Some toners lighten print tones, and other toners intensify certain tonal areas of the print. Also, be sure to fix the print completely in a nonhardening fixer.
- Different toner and paper combinations produce different results. A useful way to gather information about the effect of various toner and paper combinations is to tone test strips made at a variety of exposures for different lengths of time.
- The following toners are the most widely used:
 - —Selenium produces colors that range from a slight warming in the shadows to a strong reddish purple, depending on the concentration of the toner and the length of toning time.
 - —*Sepia* produces warm brown colors. The color depends on how much you bleach the print before toning.
 - —Combination selenium/sulfide toners produce colors that range from brown-black at strong concentrations to a warm brown at greater dilutions. Toning time affects the intensity of the color.
 - —*Polysulfide* toners produce a darker brown than sepia. The intensity of the color depends on the temperature of the toning solution and the length of toning time.
 - —*Iron blue* and *copper brown* toners produce strong, vivid blues and browns, depending on the amount of time the print is in the toning solution.
 - —Gold toners produce a variety of colors that range from a mild blue to a warm brown-black, depending on the formula. All gold-toned prints are considered archivally permanent.
 - —Dye toners can produce any number of vivid colors, depending on the dye used in the toning formula. The intensity of color depends on how much of the image silver is mordanted by the special bleach formula.
- You can successfully use different toners on a single print by knowing the properties of the toners you plan to use and by using hand-applied toner and masks.
- In addition to toning, you can also apply paints and colored pencils to a print. Sets of colors are made specially for this purpose and you can devise alternatives yourself.

Color Plate 8-1 Sepia toned print. A slight sepia tone created by partially bleaching the image silver, enhances the skin tone of this portrait.

Color Plate 8-2 Copper toned print. Copper toner has the property of lightening a print. The result is not only less density, but a flatter image. This effect is caused by the bleaching action removing small details from the print.

Color Plate 8-3 Combination sepia and gold toned print. The red tones in this print were created by first toning in sepia and then in gold chloride. The result is an image that expresses the feeling of a sunny day at the beach.

Color Plate 8-4 Split selenium toned print. A chloride-rich paper (Portriga Rapid in this case) produces a red in the shadows and remains untoned in the highlights when placed in a concentrated selenium toning solution. The result is a split tone that increases the visual depth of the image.

Color Plate 8-5 Toned and hand-colored print. The figure in this image was first toned with Kodak Polytoner and then selectively air brushed with water based paint to bring out highlights in the hair. The resulting contrast between the colors in the figure and the untoned background creates a sense of depth in the print.

Archival Processing

Photographs are fragile. The physical object is a piece of paper subject to the stresses of alternating alkaline and acid chemical baths during processing followed by a long immersion in water. The image is a thin layer of metallic silver, which is vulnerable to stains and fading caused by airborne sulfur and contamination from any number of common objects with which the print can come into contact.

These problems have been known since photography's beginnings, but there are still no simple solutions or even a consensus about what archival processing means. Photographers define the term *archival* in many ways, ranging from highly technical measurements of milligrams per square centimeter for residual thiosulfate to somewhat mystical claims of 2000-year image stability.

To make matters more confusing, archival standards and processes tend to change as research produces more information. The American National Standards Institute doesn't even mention the word archival in its Method for Evaluating the Processing of Blackand-White Photographic Papers with Respect to the Stability of the Resultant Image, preferring to use the word optimum to describe the most stable of test samples (ANSI PH4.32-1980).*

Rather than promote a theoretical definition or unrealistically exact processes, the goal of this chapter (and the one following) is to describe practical methods that can maximize a photograph's chances for survival. This chapter concentrates on processing film and prints for maximum life. Chapter 10, "Preservation and Presentation," describes how to store photographic materials and the best way to exhibit prints.[†]

WHY USE ARCHIVAL PROCESSING?

Photographs are historical records. Although this seems to be a selfevident statement, it is also one of the hardest to appreciate. No one knows which of today's most mundane activities and objects will

^{*}American National Standards Institute, Inc., 1430 Broadway, New York, NY 10018

¹ Chapters 9 and 10 are based on the best information available at the time of writing, but when in doubt, you should always consult the most current sources. The Image Permanence Institute, Gannett Memorial Building, P.O. Box 9887, Rochester, NY 14623-0887, [716]475-5199, researches archival issues for the photographic industry and possesses the most up-to-date information. The Rochester Institute of Technology College of Graphic Arts and Photography, One Lomb Memorial Drive, Rochester, NY 14623, [716]475-2758, holds periodic seminars on the preservation of photographic images, during which the most current information is discussed.

fascinate future generations and which visual records will help historians best understand our age. Does this mean that every print should be archivally processed? One (doubtless apocryphal) piece of trivia often repeated in photographic circles is that if every print made were kept under archival conditions, the entire land mass of the planet would be several feet deep in photographs by the year 2010. The answer to the question, then, is a resounding no.

The best reason to know about archival standards and processing techniques for prints is the choice that this knowledge provides. Understanding what is necessary to process a print for maximum permanence means that you don't have to expend the time, energy, and resources on prints you want to keep for only a few years. Most prints require less care in processing and shorter washing times than photographers typically give them.

Processing film is different. Film is relatively easy to process for maximum permanence and, as the source material for prints, deserves careful handling. Although the information in this chapter about print processing applies only to those prints you intend to keep, use the suggestions for film processing for all of your negatives.

PRINTING FOR ARCHIVAL PROCESSING

When you have decided on an image that you want to print and process for maximum permanence, there are two points to keep in mind:

- Always leave at least a one-inch border on the print around the image. Once the print is processed, never trim this border because airborne contaminants attack a print from its edges. The large border is a buffer that gives you time to discover and treat a problem.
- Avoid toners and processes not mentioned in this chapter. Iron, copper, and dye toners do not produce permanent images. Rubber cement and Maskoid are full of sulfur and transfer it to the print, where it stays even after the rubber cement or Maskoid is gone. Reduction and intensification tend to weaken the print emulsion and paper fibers. In general, the more you manipulate a print after it is developed, the greater the chance that the life of the print is in some way compromised.

Achieving maximum permanence may require avoiding processes that are necessary to your print statement. In such a case, you must decide whether the print statement or the permanence of the print is the important factor. It makes little sense to make an archival print that doesn't satisfy you.

Choosing a Printing Paper

There are several factors to consider when choosing a printing paper for archival processing. One is the paper's ability to release its chemical contaminants during washing. Another is its durability under normal storage and viewing conditions.

Although you can process almost all printing papers to the same standards of chemical purity, papers made with a conventional fiber backing have proved to be more durable than papers made with a

resin coating. Resin-coated paper is manufactured with a coating of polyethylene over the paper fibers in the base and, in many situations, has much to recommend it. The resin coating prevents liquid from penetrating the base, making the washing of residual sulfur from the print much more efficient. Some resin-coated papers are easier to tone and manipulate than their conventional counterparts. Apparently, however, the dimensional stability of the polyethylene coating in resin-coated paper prevents it from expanding and contracting as easily as conventional fiber paper. When displayed in strong light and under changing humidity and temperature conditions, the surface of these prints can graze and crack dramatically.

In the future, manufacturers may solve this problem, but for the present, avoid resin-coated paper when permanence is an issue. Eastman Kodak has acknowledged the problem and has promised to continue to produce conventional fiber papers as long as any doubt exists about the long-term stability of resin-coated paper.*

DEVELOPMENT

It is hard to justify spending the time to process an image to archival standards if it isn't well developed. You must use fresh developer to produce a full range of tones from highlights to shadows. For archival processing, carefully follow the manufacturer's instructions for the number of prints that a particular solution can process. Don't forget to count test strips. After you reach that limit, use the developer for work prints and contact sheets only. For film, avoid replenished developers. Use only one-shot (dilute-and-discard) developers.

STOP BATH

Most stop baths contain acetic acid (basically vinegar) and very little else. The primary purpose of a stop bath is to neutralize the alkalinity of the developer, quickly and effectively putting an end to the image development. It is most important, therefore, to be sure that the stop bath for prints is fresh. Otherwise, the fix must also act as a neutralizer, upsetting its acid balance and rendering it less effective.

For film, use a water rinse to stop development. An acid stop bath has a tendency to cause pinholes in a film's emulsion. The abrupt change in pH from alkaline to acid causes gas bubbles to form in the emulsion and pop at the surface. At least one chemical manufacturer, Sprint Systems, makes a stop bath containing buffering agents designed to prevent this problem. Unless you use such a stop bath, fill the film developing container with water, agitate for 20 to 30 seconds, dump, and repeat three times. This will stop development quickly without causing pinholes.

For prints, always count the number of prints you process in the stop bath. Discard a stop bath when you have processed half the number that the manufacturer recommends for normal use. When using an indicator stop bath, don't wait for the indicator color to change. By that time, you have begun to contaminate the fix.

^{*}Preservation of Photographs, Kodak Publication F-30. Kodak's updated version of this publication, F-40, shows an example of the problem.

FIXING FOR PERMANENCE

Most fixing formulas contain either sodium thiosulfate* or ammonium thiosulfate as the active ingredient. Sodium thiosulfate is the basis of classic fixing formulas, used since the invention of photography. Ammonium thiosulfate fix is a more recent invention. It tends to work more quickly than sodium thiosulfate and is the basis of today's rapid-type fixers.

Most photographers like to think that fix simply dissolves the undeveloped silver from the emulsion. The actual chemical reaction is far more complex and is not even completely understood. The most plausible theory is that during fixing, undeveloped silver undergoes at least three separate chemical changes before it ends up as silver disodium (or silver diammonium), which is water-soluble and begins to dissolve in the fix.

Proper fixing would be easy if converting all of the undeveloped silver to silver disodium were the only important factor. You could fix film and prints until you were sure the process was complete. Unfortunately, if you fix too long, there are two serious side effects:

- As dissolved silver compounds build up in the fixing bath, they tend to be absorbed by the fibers of the paper base, where they are extremely difficult to remove.
- After the fix converts all of the undeveloped silver, it begins to convert developed silver, a process that shows up first as a loss of highlight details.

Proper fixing is a balance between converting undeveloped silver and avoiding contamination and image destruction. Because these processes all occur at the same time, you must monitor the fixing step carefully.

Fixing Film

Freshly developed film emulsion is quite soft, so a hardening fix is appropriate, but not necessary if you handle film carefully.

To determine the correct fixing time, follow these steps:

- 1. Take an undeveloped piece of the same type of film that you are processing, and agitate it in an ounce or so of the fixer solution. For 35mm roll film, the leader that you cut off while loading the developing reel is ideal.
- 2. Time how long it takes to dissolve the milky white emulsion from the clear film base.
- **3.** Multiply the clearing time by 2 to calculate the total fixing time.

When it takes twice as long to clear a piece of film as it did when the fixing bath was first mixed, discard it, and make a fresh solution.

Fixing Prints

Some photographers advocate fixing prints in solutions of plain sodium thiosulfate crystals. This practice is based on the fact that most fixing formulas contain additional chemicals designed to

^{*}The slang for fix, hypo, derives from the mistaken idea among early nineteenthcentury photographers that sodium thiosulfate was actually sodium hyposulfate, a close chemical cousin.

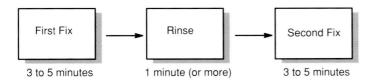

Figure 9-1 Using a two-bath fix. Rinsing a print between the two fixing baths prolongs the life of the second bath. When the first fixing bath becomes exhausted, discard it, replace it with the second bath, and mix a new second bath.

maintain the activity and acidity of the fixing bath as well as to harden a print's emulsion. These additives can prolong the time needed to wash a print adequately and make most fixers unsuitable for archival processing.

For photographers who are not interested in such a purist's approach, two options work well: a two-bath system using a nonhardening sodium thiosulfate fix or a strong concentration of ammonium thiosulfate fix used for a very short time.

Two-Bath Fixing

The nonhardening fix formula (Kodak F-24) provided in Appendix C is a good example of a fixer that works well for archival processing the two-bath method. The procedure is as follows:

- 1. Prepare two separate trays of working-strength fix.
- 2. When it is time to fix a print, place it in the first tray, and agitate it for 3 to 5 minutes.
- 3. Rinse the print in a tray of water. You can use this tray as a holding bath until you have several prints to agitate in the second fixing bath. If you do this, observe two cautions: Empty and refill the holding tray with fresh water at least every 30 minutes, and do not let the emulsion of a print dry out until all fixing is complete.
- 4. Transfer the print to the second fixing bath, and agitate for another 3 to 5 minutes.

The capacity of the F-24 formula is about 25 8×10 -inch prints per liter of working solution. Most of the fixing takes place in the first tray. The second tray completes the fixing process and remains relatively fresh. When the first tray is exhausted, discard it, replace it with the second tray, and mix a new second tray.

Alternative Quick Fixing Technique

In recent years, several manufacturers have advocated an alternative method for fixing prints based on the fact that the less time a print spends in a fixing solution, the less chance there is for it to pick up residual silver and sulfur contamination. This has the advantage that less time is needed to wash the prints clean.

The procedure for the alternative fixing approach is as follows:

- 1. Mix a single tray of ammonium thiosulfate-based fix (rapid type) without hardener at twice the normal working strength. For example, if the manufacturer recommends a working dilution of one part concentrate to eight parts water, mix one part concentrate to four parts water.
- 2. When the print is ready to fix, transfer it to the fixing tray, and agitate it for 30 seconds only. Timing is very important; it is easy to under- or overfix.

3. Transfer to a fresh water rinse for 3 minutes, and then proceed with the washing aid and the final wash.

The capacity of this fix for archival processing is 12.8×10 -inch prints per liter of working solution. After this, you can dilute the solution to normal working strength and continue to use it for nonarchival processing.

Testing Fixer

The amount of dissolved silver compounds in a fixing solution determines the exhaustion of that solution. When the silver concentration reaches 2 grams per liter, the solution forms insoluble silver compounds. These silver compounds can be absorbed by the emulsion and fibers of a print and are difficult, if not impossible, to wash out.

You can test for excess silver in a fixing solution with a potassium iodide solution. When the dissolved silver in a fix reaches unsafe levels, the test solution forms a milky yellow-white precipitate of silver iodide.

A fixing test solution, Hypo-Chek, is available from Edwal Scientific Products. To use, add a drop or two of the test solution to about an ounce of the fix to be tested. The formation of a precipitate in a sodium thiosulfate fixing solution indicates exhaustion. For an ammonium thiosulfate-based fix, exhaustion is indicated if a precipitate forms and doesn't disappear in 2 or 3 seconds.

The fixer test solution formula (Kodak FT-1) listed in Appendix C performs the same function as Hypo-Chek. To use, add five drops of FT-1 to a solution of five drops of fixer and five drops of water. The formation of an obvious precipitate indicates exhaustion. A slight cloudiness isn't an indication of exhaustion.

For archival processing, a fixing test solution is helpful only for the first bath of a two-bath sodium thiosulfate fixer. The single-bath ammonium thiosulfate fixing technique requires that you carefully monitor the number of prints you fix in it.

Residual Silver Test

If a print is fixed for too long or not for long enough, the residual silver test solutions (Kodak ST-1 or the alternative given in Appendix C) will indicate it. This test works on the principle that a toner will combine with even the invisible silver in a print emulsion to create a visible color.

The procedure for the residual silver test is as follows:

- 1. After the final wash, blot the surface water off of the print to be
- 2. Place a drop of the test solution on the white margin.
- 3. After 2 minutes, rinse off the excess test solution. Any stain other than a slight cream color (for ST-1) or faint pink (for the alternative test solution) indicates the presence of residual silver compounds that will eventually discolor the print.

If the test is positive, you can refix a print in a fresh bath of nonhardening sodium thiosulfate fixer for 3 minutes. Test again after washing to confirm that the silver is now gone.

RINSE AND WASHING AID

After fixing, rinse the print in running water for 3 to 5 minutes to remove as much excess fix as possible. This makes the job of the washing aid easier.

A washing aid is a formulation of salts that promotes an ion exchange with thiosulfate compounds to make them more watersoluble. Although the various washing aids available commercially have names like Hypo Clearing Agent and Fixer Remover, the actual process neither clears nor removes residual fix. Washing aids only improve the efficiency of the final wash; they don't replace it.

Washing aids are also important because they increase the alkalinity of the final wash. The more alkaline the wash water, the more effective the wash. This is especially important because tap water in many municipalities is becoming increasingly acidic.

For archival purposes, double the time recommended by the washing aid manufacturer. In general, this means 2 to 3 minutes for film and up to 5 minutes for prints.

WASHING

The fact that the silver disodium (or silver diammonium) left in the emulsion after fixing is water-soluble does not mean that it is gone from the print or film. Nor does it mean that any excess thiosulfate left behind is gone either, even after using a washing aid. Removing these contaminants is the purpose of washing. Washing is a process of progressive dilution. Fresh water enters the washing system, forms a solution with the chemicals in it, and then leaves.

Ideally, washing should continue until the emulsion and paper fibers in a print contain no greater a concentration of silver salts and residual thiosulfate than the fresh water entering the system. In fact, this is an impossible goal, and you should wash for only as long as your purposes require. Washing time is primarily affected by water temperature and water flow.

Water Temperature

The warmer the wash water, the more effective it is in removing residual chemicals. Water that is too warm, however, can soften an emulsion and cause damage, such as excessive grain clumping in film and even the separation of a print's emulsion from its paper base. Wash water that is too warm can also remove the effect of certain toners, such as selenium. The most effective compromise for wash water temperature is between 65° and 80° F.

Water Flow

The purpose of water flow in washing prints is generally misunderstood. Many print washing systems rely on a rapid flow rate to agitate the prints, so most photographers assume that the greater the volume of water passing over the material being washed, the better. In fact, water passing over an emulsion too rapidly doesn't allow time for the residual chemicals to go into solution, reducing washing efficiency.

There are very few standards for water flow. Kodak recommends a

rate sufficient to completely fill the washer in five minutes.* You can test the water flow in your apparatus by adding several drops of food coloring to the wash water and timing how long it takes to disappear.

You can't rely on a standard like Kodak's, however, to tell you whether film or prints are adequately washed. For that, you must use the residual thiosulfate test described later in this chapter. Only through testing can you establish the best rate of water flow for your washing system.

Film Washing

You can wash film simply and economically. Leave the film on the developing reels or hangers and in the developing tank. Fill the tank with wash water, agitate for about 30 seconds, and dump. Repeat this ten times. It is important to allow at least 30 seconds between the fill and the dump to allow the residual chemicals in the emulsion to go into solution.

For tray-developed sheet film, either transfer the film to hangers and a tank for washing, or fill two trays with wash water, and transfer back and forth every 30 seconds. Dump and refill the empty tray until you have completed ten transfers.

A convenient way to wash film is to fill containers ahead of time with water at the proper temperature. Plastic gallon jugs are ideal for this purpose. This technique protects you from possible temperature fluctuations at the faucet and can save considerable amounts of water. A quick calculation shows that a complete wash of 35mm film in a standard four-reel developing tank takes less than 3 gallons of water.

Print Washing

It is difficult, if not impossible to remove the last traces of residual chemicals from photographic paper. The fibers in the paper base retain residual thiosulfate tenaciously. In addition, an underfixed or overfixed print also contains incompletely removed or redeposited silver compounds that are insoluble in water.

Many devices sold today claim to be "archival" print washers. Although you should investigate the merits of each product individually, all that the best of these devices offer is convenience. You can construct a completely satisfactory print washer using the largest available print tray and an inexpensive tray siphon.

The most important function of the print washer is to circulate wash water evenly around the prints. The more expensive print washers do this automatically, but you can achieve the same result by slowly shuffling the prints in a tray with running water. An inverted glass in the center of the tray keeps the prints from clumping together in the middle.

Washing Test

The only way to be sure that a print is adequately washed is to test it with the residual hypo testing formula (Kodak HT-2) given in Appendix C. This test uses acidified silver nitrate to create a yellow stain on emulsions containing an unacceptable amount of thiosulfates.

^{*}Conservation of Photographs, Kodak Publication F-40, p. 52.

Figure 9-2 Print washing apparatus. A tray and inexpensive siphon make an excellent device to wash prints as long as you keep the prints moving. Note the inverted glass in the middle of the tray to keep the prints from clumping together.

Washing Test Procedure

Because the stain produced by the HT-2 test is faint and easily obscured by the tones of a typical print, you must test a separate sheet of paper prepared especially for testing.

- 1. Process an unexposed sheet of printing paper in the same way that you would any other archival print.
- 2. After a 15-minute wash, blot the surface water off of the test sheet, and place a drop of HT-2 solution in the middle. (Prints wash from the edges in, so the center is the last part to completely wash.)
- 3. After 2 minutes in subdued light, flush the print with a mild salt water solution. The presence of anything more than a slight yellow stain indicates unacceptable amounts of residual thiosulfate.
- 4. Continue to test at 15-minute intervals until you achieve an acceptable stain. The length of time this takes is your archival print washing time, assuming the same conditions of water flow and temperature. Roughly half of this amount is an adequate amount of washing for nonarchival prints.

The stain created by the HT-2 solution will continue to darken after 2 minutes. To preserve the yellow stain as it is, refix and rewash the test sheet. Preserving the test stain is not normally necessary, although you might want to keep it for your records.

Several companies sell a "hypo estimator," which is basically a printed sheet of paper or clear plastic that approximates the stains you see at different concentrations of residual thiosulfate. Although these devices are available at many stores selling photographic supplies, their usefulness is limited because all but the faintest stains indicate that the print requires more washing.

PROTECTIVE COATING (TONERS)

You can apply a protective coating to an image using a toner. Some toners not only change the color of a print, but protect the image silver from oxidizing atmospheric gases (mostly sulfur dioxide) as well

as residual sulfur from fixing. A very successful toner for producing a permanent image is sepia because the silver sulfide print cannot be further degraded by additional sulfur compounds. Most photographers do not use sepia toning for archival prints, however, because of the drastic color change that takes place.

The following toners improve the stability of prints: sepia, selenium, combination selenium/sulfide, polysulfide, and all gold toning formulas. The major drawback to most of these formulas is the potentially unwanted color change. Two toners that enhance the permanence of prints without necessarily causing a noticeable color change are selenium toner and one of the gold formulas.

Selenium

Although selenium is chemically related to sodium sulfide (the active ingredient in sepia toner), selenium toner produces only a mild deepening of the shadows when it is highly diluted. This, combined with the protection added by the selenium coating of the image silver, makes selenium toning popular with photographers making archival prints.

To use as a protective coating, follow the directions outlined in Chapter 8, adding only 35 to 70 ml of selenium toner concentrate to the toning solution. At this lower concentration, toning takes place very slowly, and it is easier to remove the print before a noticeable color change takes place. You can tone with selenium either immediately after fixing a print (followed by the final wash) or after the final wash (followed by a short rinse).

Gold

Chemically, gold is considered to be a noble metal for its resistance to combination with other compounds. This means that gold won't tarnish the way that silver does when exposed to atmospheric sulfur.

The Kodak GP-1 toner formula given in Appendix C provides the protective coating of gold with a minimum of color change, usually a slight blue color in the shadows. Some photographers also claim that the GP-1 formula increases the separation of tones in the highlights, although this doesn't seem to be true for all papers or in all situations.

HYPO ELIMINATOR

After a print has been washed and before it is toned, you can treat it with the hypo eliminator formula (Kodak HE-1) provided in Appendix C. A mild solution of hydrogen peroxide and ammonia, HE-1 oxidizes small amounts of thiosulfate compounds in a print.

To use, place prints in a tray of freshly mixed HE-1 solution, and agitate for 6 minutes. After use, wash prints for an additional 20 minutes.

Although it is effective, there are some drawbacks to using the hypo eliminator formula:

 HE-1 tends to soften the print emulsion so that the chances of damaging the print surface are increased. This suggests that another process is necessary: hardening.

Figure 9-3 Drying prints on fiberalass screens. Fiberglass screens are an economical way to dry prints without damaging them. If the humidity is so low that your prints curl excessively as they dry, sandwich the wet prints between two screens.

• HE-1 tends to yellow the paper base, which some photographers find objectionable.

Generally, most photographers don't consider the benefit of using HE-1 worth the effort and added risk.

PRINT DRYING

It is possible to exercise great care while processing a print and then damage it when the print dries. Two things to avoid when drying a print are heat and contact with any potential contamination source. This means that mechanical print dryers that use a canvas belt to press prints against a heated drum are a poor choice for archivally processed prints. Blotters, popular with many photographers, are also a bad choice because they are subject to contamination from previously dried prints and, even when new, can embed fibers in the print emulsion.

One way to dry prints is by clipping a corner of the wet print to a clothes line with a clothes pin. As long as the clothes pins are used only for archival prints, this method offers the least potential for damage. The only disadvantages are a slight indentation of the print corner held with the pin and the fact that, especially in dry climates, prints dried this way tend to curl badly.

Another drying method is to use fiberglass window screening stretched on a frame (Figure 9-3). Fiberglass screening is inexpensive and available at most hardware stores. The fiberglass doesn't absorb chemicals and can be easily washed if surface contamination is a problem.

To dry prints this way, remove the surface water with a squeege, and lay the print face down on the screen. If curling is a problem, you can sandwich prints between two layers of screen. The weight of the frame of the top screen will prevent curling. Be sure to wash drying screens regularly. A small amount of chlorine bleach in the wash water followed by a fresh water rinse will ensure their cleanliness.

SUMMARY

- Because the standards for archival processing are not completely clear and subject to change, it is best to think of archival processing as those techniques that maximize a photograph's chances for long-term survival.
- One reason to learn about archival processing is to discover that only a small number of prints require exact processing and that you can devote less time and resources to the mechanics of producing prints for temporary purposes.
- Because it is relatively easy to wash film and because negatives are the source material for your prints, you should always process film for maximum permanence.
- Always develop and stop archival prints with fresh solutions and for the correct amount of time. These steps do not contribute directly to the print's life, but it is important to make the best possible print if you want it to last a long time.
- You can use one of two different fixing methods for archival prints: a two-bath system using a sodium thiosulfate-based fix or a single bath of a concentrated ammonium thiosulfate-based
- Two tests help determine proper fixing. The fixer test solution precipitates silver iodide if there is an unacceptable amount of dissolved silver in the fix. The residual silver test makes improperly fixed silver compounds in the emulsion visible by
- A washing aid promotes an ion exchange with thiosulfate compounds to make them more water-soluble and to improve the efficiency of the final wash. A washing aid is not a substitute for adequate washing.
- Print washing time is affected by the rate of flow and the temperature of the wash water.
- A residual thiosulfate test can determine if the final wash is adequate for archival purposes.
- Some toners, such as a weak solution of selenium or the gold protective formula, protect the image silver without drastically changing print color.
- A hypo eliminator formula oxidizes small amounts of residual thiosulfate compounds in a print at the risk of softening the emulsion and turning the paper base slightly yellow.
- Hanging wet prints on a clothes line or placing them face down on fiberglass screens allows them to dry without heat and with the least chance of contamination.

Preservation and Presentation

Photographers spend large amounts of money on cameras, film, and printing paper. They devote long hours in the darkroom. Many of these same photographers, however, neglect to follow through with the same effort when storing or displaying the fruit of all this labor. This chapter discusses these final steps of the printing process:

- print finishing, such as spotting and adding documentation
- storing negatives and prints for maximum permanence
- preparing a print for display

PRINT FINISHING

Before prints go into storage or are put up for display, they should be spotted, signed, and given any other necessary documentation. This is also the time to make decisions about adding a surface treatment.

Spotting

Even the most careful worker's prints will have a few white spots caused by dust and lint on the negative when the print was made. Any foreign matter blocks light and forms a white "shadow" on the print. The problem is literally magnified when you make an enlargement, but it exists even when you contact print large-format negatives.

Aside from being scrupulously clean in the darkroom and carefully dusting the negative before printing, the traditional solution for dust spots is a neutral color dye painted over the spot to make it less noticeable. This process is called *spotting*.

Some traditionalists like to make their own spotting solutions by mixing permanent ink and gum arabic, but commercial spotting dyes are widely available and easy to use. The two most popular spotting products, SpoTone from Retouch Methods Company and Touchrite from Berg Color-Tone, come in small bottles of different shades of gray. To use them, mix small amounts from the appropriate bottles to match the particular color of the print on which you are working. Each product comes with complete instructions.

A practiced hand can spot a print in such a way that no traces of dust spots are visible under the most careful scrutiny. Although this is a useful skill, the real goal of spotting is camouflage, not complete eradication. Few people will study a print to discover your spotting technique.

A general rule is to spot any flaw noticeable within 10 seconds of looking at a 6-square-inch area on a print. Ignore the small flaws that invariably appear as you are working on the ones you noticed

first. Even the best dyes slightly alter the surface reflectance of the print, so minimizing the amount of spotting you do actually reduces the possibility that a viewer will notice. Minimizing the time you spend spotting also reduces the possibility of accidentally harming the print during handling.

Spotting Tips

Practice is the best way to improve your spotting technique. Keep the following suggestions in mind as you practice:

- Buy a good–quality red sable brush from an art supply store. and use it only for spotting. The best brush is one that will form and hold a point when it is wet and given a quick shake. Depending on preference, sizes between 0 and 0000 work best.
- Wear white cotton gloves to minimize the transfer of finger oils and dirt to the print surface. Most camera stores sell inexpensive gloves specifically for handling photographic materials.
- After you mix the appropriate color of spotting dye, let the mixture dry in a small white plastic or porcelain dish. To use, dip your brush in a vial of distilled water, and touch the tip of the brush to the dried color. Once the brush absorbs a small amount of color, dab it on a paper towel or a sheet of typing paper to remove any excess.
- Build up color on the print with a stippling motion rather than a brushing stroke. You can add a drop or two of Photo-Flo to the distilled water to make applying the dye easier.
- If you apply too much dye, wipe it off immediately with a cotton swab. If the dye dries, try dipping the swab in a weak solution of nonsudsing household ammonia.
- Straight lines caused by scratches on the negative are among the hardest flaws to hide. Try applying the spotting dye at right angles to the direction of the scratch.
- Spotting works best on prints that haven't been hardened. If a hardened print won't spot well and making a new print isn't an option, use the dehardening formula described under "Archival Processing Formulas" in Appendix C.

Fixing Pinholes (Black Spots)

Occasionally, dust on the film surface during exposure or emulsion damage caused by going from an alkaline film developer to a strong acid stop bath creates small clear areas on the negative called pinholes. Pinholes show up as black spots on the print. Some films, notably black-and-white infrared, are especially prone to pinholes during processing.

Some commercial products claim to fix pinhole spots on prints. Most either don't work well or duplicate the following procedure:

- 1. At the end of the fixing step, rinse the print, place it on a flat surface under good light, and remove any excess water.
- 2. Using a strong concentration of Farmer's reducer on a small brush, bleach the black spot completely. Try to limit the bleached area to the actual spot as much as possible. See the directions for using Farmer's reducer in the section on the local reduction of prints in Chapter 7.

3. Once the print has been processed and is dry, spot the bleached pinhole just as you would any other dust spot.

With some practice, you can successfully hide most pinhole spots.

Signing and Documentation

Some photographers feel that until a print is signed, the person who created it hasn't fully accepted responsibility for the finished product. Other photographers feel that the date, location, and subject are essential documentation. Ultimately, what you write on a print is a personal decision, but how you do it can affect its longevity.

Use only a soft lead pencil to write on an archivally processed print. To avoid damaging the emulsion, all marks should be on the back and opposite a non-image area (border). Some photographers also sign the front of the mounting board when a print is framed, so that their signature is visible.

Unless it is of unusual interest, only write technical data about exposure and contrast on work prints.

Surface Treatments

Coating the surface of a print with a protective finish that modifies its surface reflectance has long been popular with photographers. This probably began in imitation of the nineteenth–century practice of varnishing paintings before exhibition.

Photographers have used various coatings over the years: wax, varnish, lacquer, even mixtures of ether and cellulose. Today, acrylic lacquers are available in convenient spray cans.

The advantages of adding a protective coating are many. Aside from making the print surface either more or less reflective, most coatings protect the print from spilled liquids, allow fingerprints to be easily wiped off, or prepare the surface for hand-applied color.

Surface treatments are best applied to prints that are not intended for archival storage. There is very little information to suggest that any surface treatment is ultimately safe for prints and much to suggest that most products will do harm. Even so called "pure" wax products should be viewed with skepticism because there is no way to predict the long-term interaction between paper emulsions and a foreign material applied to the surface.

STORAGE

Many photographers don't take negative and print storage seriously. They stuff their negatives into the plastic pages of three-ring binders and throw their prints into any convenient box. Properly filing negatives and storing prints is easy to put off in favor of the more glamorous aspects of photographing and printing.

Many factors, however, can affect photographic materials in storage. Even properly processed film and prints are susceptible to damage. Optimum storage conditions should protect photographic materials from both chemical and physical damage.

Chemical contamination can come from acid and sulfur compounds present in many film and print storage containers and in atmospheric pollution. Handling prints and negatives with bare fingers transfers salts, chlorides, and fatty acids to their surface. If a print is being displayed, the frame and mounting materials can also be sources of contamination. Physical damage is most likely to occur during handling and from insect and fungus attack.

Proper Storage Conditions

Even if you choose a good storage container, uncontrolled temperature and humidity can cause problems for photographic materials. Large institutions with photographic archives have the resources to control temperature and humidity carefully. Individuals usually don't. The following discussion assumes the intent to achieve the best possible storage conditions within budget and space limitations.

The ideal range of temperature and humidity for black-andwhite materials is 65° to 75° F and 45% to 55% relative humidity. Although it is best to have both temperature and humidity at constant levels, if you can only control one, then it is best to control humidity. Gelatin is more susceptible to harm from unusually high or low humidity than from extremes in temperature.

Gelatin emulsions and most papers are hygroscopic, meaning that, under conditions of excess humidity, they absorb moisture from the air. Even resin-coated paper absorbs moisture at the edges where the paper fibers are exposed. As moisture is absorbed by negatives and prints, a series of harmful events take place:

- The emulsion swells and softens. If a softened emulsion is touching a porous paper surface, the paper fibers will embed themselves in the emulsion. If the emulsion is touching a smooth surface, the gelatin will adhere to it and develop a glossy appearance, a defect called *ferrotyping*.
- At a relative humidity greater than 60%, mold spores and other microorganisms that are naturally present in the air become more active. Gelatin is a perfect medium for them, and as they grow, they in turn attract insects, which do even worse damage.
- Airborne sulfur in the form of sulfur dioxide, which is especially a problem in urban areas, combines with atmospheric oxygen to form sulfur trioxide. This in turn combines with moisture to form sulfuric acid, which destroys paper and silver. Iron and copper enhance this reaction, a particular problem for prints toned with iron blue and copper brown toners.
- Although high humidity is the greatest problem, below a relative humidity of 40%, gelatin emulsions can become brittle and crack.

Improving Humidity Conditions

The best solution for excess humidity is to dehumidify the area where you store photographic materials. Some air conditioners remove moisture from the air, but many do not, especially window units. You should purchase a reliable humidity gauge to monitor your storage area to see if the conditions there warrant additional effort.

For many people, it is not possible or practical to install air conditioners and dehumidifiers. In lieu of this, there are other things you can do to ensure the best conditions for your film and prints:

Avoid storing photographic materials in unheated buildings

- and basements. Especially in damp climates, the relative humidity can be much higher than in similar heated spaces.
- Open storage boxes, cupboards, and drawers containing film and prints for at least 2 hours every week to promote air circulation.
- When the storage area is poorly ventilated, use commercially available drying agents, such as calcium chloride and silica gel. Be sure that these materials do not come in contact with your film and prints. Some archivists worry that they are a source of extra contamination.
- Instead of drying chemicals, leave an incandescent light bulb on in the storage area. Excess humidity is more of a problem than the slightly higher temperatures produced by the light.
- To discourage insect attack, place mothballs in storage cases, making sure that they are not in actual contact with film or prints. As with using chemical desiccants, this practice is controversial and probably shouldn't be used unless there is evidence of actual insect damage.
- If you find superficial mold and dirt on the surface of your negatives or prints, clean it off as soon as possible by gently applying film cleaner with cotton balls.

Negative Storage

Because negatives are more fragile than prints and because you can replace a print if the original negative is available, the proper storage of negatives is especially important. A description of the traditional method for storing negatives, the glassine envelope (Figure 10-1), illustrates the problems you can encounter.

- Glassine is translucent rather than transparent, meaning that the negative itself must be handled every time you need to examine the image or make a routine contact print.
- Most glassine contains acid and sulfur, which can attack the image silver.
- The glue used to seal the envelope's seams is hygroscopic. In humid climates, it attracts moisture from the air, which in turn can soften the film emulsion, making it more vulnerable to fungus and insect damage.

Figure 10-1 Typical glassine negative envelope. Glassine is a translucent paper-based material traditionally used for negative storage. As the text indicates, there are a number of problems associated with using glassine to store your negatives.

Figure 10-2 Making a seamless paper negative envelope for a 4 x 5-inch negative. (a) shows the shape of the acid-free paper and the location of the folds. (b) shows the first fold. (c) shows the second fold. (d) shows the final envelope with the flaps slightly extended.

Finally, the double thickness of the envelope at the seams causes uneven pressure on the negative when many negatives are stored together. The uneven pressure can distort the image on the negative over time.

The following are descriptions of some alternatives to glassine envelopes for negative storage. No method currently available completely satisfies the need for protection and easy access and, at the same time, is forgiving of a variety of storage conditions. You should evaluate your particular needs and the limitations of each alternative when deciding how to store your negatives.

Paper envelopes for negative storage can be made from archivally processed paper, such as Hollinger Permalife. You can fold these envelopes in a way that produces no side seams and doesn't need glue (Figure 10-2). The paper breathes, so moisture and harmful gases aren't trapped inside. Paper envelopes, however, tear easily and are opaque, requiring removal to see the image or to make contact prints. This method is best in humid climates when you need only limited access to the negatives.

Clear plastic sleeves made of archivally processed polyethylene, polypropolyene, or polyester are widely available for most negative sizes. These offer the convenience of viewing and contact printing without removing the negative from the protection of the sleeve. These sleeves, however, build up static electricity that attracts dust and, in high humidity conditions, can cause ferrotyping (Figure 10-3).

Recently, suppliers have begun to offer negative envelopes made from Tyvek, a trade name for spun fiber polyethylene. This material shares the archival qualities of sheet polyethylene, but like paper, it discourages ferrotyping in high humidity. In addition, the material resists tearing. Tyvek's major drawback is that it is opaque. Negatives stored in Tyvek envelopes require additional handling to view and contact print.

Once you make a choice about how to protect and organize your negatives, store them loosely in an acid-free storage box (Figure 10-4). Do not store page-size negative sleeves in three-ring binders even if the pages are conveniently punched for such binders. The pressure of the binder on the pages and the fact that the binders are open on three sides make this a disastrous way to store your negatives.

Figure 10-3 Negative sleeves that have ferrotyped negatives. The combination of humidity, pressure from stacking several binders together, and the smooth surface of the polyethylene sleeves has caused the negatives to ferrotype. Note the dark patterns caused by the negative surface sticking to the plastic. These negatives are ruined, and the images are permanently lost.

Figure 10-4 Storing negatives in an acid-free cardboard box. A safe and convenient way to store negatives is to place each negative strip in a clear acetate or Mylar sleeve and then group the sleeves in an acid-free paper envelope on which you can write catalog information. The envelopes are then placed in an acid-free cardboard storage box. This method allows safe handling and convenient viewing, although the negatives are still susceptible to ferrotyping in conditions of high humidity.

Print Storage

The primary requirements for print storage are generally the same as for negatives. The additional size and weight of prints, however, makes the choice of storage container more critical.

Various cabinets and boxes made from acid-free materials are designed especially for print storage. Most cabinets and some boxes are made from metal with a baked-on enamel or polyester finish. These containers are the most rigid and protective available as well as the most expensive.

Wooden cabinets and boxes can be less expensive, especially if homemade. Wood, however, is full of resins and, if bleached, contains oxidizing chemicals that can attack silver images. Seal any wooden container with well-dried paint or varnish, and line it with acid-free cardboard. Water-based polyurethane varnish is especially useful for sealing wood.

The most cost-effective print storage boxes are made from archivally processed cardboard. The best designs use metal clasps to attach the corners instead of glue, which might attract insects

Figure 10-5 Print storage boxes. Storage boxes are available in a wide variety of sizes to match most printing papers. The boxes shown here are made from alkaline-buffered cardboard, have a drop front to make it easy to remove prints, and use metal clasps instead of glue to hold the corners together.

(Figure 10-5). Suitable boxes are sold by many vendors in a variety of sizes, both alkaline buffered and unbuffered.* The biggest drawback with cardboard boxes is that they aren't very sturdy, particularly for larger prints.

For individual prints, polyethylene bags are available in most popular print sizes. Don't use these bags for long-term storage, however, as polyethylene doesn't breath and under certain conditions can ferrotype the surface of the print.

Regardless of the storage method, observe the following cautions:

- Don't store archivally processed prints with nonarchival ones. Also, don't store archival prints in a box that previously held nonarchival prints. Acid and sulfur compounds are known to migrate and may contaminate a container that has held poorly washed prints.
- Don't mount prints until you need them for display. This saves space and expense. Once prints are mounted, store them separately from unmounted prints.
- When storing unmounted prints, interleave them with sheets of acid-free paper.
- Don't stack mounted prints without window mats (see the section on mounting techniques later in this chapter). When storing prints with window mats, place a cover sheet of acidfree paper between the print and the window.
- Fit prints as tightly as possible in their storage box to minimize movement. This means storing prints of the same size together in a box that matches the print dimensions.

MOUNTING MATERIALS

Mounting a print with a stiff backing board serves to protect the print and to enhance the conditions under which it is viewed. Although there are many techniques and materials from which to

^{*}Alkaline-buffered storage containers can cause the dyes in some color prints and the dyes in dye-toned prints to fade faster than they ordinarily would.

choose, understanding your purpose for mounting increases the possibility that the choices you make will add to and not detract from your print statement.

There are three reasons to mount a print:

- 1. To hold a print flat for easy viewing. A flat print reflects light in one direction only, making it easy to position the print so that you can view it without reflections.
- 2. To protect the print. The mount is a barrier between the print and possible chemical contamination or physical abuse. The mount absorbs the edge dings, the fingerprints, and the coffee spills that are inevitable when a print is handled and displayed.
- 3. To provide a neutral viewing space around the image. The borders of the mount make it possible to view a print without interaction from the background.

You can satisfy these requirements and still have a variety of choices for type of mount board, size of the mount, and position of the print on the mount. Most photographers make their choices either to focus attention on the mounting technique and make it part of the print statement or to make it visually neutral and not interact with the image at all.

Mount Board

Before the relatively recent concern for archival standards in photography, the typical mounting board was a thin sheet of rag paper covering a thick core of brown wood pulp. The pulp contained large amounts of lignin, chlorine, and sulfur, typical by-products of the paper-making process. Many examples of this type of board had an obvious pebble pattern.

Today, mounting board is available without harmful chemicals and comes in a wide variety of colors and finishes. The color and quality of these boards are uniform throughout their thickness. There is little reason to use a lesser-quality board unless you are mounting a temporary study print.

Figure 10-6 Mounted and framed print against a brick wall. The mount board and frame isolate this image from the texture and color of the brick wall behind it. Without the neutral space that the mount board provides, the bricks would influence what we see in the image.

Two types of archival mounting material are currently popular; they are generically known as museum board and conservation board. Museum board is made from layers of rag fiber paper. Conservation board is made from treated wood pulp and is frequently buffered with calcium carbonate so that it is slightly alkaline. Nonbuffered conservation board is also available for color and dyetoned prints.

Museum board is the traditional choice because it was the only archival mounting material available until recently. Museum board, however, is relatively expensive, and the quality of the rag fibers used in museum board today is suspect. With the popularity of "noiron" fabrics, pure cotton rags are increasingly hard to find and polyester fibers often end up in rag paper where they form translucent blotches.

Conservation board is generally less expensive than museum board, and it is available in a greater variety of colors. In addition, because there are no fibers running directionally, pulp paper is easier to cut for window mats, especially using less expensive mat-cutting devices.

Both museum board and conservation board are available under a variety of trade names in two-ply and four-ply thicknesses (roughly 0.03 and 0.06 inches). Some companies also offer additional thicknesses.

Mount Sizes

Just as prints made with a single purpose or theme benefit from a consistent image size, the mount size you choose should also reflect a similar concern. Many different mount and frame sizes in an exhibit serve to call attention to the display decisions rather than the

You should choose a mount board size based on the image size and standard frame sizes. Generally, a 5×7 -inch or smaller image looks good on an 11×14 -inch mount. Images up to 8×10 inches work well on 12×16 - or 14×18 -inch mounts. Larger size images (up to 11×14 inches) can be mounted on 16×20 - or 24×30 -inch mounts.

Choosing a common mount (and frame) size has the additional benefit of standardizing the mounting and framing process. You benefit from the economy of scale by ordering mount board and frames that are all the same size. Having similar-size storage containers is also a benefit.

The least expensive way to buy mount board is to purchase large sheets and cut them to size yourself. Check the dimensions of full sheets of board before you make a final decision about the size of your mounts. For example, you can cut a 32 × 40-inch sheet of museum or conservation board into four 16×20 -inch or six 12×16 -inch boards.

Print Position

Although there are no absolute rules, most mounts should leave at least 2 inches of space around the edges of the print for protection and no more than 5 inches of space to prevent the image from appearing lost.

The following are some guidelines for positioning prints:

- With a vertical image on a vertical mount, the right and left margins should be equal, and the bottom margin should be approximately 25% larger than the top (Figure 10-7a). For example, a 9 × 11-inch image on a 16 × 20-inch mount would have right and left margins of 3½ inches, a top margin of 4 inches, and a bottom margin of 5 inches.
- With a horizontal image on a horizontal mount, the right and left margins should be equal, and the bottom margin should be 25% to 35% larger than the top (Figure 10-7b). For example, a 9×11 -inch image on a 16×20 -inch mount would have right and left margins of 4½ inches, a top margin of approximately 3 inches, and a bottom margin of approximately 4 inches.
- With a horizontal image on a vertical mount, the right and left margins should be equal, and the bottom margin should be 25% to 50% larger than the top (Figure 10-7c). This type of positioning works best with smaller prints (5×7) inches or smaller on 11×14 -inch or smaller mounts. For example, with a 5×7 -inch image on an 11×14 -inch mount, the right and left margins would be 2 inches, the top margin would be between 3 and 4 inches, and the bottom margin would be between 5 and 6 inches.

MOUNTING TECHNIQUES

There are two primary techniques for mounting prints: dry mounting and window matting.*

- Dry mounting is a process that uses heat and pressure to glue a print to a mounting board with a material called dry mounting tissue. This process requires a dry mounting press, a device designed to provide a controlled amount of heat and pressure to the print and mounting board.
- Window matting places a print between two pieces of mount board. The top board has a beveled window cut in it to display the image. The print is attached to the bottom board.

Figure 10-7 Three popular ways to position prints on mounts. Mounting a print in other ways tends to call attention to the mounting decisions.

^{*}The sections on mounting techniques and framing discuss the choices available to photographers who wish to display archivally processed prints. For specific techniques for dry mounting, cutting window mats, or framing, consult a book on framing techniques. Some useful volumes are listed in Appendix E. Your local library may offer additional information.

Dry Mounting

Dry mounting involves trimming the border of a print and attaching it to a mounting board with a piece of specially treated tissue. The print, the tissue and the mounting board are all placed in a heated press until the tissue, permanently bonds the print and the board.

This process works because dry mounting tissue is thermoplastic. It softens under heat and flows into the porous fibers of print paper and mount board. When the tissue cools, the bond is permanent. Resin-coated papers and Polaroid prints require special low-temperature tissue.

The chief advantage of dry mounting is that prints are held very flat. In addition, dry mounting tissue is chemically inert and seals off the back of a print from chemical contamination.

The disadvantages of dry mounting are that it requires trimming the print borders, which exposes the image to direct chemical attack. In addition, dry mounting involves extra handling of the print, during which there is the potential for physical damage. Finally, the fact that a dry-mounted print is permanently attached to its mount is a problem to some archivists who prefer that a print be removable in case the mount becomes damaged or the print requires some restoration treatment.

General Tips for Dry Mounting

- Be sure to remove any dust and grit from the tissue, print, and mount. Foreign matter caught under the print creates a noticeable bump.
- In humid climates, dry out the mount board and print by preheating them in the dry mount press. Excess moisture can turn to steam and cause bubbles under the surface of a dry mounted
- Carefully check the press temperature. Some printing papers have soft emulsions that can glaze over if heated too much. Don't trust the thermostat used on most presses; instead, use temperature-indicator strips that melt at specific temperatures.
- When you first remove the print from the press, the dry mounting tissue is warm and soft. Place the print under a flat weight until it cools so that the adhesion of the print and mounting board is solid.
- After the mounted print is cool, bend the mount and print backward to check for complete adhesion. If one or more corners lift off, replace the print in the press and reheat.

Window Matting

Many photographers who make archival prints prefer to mount their prints in a sandwich between two pieces of museum board or conservation board. This arrangement is usually called a window mat because the top board has a beveled window cut in it to show the image.

There are two ways to cut window mats: overlapping and floating. An overlapping window covers the edges of the image by approximately 1/8 inch on all four sides (Figure 10-8a). A floating window is sized to leave approximately a ¼-inch border around the image (Figure 10-8b). The overlapping window mat is the traditional way to display

Figure 10-8 Types of window mats. (a) An overlapping window covers the outer edge of the image (indicated by the dotted line) by a small amount. (b) A floating window leaves space around the image visible.

an image. The floating window mat is suited for images in which all of the border detail is important to the print statement.

The two pieces of board in a window mat are attached with a hinge of tape along either the top or one of the sides. The print is then positioned under the window and attached to the backing board. You can cut a window mat for a dry–mounted print, but it is difficult to match the location of the mounted print to the location of the window. Instead, it is preferable to attach the print to the bottom mount board using *mounting corners*, which are rectangles of acid–free paper folded in a triangle as shown in Figure 10-9.

The size of the paper corner depends on the size of the print you are mounting. For 8×10 -inch paper, corners made from a $2\times \sqrt[3]{4}$ -inch rectangle are usually suitable. For larger paper sizes, such as 11×14 and 16×20 inches, the rectangle can be $3\times 1\sqrt[4]{2}$ inches or larger. If the corner proves to be too large, you can cut it to size across the open end of the triangle.

Use two corners to hold the bottom of the print and one corner to hold the top of the print (Figure 10-10). The paper corners are hidden behind the window.

Figure 10-9 Make a mounting corner by folding a rectangular piece of acid-free paper into a triangle.

Figure 10-10 Attaching a print to a mount board with corners. Tape three corners to hold the print on the mat. Allow enough room for the print to expand in humid conditions and not buckle in the mount.

The advantage of displaying a print in a window mat is that you can remove the print when the mat becomes damaged or the print shows signs of needing restoration. In a window mat, the print doesn't need to have its edges trimmed as it does when dry mounted. Finally, the window mat keeps the print emulsion from touching the glazing of a framed print and becoming ferrotyped in a humid climate.

The disadvantages of window matting are that it requires twice as much mount board as dry mounting. To economize, you can use four-ply board for the window and two-ply for the backing. Also, cutting a beveled window requires some practice and special tools.

General Tips for Window Matting

- Use only linen or acid-free paper tape with a water-activated adhesive to attach the mounting corners and to hinge a window board to the backing board. Wet the adhesive with distilled water, or mix a little baking soda with your tap water to make sure it is alkaline. Avoid pressure-sensitive tape, even if acid- and sulfur-free because the adhesive remains tacky and will eventually migrate through porous objects like a mount board.
- When mounting with corners, allow a little space for the print to swell. In humid conditions, a print can buckle if the corners are too tight.

FRAMING PRINTS

Framing is the best way to protect a print while it is on display. A properly framed print is encased by a package of materials: the frame, glazing, vapor barrier, and backing (Figure 10-11).

Frame

The best material for the frame is metal. If the metal is painted, make sure that the paint is completely dry. A wood frame can bleed

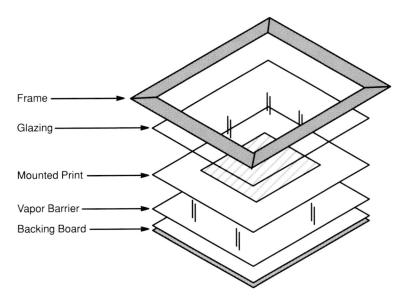

Figure 10-11 How a framed print is assembled.

resins and other harmful products into the mount if it is not sealed with a polyurethane varnish that has had at least two weeks to dry. Plastic is another common material used for frames, but to date no plastic frames are made to archival standards.

Glazing

Glazing refers to the transparent material through which you view the print. Glass and plastic are the two most common types of glazing. Glass is generally less expensive and is easier to keep clean than plastic. In addition, glass is chemically inert and safe for archival prints. If you use glass, avoid the lightly textured nonglare glass sold by many framing stores. The surface of this glass causes a soft reflection at all viewing angles, which prevents you from clearly seeing the tones in the print.

Plastic glazing is lighter than glass, won't shatter if dropped, and is manufactured in a variety of ways that filter ultraviolet light to protect color and dye-toned prints. However, plastic is hard to clean, scratches easily, and is generally more expensive than glass. Also, plastic glazing must be specially processed to be free of reactive agents that harm the long-term survival of prints, a process that adds to its expense.

Vapor Barrier and Backing Board

Behind the mounted print should be a vapor barrier and a stiff board that holds the mat and print flat. The vapor barrier is an inert layer that separates the mount from the backing. Its purpose is not to make the frame airtight. Photographs are in a constant state of change; they swell and contract from temperature and humidity changes. The vapor barrier prevents rapid humidity changes that might cause the print to buckle. You can make a satisfactory vapor seal from a sheet or two of aluminum foil or polyester (Mylar).

Even though the vapor barrier chemically isolates the mat from the backing board, not all materials are satisfactory for backing. Wood-based products, such as plywood or particle board, give off formaldehyde fumes. In addition to the suppliers listed in Appendix D, many framing shops sell acid-free corrugated board and plastic foam products suitable for backing a framed print.

SUMMARY

- Before prints are finished, they should be spotted, signed, and given any other documentation you feel is necessary.
- Spotting is the process of hiding dust spots on prints by covering the spot with a gray dye.
- Write on the back of archivally processed prints only with a soft lead pencil and only opposite a nonimage area.
- Avoid any surface treatments, such as waxes and varnishes, on archivally processed prints.
- Proper storage conditions should protect film and prints from chemical and physical damage.
- The optimum range of temperature and humidity for storage and display is 65° to 75° F and 45% to 55% relative humidity. If you can control only one of these conditions, control the

- humidity because improper humidity can cause worse problems than improper temperature.
- Choices for negative storage are many, but no one method provides a full range of protection, easy access, and tolerance for a variety of storage conditions. The choice you make should reflect your individual needs.
- Prints have the same storage requirements as negatives. In addition, the size and weight of prints means that the choice of container is important.
- There are three reasons to mount a print: to hold the print flat for easier viewing, to protect the print, and to provide a controlled viewing space around the print.
- · Museum board and conservation board are two archivally safe choices for mounting. Both are available in a variety of colors and thicknesses.
- Unless you have a specific reason to do otherwise, use uniform mount and frame sizes.
- Position a print on the mount so that the border is at least 2 inches wide and no more than 5 inches wide.
- There are two choices for mounting prints: dry mounting and window matting. Your choice depends on which is most convenient and best supports your print statement.
- Dry mounting uses heat and pressure to attach a print to a mounting board with a special mounting tissue.
- Window matting places the print between two pieces of mount board. There are two types of window mats: overlapping, which covers the edges of the image by approximately 1/8 inch on all four sides, and floating, which leaves a border of approximately 1/4 inch around the image.
- A framing package should consist of a chemically inert frame, glazing, the mounted print, a vapor barrier, and a stiff, acid-free backing board.

Enlarger Alignment

If a negative in an enlarger is held in a plane exactly parallel to the baseboard (on which the easel sits), then it is possible to get a uniformly sharp enlargement. If any part of the negative falls outside a parallel plane, then one part of the image may be focused on the printing paper, but the rest will be slightly out of focus.

Usually, you notice that an enlarger is out-of-alignment when the image in the center and three corners of a print are sharp, and the fourth corner appears slightly out of focus. Sometimes, an alignment problem can be so severe that half a print will be sharp, and half out of focus. Stopping the enlarging lens down to increase the depth of field only corrects slight alignment problems; the best solution is to make sure that the negative stage, lens board, and baseboard are all exactly parallel.

CHECKING ALIGNMENT

Never assume that an enlarger is correctly aligned. Moving, hard use, and large temperature changes can contribute to misalignment. Even new enlargers aren't always correctly aligned as a result of inadequate quality control during manufacture or rough handling during shipping. It is important, then, to check an enlarger before you first use it and to continue to check its alignment at regular intervals.

Alignment Test

An out-of-alignment enlarger is hard to spot during ordinary use. Some images do not have enough fine detail in all corners for you to notice if one is slightly out of focus. It is better to test specifically for alignment problems.

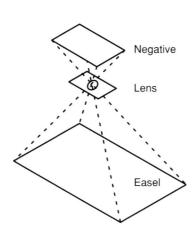

Figure A-1 For a print to be uniformly sharp, the planes of the negative, the lens, and the easel must all be parallel.

A useful alignment test involves making a print of a specially designed test negative. On a print, you can see if the image projected by the enlarger is sharp from corner to corner. If you only look at an image projected on the baseboard, your eyes can't resolve the detail accurately enough to see any but the greatest alignment problems. A focusing aid usually isn't much help because most focusing devices don't let you see the corners of a projected image.

The Test Negative

The best negative for an alignment test is one with high contrast and uniformly fine detail in the center and all four corners. Very few images you can photograph fit this requirement as well as one you can make from a piece of film that has been exposed and developed to a maximum density. With 35mm roll film, the black leader, usually discarded after development, is ideal. You can also make a suitable density negative by pointing your camera at a blank wall, putting the lens out of focus, and overexposing by the equivalent of five or more f-stops.

If you are using a piece of film leader for your test negative, define the actual "image" area by placing the film in your negative carrier and tracing the outline of the opening on the emulsion side of the film. Next, place the film on a flat surface, and scratch a rough X through the emulsion from each corner of the image area to the center. Be careful that you don't scratch so hard that you distort the clear film base. The "image" you scratch on the film should contain many jagged edges and fine detail on which you can easily focus (Figure A-2.)

Alignment Test Procedure

With the alignment test negative in the enlarger, perform the following steps:

- 1. Project an image large enough to cover a full 8×10 -inch sheet of paper without cropping any of the scratched-on "image."
- 2. Open the enlarging lens to its maximum aperture, and focus the projected image at its center, where the X crosses.
- 3. Leaving the lens wide open, make a series of test strips. You are looking for an exposure that produces a fully black X without losing any of the fine detail in the scratches. Switch to grade 3 paper, if necessary, to increase the contrast of the image without having the fine details fill in.
- **4.** Make a full-size print of the test negative.

Figure A-2 Example of an X pattern scratched on a piece of black film.

Evaluating the Alignment Test Print

When the print is developed, stopped, and fully fixed, examine it under bright light. Use a magnifying glass, if necessary, to discover if the fine detail in the print is uniformly sharp.

- If the test print is sharp in the center and in all four corners. your enlarger is in alignment.
- If the test print is sharp in the center, but one or two corners are fuzzy, the enlarger is out of alignment.
- If the center of the print is sharp, but all four corners are out of focus, heat from the enlarging lamp has caused the negative to buckle or "pop" so that it is no longer perfectly flat. Turn off the enlarging lamp, and let the enlarger cool down before trying the alignment test again. Some enlarger designs are more prone to overheating the negative than others. If you can't solve an overheating problem by reducing the amount of time the enlarger light is on while focusing or by placing heat-absorbing glass between the enlarger lamp and the negative, you should consider replacing your enlarger.

ALIGNING AN ENLARGER

Enlargers vary as to how easy they are to align. Some enlargers, such as the Omega D series, are manufactured with adjustment screws on the negative and lens stages and are relatively easy to align with only a screwdriver. In other enlargers, notably the Beseler 23C and MCRX series, the negative and lens stages are manufactured in one piece, and alignment can be tricky at best. Before you begin the alignment process described here, examine your enlarger and decide what tools and methods you need to employ to physically change the relationship of the negative stage, the lens board, and the baseboard.

Some enlarger manufacturers sell special tools to help in aligning an enlarger. These devices work no better than an inexpensive carpenter's level you can purchase at any hardware store. An adequate level need be no longer than 6 inches. A smaller level, sometimes called a *line level* will also work well.

Leveling the Baseboard

First, make sure that the baseboard of the enlarger is level. Do this by placing the carpenter's level on the baseboard in six different places: once on each of the four sides and once on each of the diagonals (Figure A-3). Place small pieces of cardboard under any corners

Figure A-3 Checking the level of the baseboard. To make sure that the enlarger baseboard is level, check it in at least six locations: once on each of the edges and also from corner to corner.

Figure A-4 Alternative method for checking the level of the negative stage. If you cannot fit your level directly on the negative stage, put a piece of glass in the negative stage and place the level

that are too low, and continue checking until the baseboard is perfectly level. If you discover during this process that the baseboard is warped and cannot be accurately leveled, place your easel on the baseboard, and level the easel instead.

Leveling the Negative Stage

To determine if the negative stage is parallel to the baseboard, place the level where the negative carrier normally rests. Check the same locations on the negative stage that you checked on the baseboard. Depending on the enlarger and the size of the level, you might have to remove the condensers or the entire enlarger head to accomplish this.

If removing the enlarger head isn't possible, place a sheet of glass of approximately 8×10 inches in the negative stage so that the long end projects from the front of the unit. Close the enlarger on the glass to hold it firmly, and place the level on the portion that protrudes (Figure A-4).

If the negative stage isn't level, make the necessary adjustments to your enlarger to make it level, being careful that the baseboard remains steady while you are working.

Leveling the Lens Board

The final step is to place the carpenter's level on the lens board and determine if it is parallel to both the baseboard and the negative stage. As with the negative stage, doing this is easier with some enlargers than with others. You may have to remove the flexible bellows that connect the negative stage to the lens board in order to place the level directly on it.

Making the lens board parallel to the baseboard and negative stage is an essential step that is often overlooked. Even if the negative and printing paper are precisely parallel, an out-of-alignment enlarging lens changes the image's plane of focus.

Double Checking

Once you have leveled both the negative carrier and the lens board, recheck the baseboard to make sure that it hasn't moved off level

while you were working. If you find that it has, repeat the entire procedure until you are satisfied that all three points on your enlarger are parallel.

Finally, if the condenser of your enlarger rests directly on the negative carrier (as, for example, on many Omega models), place the empty negative carrier in the negative stage, lower the lamp house onto it, and loosen the screws holding the condenser so that it rests flat on the carrier. Then retighten the screws. This ensures that the enlarger won't leak light around the negative stage.

Appendix B

Developer Formulas

The formulas in this appendix are among the most useful found in the formularies listed in Appendix E. They are organized in the following order:

- neutral-color developers
- warm-color developers
- cold-color developers
- low-contrast developers
- high-contrast developers
- Beers variable-contrast developer

Substituting Percentage Solutions

Some developer formulas require a very small amount of the restrainer, potassium bromide. If measuring a very small amount of a dry chemical is difficult, you can prepare a 10% stock solution of it and add 10 ml of that solution for every gram of the dry chemical specified in the formula. For example, 2 grams equals 20 ml of a 10% solution, and 0.8 grams equals 8 ml of a 10% solution. Prepare a 10% solution by dissolving 10 grams of dry chemical in 100 ml of water.

Using Alternate Forms of Sodium Sulfite and Sodium Carbonate

Usually, formulas with sodium sulfite require the anhydrous, or desiccated form of the chemical. If you have a formula that requires the crystal form of sodium sulfite or if only the crystal form is available, you can use the following table for conversions:

If the Formula Specifies:	And You Have:	Multiply by:
Sodium sulfite (anhydrous)	Sodium sulfite (crystal)	0.5
Sodium sulfite (crystal)	Sodium sulfite (anhydrous)	2.0

Likewise, most formulas with sodium carbonate specify the monohydrated form. If a formula requires one of the other two forms, anhydrous or crystal, or if you have only one of the other two forms available, you can use the following table for conversions:

If the Formula Specifies:	And You Have:	Multiply by:
Sodium carbonate (monohydrate)	Sodium carbonate (anhydrous)	1.20
Sodium carbonate (monohydrate)	Sodium carbonate (crystal)	2.33
Sodium carbonate (anhydrous)	Sodium carbonate (monohydrate	0.83
If the Formula Specifies:	And You Have:	Multiply by:
Sodium carbonate (anhydrous)	Sodium carbonate (crystal)	1.94
Sodium carbonate (crystal)	Sodium carbonate (monohydrate	0.43
Sodium carbonate (crystal)	Sodium carbonate (anhydrous)	0.52

NEUTRAL-COLOR DEVELOPERS

Neutral-color developers tend to produce an image with the least noticeable bias toward either a warm or cold color possible for a given printing paper. For example, when a warm-color paper is developed in a neutral-color developer, the result is still a reddish print, but less so than when the same paper is developed in a warmcolor developer.

If a paper has a slight greenish cast when developed in one of the following developers, you can substitute a commercial anti-foggant for the potassium bromide in the formula. Preparations such as Edwal's Liquid Orthazite or Kodak's Benzotriazole tend to provide a more neutral color than potassium bromide, although at a greater cost. Follow the manufacturer's recommendations for how much of a particular anti-foggant to substitute for potassium bromide.

Kodak D-72

This formula is known as a universal Elon-hydroquinone paper developer. A variation of D-72 is sold prepackaged as Dektol. Use diluted 1:2 with a normal development time of 2 minutes.

Water (110° F)	500.0 ml
Metol (Elon)	3.0 grams
Sodium sulfite (anhydrous)	45.0 grams
Hydroquinone	12.0 grams
Sodium carbonate (monohydrate)	80.0 grams
Potassium bromide	2.0 grams
Cold water to make	1.0 liter

Ilford ID-20

This formula tends to produce the most neutral color with bromidebased papers, such as Kodabromide and Ilfobrom. Use diluted 1:1 with a normal development time of 2 minutes.

Water (110° F)	750.0 ml
Metol (Elon)	1.5 grams
Sodium sulfite (anhydrous)	25.0 grams
Hydroquinone	6.0 grams
Sodium carbonate (monohydrate)	35.0 grams
Potassium bromide	2.0 grams
Cold water to make	1.0 liter

Agfa Metinol U Equivalent

Metinol U used to be more widely distributed and sold than it is currently. A proprietary formula, Metinol U produces the most neutral color possible on Brovira papers. This formula produces equivalent results to Metinol U. Use undiluted with a normal development time of 2 minutes.

Water (110° F)	3.0 liters
Metol (Elon)	4.0 grams
Sodium sulfite (anhydrous)	52.0 grams
Hydroquinone	12.0 grams
Sodium carbonate (monohydrate)	120.0 grams

Potassium bromide	4.0 ml*
Cold water to make	4.0 liters

*of a 10% stock solution. See the beginning of this appendix for a description of how to make a percentage solution.

Beers Developer (Normal Contrast)

When mixed for normal contrast, Beers formula is an excellent neutral-color developer. See the section on Beers variable-contrast developer later in this appendix for more information.

GAF 113

This formula contains Amidol and thus is more expensive to prepare than most of the other developer formulas listed here. GAF 113, however, yields very rich, deep black shadow tones and may be worth the trouble and expense to some photographers.

Mix the developer just before using because it cannot be stored after it is mixed. Do not mix the dry chemicals with hot water. Use without dilution for normal contrast, or dilute as much as 1:20 to produce very low contrast without losing dark shadows. Normal development time is 2 minutes.

Water (room temperature)	750.0 ml
Sodium sulfite (anhydrous)	44.0 grams
Potassium bromide	0.5 grams
Amidol	6.6 grams
Room-temperature water to make	1.0 liter

WARM-COLOR DEVELOPERS

Warm-color developers produce a variety of image colors, depending on the formula and the paper being used. Warm-color papers developed in warm-color developers tend to produce colors that range from brown-black to very warm brown. Neutral-color papers developed in warm-color developers tend to produce warm black and brown-black colors.

Kodak D-52

A variation of this formula is sold prepackaged as Kodak Selectol. This formula has a long life as a stock solution. Use diluted 1:1 with a normal development time of 2 minutes.

Water (110° F)	500.0 ml
Metol (Elon)	1.5 grams
Sodium sulfite (anhydrous)	22.5 grams
Hydroquinone	6.0 grams
Sodium carbonate (monohydrate)	17.0 grams
Potassium bromide	1.5 grams
Cold water to make	1.0 liter

Xerox HD-6

Before the advent of dry paper copying machines, Xerox (then known as the Haloid Corporation) used to sell photographic materials and publish formulas. This formula produces rich, warm colors

with very even tonal separation. Papers developed in HD-6 require longer exposures when developed in other developers (note the relatively small amount of sodium carbonate). Use diluted 1:1 with a normal development time of 2 minutes.

Water (120° F)	750.0 ml
Metol (Elon)	1.5 grams
Sodium sulfite (anhydrous)	25.0 grams
Hydroquinone	6.5 grams
Sodium carbonate (monohydrate)	17.5 grams
Potassium bromide	1.5 grams
Cold water to make	1.0 liter

Ansco 135

This formula yields a deep, warm black on bromide-based papers. Increasing the potassium bromide content (up to five times the recommended amount) increases the warmth at the expense of an added greenish cast and longer than normal development times.

Use undiluted for normal contrast. Dilute 1:1 for a noticeably lower contrast without losing dark shadow tones. Normal development time is 2 minutes.

Water (120° F)	750.0 ml
Metol (Elon)	1.6 grams
Sodium sulfite (anhydrous)	24.0 grams
Hydroquinone	6.6 grams
Sodium carbonate (monohydrate)	24.0 grams
Potassium bromide	2.8 grams
Cold water to make	1.0 liter

Agfa 120

This developer produces a variety of brown to warm black colors on various papers, depending on dilution and exposure times. For Brovira, a warm black can be produced at a dilution of 1:5 and a development time of 4 to 5 minutes. For Portriga Rapid, a brown-black can be achieved at a 1:4 dilution and 3 minutes of development. Try Ilford and Kodak papers at 1:5 and 4 to 5 minutes of development.

Water (110° F)	750.0 ml
Sodium sulfite (anhydrous)	60.0 grams
Hydroquinone	24.0 grams
Sodium carbonate (monohydrate)	80.0 grams
Cold water to make	1.0 liter

Gevaert G.262

This is a specialized warm-color paper developer that contains no metol. Image color tends toward red as you either increase the dilution or change the development time from 1½ to 6 minutes. Some printing papers (Kodak, in particular) react in unusual and inconsistent ways to this developer.

Undiluted, the image color will be brown-black. Diluted 1:2, the image color will be brown. Diluted 1:4, the image color will be brown-red. Diluted 1:6, the image color will be red.

Water (120° F)	750.0 ml
Sodium sulfite (anhydrous)	70.0 grams
Hydroquinone	25.0 grams
Sodium carbonate (monohydrate)	90.0 grams
Potassium bromide	2.0 grams
Cold water to make	1.0 liter

COLD-COLOR DEVELOPERS

Although it is relatively easy to increase the warmth of an image by increasing the amount of potassium bromide in a developer, it is much more difficult to create a cold color because a normally active developer with only a small amount of restrainer will produce chemical fog. The effects of cold-color developers are subtle and often only noticeable when used in combination with cool- or neutralcolor papers.

DuPont 54-D

This formula is, for practical purposes, identical to a Kodak formula published as D-73. The effects of this developer on image color are very subtle with most modern paper emulsions.

Dilute 1:2 to make a working solution with a normal development time of 2 minutes.

Water (110° F)	750.0 ml
Metol (Elon)	2.7 grams
Sodium sulfite (anhydrous)	40.0 grams
Hydroquinone	10.6 grams
Sodium carbonate (monohydrate)	75.0 grams
Potassium bromide	0.8 grams
Cold water to make	1.0 liter

Burki and Jenny Cold-Tone Developer

Published in 1943, this formula produces a more noticeable blue coloration than DuPont 54-D on most papers. Dilute 1:2 to make a working solution with a normal development time of 2 minutes.

Water (110° F)	750.0 ml
Metol (Elon)	3.0 grams
Sodium sulfite (anhydrous)	40.0 grams
Hydroquinone	12.0 grams
Sodium carbonate (monohydrate)	75.0 grams
Potassium bromide	0.8 gram
Benzotriazole (or Kodak Anti-Fog No.1)	6.0 ml*
Cold water to make	1.0 liter

^{*} of a 1% stock solution. See the beginning of this appendix for a description of how to make a percentage solution. You can increase the blue color by adding up to 15 ml of the benzotriazole solution.

GAF 130

Glycin, one of the reducing agents in this formula, is expensive but used in small quantities. Because this developer produces excellent tonal separation on most papers, the added expense may be worthwhile. Normal dilution is 1:1, although you can use this developer undiluted for greater contrast and diluted 1:2 for lower contrast. Normal development time is 2 minutes.

Water (110° F)	750.0 ml
Metol (Elon)	2.2 grams
Sodium sulfite (anhydrous)	50.0 grams
Hydroquinone	11.0 grams
Sodium carbonate (monohydrate)	78.0 grams
Potassium bromide	5.5 grams
Glycin	11.0 grams
Cold water to make	1.0 liter

LOW-CONTRAST DEVELOPERS

Low-contrast developers noticeably reduce the contrast of any printing paper, although the effect is usually less than that obtained by a full paper grade. The advantages of using a low-contrast developer include having a finer degree of contrast control and the ability to obtain a greater range of contrast on some papers that come in only a limited number of contrast grades.

GAF 120

GAF 120 is one of the most popular low-contrast developers. This formula produces an image similar to Kodak's Selectol-Soft, a proprietary developer, although it will last longer in the developing tray than the Kodak product. Use diluted 1:2. Normal development time is 2 minutes.

Water (110° F)	750.0 ml
Metol (Elon)	12.3 grams
Sodium sulfite (anhydrous)	36.0 grams
Sodium carbonate (monohydrate)	36.0 grams
Potassium bromide	1.8 grams
Cold water to make	1.0 liter

Ilford ID-3

This formula is slightly cloudy when mixed and will darken as you use it, but it has a long working life. ID-3 is also suitable for developing film when low contrast is needed. Use undiluted. Normal development time is 2 minutes.

Water (120° F)	1.0 liter
Metol (Elon)	3.0 grams
Sodium sulfite (anhydrous)	12.5 grams
Sodium carbonate (monohydrate)	21.75 grams
Potassium bromide	0.5 gram
Cold water to make	2.0 liters

Agfa 105

This formula can be considered a low-contrast version of Metinol U (see the section on neutral-color developers, and compare the formulas). This makes it useful when you want the same image color but

need a lower contrast result. Use undiluted with a normal development time of $1\frac{1}{2}$ minutes.

Water (110° F)	750.0 ml
Metol (Elon)	3.0 grams
Sodium sulfite (anhydrous)	15.0 grams
Sodium carbonate (monohydrate)	15.0 grams
Potassium bromide	1.0 grams
Cold water to make	1.0 liter

Beers Developer (Low Contrast)

When mixed for low contrast, Beers formula is an excellent neutralcolor, low-contrast developer. See the section on Beers variable-contrast developer later in this appendix for more information.

HIGH-CONTRAST DEVELOPERS

High-contrast developer formulas typically contain a greater percentage of hydroquinone than metol. To make up for the lower reduction potential of hydroquinone, these formulas usually contain additional sodium carbonate.

High-contrast developers allow a degree of contrast control finer than a full paper grade and increase the range of contrast for papers that have only a limited number of available grades.

Agfa 108

This is a high-contrast developer that works well with most normalcontrast papers. It has a slight green cast when mixed with potassium bromide. A more neutral color will result if you substitute 30 ml of Edwal Liquid Orthazite for the potassium bromide.

Use undiluted with a normal development time of 2 minutes. A longer development time will increase contrast even more.

Water (120° F)	500.0 ml
Metol (Elon)	5.0 grams
Sodium sulfite (anhydrous)	40.0 grams
Hydroquinone	6.0 grams
Sodium carbonate (monohydrate)	40.0 grams
Potassium bromide	2.0 grams
Cold water to make	1.0 liter

Beers Developer (High Contrast)

When mixed for high contrast, Beers formula is an excellent neutralcolor, high-contrast developer. See the section on Beers variable-contrast developer later in this appendix for more information.

Defender 57-D

Originally created for high-contrast copy paper, this formula creates a warm-color image suitable for some papers. Use undiluted with a normal development time of 1 to 2 minutes and up to 4 minutes for higher contrast.

Water (120° F)	500.0 ml
Metol (Elon)	1.5 grams
Sodium sulfite (anhydrous)	19.5 grams
Hydroquinone	6.0 grams
Sodium carbonate (monohydrate)	24.0 grams
Potassium bromide	0.8 gram
Cold water to make	1.0 liter

Edwal 120

The pyrocatechol (also known as pyrocatechin and catechol) in this developer is chemically similar to hydroquinone, but with a greater reduction potential. Normally a formula with pyrocatechol gives bromide prints a rich brown color. Adding the optional potassium bromide to this formula yields prints with a neutral or, as you increase the amount of potassium bromide, even a cold color.

To use, mix one part of solution A and two parts of solution B with one part water. Normal development time is 2 minutes.

Solution A

Water (120° F)	500.0 ml
Pyrocatechol (1,2-Dihydroxybenzene)	20.0 grams
Sodium sulfite (anhydrous)	40.0 grams
Cold water to make	1.0 liter

Solution B

Water (120° F)	500.0 ml
Potassium carbonate (anhydrous)	120.0 grams*
Potassium bromide (optional)	2.0 to 6.0 grams
Cold water to make	1.0 liter

^{*} Although the results won't be exactly the same, you can substitute 134 grams of sodium carbonate (monohydrate) for the potassium carbonate.

Alternate Formula for Edwal 120

Because of the expense of pyrocatechol and the fact that most special purpose developers aren't used frequently, some photographers prefer to mix Edwal 120 as a single-solution developer. Store the following formula in an airtight container and use within a week of mixing.

Water (120° F)	500.0 ml
Pyrocatechol (1,2-Dihydroxybenz	ene) 5.0 grams
Sodium sulfite (anhydrous)	10.0 grams
Potassium carbonate (anhydrous)	60.0 grams ⁺
Potassium bromide (optional)	1.0 to 3.0 grams
Cold water to make	1.0 liter

[†] Although the results won't be exactly the same, you can substitute 67 grams of sodium carbonate (monohydrate) for the potassium carbonate.

BEERS VARIABLE-CONTRAST DEVELOPER

Beers formula is the classic variable-contrast paper developer. In its normal-contrast dilution, it produces a very neutral image color for most papers. Normal development time is 1½ to 2 minutes.

Solution A

Water (110° F)	750.0 ml
Metol (Elon)	8.0 grams
Sodium sulfite (anhydrous)	23.0 grams
Sodium carbonate (monohydrate)	23.5 grams
Potassium bromide	1.1 grams
Cold water to make	1.0 liter

Solution B

Water (110° F)	750.0 ml
Sodium sulfite (anhydrous)	23.0 grams
Hydroquinone	8.0 grams
Sodium carbonate (monohydrate)	31.5 grams
Potassium bromide	2.2 grams
Cold water to make	1.0 liter

Contrast-Control Dilutions

The stock solutions are mixed in different ratios and diluted with water to make working solutions for contrast control. The total range of control is about one full paper grade.

	Low	2	3	Medium	5	6	High
Solution A	500 ml	435 ml	372 ml	310 ml	250 ml	190 ml	128 ml
Solution B	0 ml	65 ml	128 ml	190 ml	250 ml	310 ml	872 ml
Water	500 ml	0 ml					

Miscellaneous Formulas

The formulas in this appendix are organized in the following order:

- reduction and intensification (covered in Chapter 7)
- toners (covered in Chapter 8)
- archival processing (covered in Chapter 9)

Using Alternate Forms of Sodium Thiosulfate

Most formulas that use sodium thiosulfate require the crystal form (pentahydrate). If you have a formula that requires the anhydrous form or if you have only the anhydrous form available, you can use the following table for conversions:

If the Formula Specifies:	And You Have:	Multiply by:
Sodium thiosulfate (crystal)	Sodium thiosulfate (anhydrous)	1.6
Sodium thiosulfate (anhydrous)	Sodium thiosulfate (crystal)	0.6

REDUCTION AND INTENSIFICATION

The following formulas are useful when repairing flaws in negatives and prints that cannot be fixed using other printing techniques. Reducers and intensifiers are most useful when a negative or print is either badly exposed or improperly developed.

Farmer's Reducer—DuPont 1-R (Subtractive)

DuPont formula 1-R is a subtractive reducer that is useful for removing excess density from overexposed negatives or prints.

Agitate the negative being reduced in the working solution for up to 5 minutes, depending on the amount of reduction needed. Stop reduction by washing with running water. The process can be repeated using a fresh solution.

Stock Solution A

Water (hot)	300.0 ml
Potassium ferricyanide	37.5 grams
Cold water to make	500.0 ml

Stock Solution B

Water (hot)	1.5 liters
Sodium thiosulfate (crystal)	480.0 grams
Cold water to make	2.0 liters

To Use

Stock solution A	30.0 ml
Stock solution B	120.0 ml
Cold water to make	1.0 liter

Farmer's Reducer—DuPont 1a-P (Proportional)

DuPont formula 1a-P is a proportional reducer that is useful for removing excess contrast from overdeveloped negatives or prints.

To use, prepare from the stock solutions used to mix the DuPont Subtractive formula 1-R. Agitate the negative or print in working solution A for 1 to 4 minutes. Transfer to solution B for 5 minutes. Rinse, inspect, and repeat as necessary. After reduction is complete, wash thoroughly.

Working Solution A

Stock solution A	100.0 ml
Cold water to make	1.0 liter

Working Solution B

Stock solution B	210.0 ml
Cold water to make	1.0 liter

Chromium Intensifier

This is a bleach-and-redevelopment process that increases the contrast of an image by changing the image silver to a more opaque combination of silver and chromium.

To use, agitate in the intensification solution until the image has completely lightened to yellow. Wash, and redevelop in a paper developer. Repeat up to three times, if necessary, to add intensification. Warning: Always use rubber gloves when handling solutions containing potassium dichromate. If the solution touches your skin, flush immediately with water.

Stock Solution A

Water (120° F)	500.0 ml
Potassium dichromate	100.0 grams
Cold water to make	1.0 liter

Stock Solution B

Water (room temperature)	900.0 ml
Hydrochloric acid*	100.0 ml

Just before use, mix the stock solutions as follows:

Strong intensification:	10 parts A	100 parts water	2 parts B*
Medium intensification:	20 parts A	100 parts water	10 parts B [⋆]
Slight intensification:	20 parts A	100 parts water	40 parts B*

^{*}Always add an acid or an acid solution last to any formula.

Formalin Supplementary Hardener—Kodak SH-1

A hardener is necessary when a process softens an emulsion so much that damage is likely to result. Kodak's Formalin Hardener is useful when reducing or intensifying prints or negatives or when using the HE-1 solution for archival processing.

To use, agitate film and prints in the hardening solution for 3 minutes at room temperature, rinse, agitate for 5 minutes in a fresh stop bath, and wash.

Water (room temperature)	500.0 ml
Formaldehyde (37%)	10.0 ml
Sodium carbonate (monohydrate)	5.9 grams
Room-temperature water to make	1.0 liter

TONERS

Toning affects the color of a print and in some cases can protect the silver image from fading. The formulas in this section are listed in alphabetical order.

Copper Brown Toner

This formula produces red-brown colors, depending on the paper emulsion. Start with a slightly overexposed print because the ferricyanide bleaches the print while toning.

To use, mix equal parts of each solution just before use. Tone by inspection, and stop by washing when the desired color is reached.

Solution A

Water (room temperature)	500.0 ml
Copper sulfate	6.2 grams
Potassium citrate (either green or brown)	25.0 grams
Cold water to make	1.0 liter

Solution B

Water (room temperature)	500.0 ml
Potassium ferricyanide	5.2 grams
Potassium citrate (either green or brown)	25.0 grams
Cold water to make	1.0 liter

Dye Toners

A mordanting bleach allows organic dyes to attach themselves to image silver. The following dyes can be used in either the single-solution or two-solution dye toner formulas. These dyes are available in small quantities from Eastman Fine Chemicals, as listed in catalog 54.

Catalog Number
120 5046
113 3255
113 3461
112 5939
112 6846
107 0739
117 1867
113 3354

^{*}Use 0.4 gram (instead of 0.2 gram) in the following toner formulas.

[†]Use 0.1 gram (instead of 0.2 gram) in the following toner formulas.

Single-Solution Dye Toner

To use, agitate prints in the toning solution from 3 to 9 minutes at room temperature. Be careful not to overtone because the print may develop a chalky appearance and seem to lose contrast.

Toning Bath (Kodak T-20)

Dye	0.2 gram
Methyl alcohol	100.0 ml
Potassium ferricyanide	1.0 gram
Glacial acetic acid	5.0 ml*
Distilled water to make	1.0 liter

^{*}You can substitute 18 ml of 28% acetic acid.

Two-Solution Dye Toner

To use, first place the print in the mordant for 1 to 5 minutes. The image will turn a brownish gray. The longer you bleach, the more silver is mordanted and the deeper the dye tone will be. Then wash for 5 minutes or until all of the bleach is removed from the print, and agitate in the Kodak T-17a dye bath for 2 to 5 minutes. Rinse, use stain remover if necessary, and wash.

Mordant

Iodine	15.0 grams
Potassium iodide	50.0 grams
Glacial acetic acid	25.0 ml*
Distilled water to make	1.0 liter

^{*}You can substitute 90 ml of 28% acetic acid.

Dye Bath (Kodak T-17a)

Dye	0.2 gram
Acetic acid (10%)*	5.0 ml
Water to make	1.0 liter

^{*}Made by mixing one part glacial acetic acid to nine parts water or one part 28% acetic acid to three parts water.

Stain Remover

If there is an iodine stain in the gelatin of the print after toning, immerse the print into the following stain remover for no longer than 5 minutes.

Sodium bisulfite	500.0 grams
Water	750.0 ml
Sulfuric acid	100.0 ml*

^{*}Gradually add the acid to the solution after all of the sodium bisulfite is dissolved.

Gold Toners

Gold toners are very flexible, offering a range of colors from warm brown to a cool blue. In addition, the inert quality of gold makes toned prints extremely stable.

Gold Protective Toner (Kodak GP-1)

GP-1 produces a slightly cool blue tone on bromide papers. When used on a previously sepia-toned print, it produces bright red colors. Works most consistently when mixed with distilled water.

Mix immediately before use. Tone fully washed prints for about 10 minutes or until a slight image color occurs. Then wash for an additional 10 minutes. Capacity is 30.8×10 -inch prints per liter.

Distilled water (room temperature) 750.0 ml 1% gold chloride solution 10.0 ml Sodium thiocyanate 10.0 grams* Distilled cold water to make 1.0 liter

Nelson Gold Toner (Kodak T-21)

T-21 is somewhat difficult to prepare. It produces a wide variety of warm brown-black colors, depending on the length of time a print is in the toner.

To use, add 125 ml of stock solution B to the entire amount of stock solution A. When a sediment has formed at the bottom of the container, pour off the clear liquid from the top to use. Use the toning solution between 100° and 110° F. Tone for 5 to 20 minutes, depending on the desired color. Be sure that all prints are completely wet before toning.

Stock Solution A

Warm water (125° F)	4.0 liters
Sodium thiosulfate (crystal)	960.0 grams
Ammonium persulfate	120.0 grams

Make sure that the sodium thiosulfate is completely dissolved before adding ammonium persulfate. The solution should turn milky. If it doesn't, raise the temperature and stir until it does. Then cool the solution to room temperature, and add a solution composed of the following:

Cold water 64.0 ml Silver nitrate 5.2 grams Sodium chloride 5.2 grams*

Stock Solution B

Water	64.0 ml
Gold chloride	1.0 gram

Iron Blue Toner

This toner is easy to mix and use. It produces a vivid cyan blue on most printing papers.

To use, agitate the print in a tray of toner for 5 to 10 minutes or until the color of the print is what you want. Then wash until all of

^{*}Dissolve sodium thiocyanate separately in about 40 ml of distilled water and add to the gold chloride. Ammonium or potassium thiocyanate may be substituted.

^{*} Make sure that the silver nitrate is completely dissolved before adding the sodium chloride.

the vellow is removed from the white borders of the print. Overwashing or washing in overly chlorinated water will cause the blue to fade.

Water (110° F)	500.0 ml
Ferric ammonium citrate (green scales)	4.0 grams
Oxalic acid	4.0 grams
Potassium ferricyanide	4.0 grams
Cold water to make	2.0 liters

Polysulfide Toner (Kodak T-8)

This is a single-solution sulfide toner. The brown tones produced on most papers are darker than the tones that a bleach-and-redevelop toner like sepia will produce.

To use, agitate the print in the toner for 15 to 20 minutes at 70° F or for 3 to 4 minutes at 100° F. Wash the print well after toning to remove any sediment that might be left on the surface from a partially exhausted toner. You can lightly brush off the sediment if washing is not enough. Capacity is approximately 40 8 × 10-inch prints per liter.

Water (110° F)	750.0 ml
Polysulfide (liver of sulfur)	7.5 grams
Sodium carbonate (monohydrate)	2.4 grams
Cold water to make	1.0 liter

Red Toner

This toner produces rich red colors on most papers. Start with a slightly overexposed print because the ferricyanide bleaches the print while toning.

Mix immediately before using, and tone for a minute longer than it takes to produce a red color in the darkest shadows or until the desired effect is reached. Then rinse the print, refix, and wash, using a washing aid as usual. Pink stains in the highlights can be cleared by soaking the print in a weak solution of nonsudsing household ammonia (ammonium hydroxide): approximately five drops per liter of water.

Water (110° F)	500.0 ml
Ammonium carbonate (saturated)*	60.0 ml
Copper sulfate	1.5 grams
Potassium ferricyanide	3.0 grams
Cold water to make	2.0 liters

^{*} To make a saturated solution, add 50 grams of ammonium carbonate to 250 ml of water, and let it stand for several days, shaking periodically. Not all of the ammonium carbonate will dissolve at room temperature. To use, decant the solution (i.e., pour off and use only the liquid, leaving any undissolved ammonium carbonate behind).

Sepia

Sepia toner produces warm colors, primarily on neutral-color papers. To use, mix 500 ml of solution A with 500 ml of water in a tray, and agitate the print until all traces of black silver have gone (can be up to 10 minutes, depending on how fresh the bleach is). You can

bleach for less time if you want a darker brown. Rinse the bleached print for 2 minutes to remove the yellow, and then place it in a tray containing 125 ml of solution B per liter of water. Full toning takes place in about 30 seconds. You cannot overtone. Use only in a wellventilated area.

Bleaching Solution A

Water (110° F)	1.0 liter
Potassium ferricyanide	75.0 grams
Potassium bromide	75.0 grams
Potassium oxalate	195.0 grams
28% Acetic acid	40.0 ml
Cold water to make	2.0 liters

Toning Solution B

Water (room temperature)	$300.0 \mathrm{ml}$
Sodium sulfide (not sulfite)	45.0 grams
Cold water to make	500.0 ml

ARCHIVAL PROCESSING

The long-term preservation of photographs requires careful control of the printing process and rigorous testing to be certain that all harmful compounds are removed from the photographic paper. The following formulas make careful processing easier and provide tests for the two compounds most harmful to prints: undissolved silver and residual sulfur.

Nonhardening Fix (Kodak F-24)

A nonhardening fix has an advantage over formulas containing a hardener for toning and archival washing. A nonhardened print will accept toning more evenly and will release sulfur compounds more easily when washed.

A two-bath system is recommended. Agitate constantly in each tray for 3 to 5 minutes. A storage tray of running water may be used between the trays to prolong the life of the second tray. Move the second tray up when the first is exhausted, and mix a fresh second tray. Capacity is 25.8×10 -inch prints per liter.

Water (125° F) Sodium thiosulfate (crystal) Sodium sulfite (anhydrous)	500.0 ml 240.0 grams 10.0 grams
Sodium bisulfite	25.0 grams
Cold water to make	1.0 liter

Fixer Test (Kodak FT-1)

The FT-1 test works because excess silver in a fixing solution forms a milky yellow-white precipitate in the presence of certain iodine compounds.

To use, add five drops of FT-1 to a solution of five drops of fixer and five drops of water. The formation of an obvious precipitate indicates exhaustion. A slight cloudiness isn't an indication of exhaustion.

Water (room temperature) 750.0 ml 190.0 grams Potassium iodide 1.0 liter Room-temperature water to make

Washing Aid

The following formula is similar to Kodak's Hypo Clearing Agent. Dilute 1:9 to make a working solution.

Water (125° F)	500.0 ml
Sodium sulfite (anhydrous)	200.0 grams
Sodium bisulfite*	2.0 grams
Cold water to make	1.0 liter

^{*}Sodium bisulfite hardens gelatin emulsions. Leave this chemical out when using this formula for archivally processed prints.

Hypo Eliminator (Kodak HE-1)

The HE-1 formula oxidizes residual amounts of fix in an emulsion to a compound that is harmless to silver images. This formula can cause the base of some papers to turn from white to cream.

Prepare immediately before use. After prints have been toned (except for gold toners) and washed, place in a tray of HE-1, and agitate for 6 minutes. Wash again for 20 minutes. Caution: print emulsions are softened in this process, so be careful, or use the Formalin supplementary hardener (SH-1). Capacity is 50 8 × 10-inch prints per liter.

Water (room temperature)	500.0 ml
Hydrogen peroxide (3% solution)	125.0 ml
Ammonia (3% solution)	100.0 ml*
Room-temperature water to make	1.0 liter

^{*}To make ammonia solution, add 1 part 28% ammonia to 9 parts water.

Dehardening Solution

Most toners and many archival after treatments are not as effective if a print has been hardened during fixing. The following formula will soften the emulsion of a hardened print so that toning, spotting, and washing are more effective.

To use, soak the print for up to 10 minutes in the solution, agitating occasionally.

Water (room temperature)	750.0 ml
Sodium carbonate (monohydrate)	20.0 grams
Room-temperature water to make	1.0 liter

Residual Hypo Test (Kodak HT-2)

The HT-2 solution reacts with fix to cause a yellow-brown stain. The darker the stain, the more fix remains in the emulsion.

To use, place a drop on the center of a blank white piece of print paper that has been washed with the prints to be tested. After 2

minutes in subdued light, flush the print with a mild salt water solution. The presence of anything more than a slight yellow stain indicates that fix remains in the print and that the prints need more washing.

The HT-2 solution should be stored in a dark glass bottle away from strong light. Because you use this solution only a drop at a time, a convenient way to store it is in a small brown eye dropper bottle, available at most drug stores.

Water (room temperature)	750.0 ml
28% Acetic Acid	125.0 ml
Silver nitrate	7.5 grams*
Room-temperature water to make	1.0 liter

^{*}Silver nitrate requires 24 hours to completely dissolve.

Residual Silver Test (Kodak ST-1)

The ST-1 test detects the presence of undissolved silver compounds in the print. These can be the result of either inadequate fixing or overfixing in which previously dissolved silver is absorbed into the paper fibers.

To use, place a drop of the solution on a clear area of the print, such as the border. Wait 5 minutes. A noticeable brown stain indicates excess silver in the emulsion. Use only in a well-ventilated area. The solution keeps only 3 months.

Water (room temperature)	60.0 ml
Sodium sulfide (not sulfite)	7.5 grams
Room-temperature water to make	100.0 ml

Alternative Residual Silver Test Solution

Another residual silver test solution can be made from a 10% solution of selenium toner concentrate, mixed as follows. Use this solution in the same manner as ST-1. Residual silver is indicated by a red stain.

Water (room temperature)	90.0 ml
Selenium toner concentrate	10.0 ml

Appendix D

Supplies

The following is a list of suppliers that sell unusual or hard-to-get items through the mail. In most cases, you can write or call for information. Note that most of the 800 numbers are for use only inside the United States.

ARCHIVAL STORAGE

Franklin Distributors Corp. P.O. Box 320 Denville, NJ 07834 (201)267-2710

Polypropylene negative storage sleeves and related negative storage devices.

The Hollinger Corporation P.O. Box 8360 Fredericksburg, VA 22401 1-800-634-0491 (703)898-7300 Archival storage boxes, mat board, and Permalife paper for interleaving and cover sheets. Only current source of Tyvek negative storage envelopes. Discounts for quantity purchases.

Light Impressions
439 Monroe Avenue
Rochester, NY 14607-3717
1-800-828-9859
(716)271-8960

Archival supplies and other products, many made especially for Light Impressions. Separate catalogs for books, archival supplies, and general photographic equipment.

Photofile 2020 Lewis Avenue Zion, IL 60099

(708)872-7557

Innovative polyester film storage devices. Samples sent on request.

TALAS

Division of Technical Library Service 213 West 35th Street New York, NY 10001-1996 (212)736-7744 Archival supplies, primarily for libraries. Many products are useful to photographers. An illustrated catalog costs \$4; a price list, \$2.

University Products

517 Main Street P.O. Box 101 Holyoke, MA 01041-0101 1-800-628-1912 (413)532-9431 Archival storage and framing supplies for artists working in all mediums. An illustrated catalog costs \$4.

CHEMICALS, GENERAL

Bryant Laboratory, Inc. 1101 Fifth Street Berkeley, CA 94710 (510)526-3141

Chemicals and laboratory equipment selected specifically for artists.

Photographer's Formulary P.O. Box 5105 Missoula, MT 59806

1-800-777-7158 (406)543-4534

Hard-to-find chemicals and packaged versions of popular formulas not normally available in stores.

Sprint Systems of Photography 100 Dexter Street

Pawtucket, RI 02860 (401)728-0913

Innovative darkroom chemicals Available in some camera stores as well as through mail order.

Zone V

Stage Road P.O. Box 218 South Strafford, VT 05070 (802)765-4508

Hard-to-find chemicals specifically for photographers. Also publishes a newsletter discussing photographic chemistry.

CHEMICALS, SPECIALTY

Berg Color-Tone, Inc.

P.O. Box 430 East Amherst, NY 14051 (716)684-0511

Specialty toners and print-retouching supplies as well as a source of toning information. One of only two sources for commercially packaged dve toners.

D.F. Goldsmith

909 Pitner Avenue Evanston, IL 60202 (708)868-7800

Gold chloride sold by the gram and silver nitrate sold by the ounce. Write or call for current price quotation. Be sure to specify the quantities vou are interested in.

Eastman Fine Chemicals

Eastman Kodak Company Rochester, NY 14650 1-800-225-5352 (716)588-4817

The only known source for organic dyes used in dye toner formulas. Also a source of standard laboratory chemicals.

DARKROOM EQUIPMENT

Kostiner Photographic Products

12 Water Street P.O. Box 322 Leeds. MA 01053 (413)586-7030

Specialty products for the darkroom, including archival washers for prints and film, print drying screens, and a variety of enlarging easels.

Light Impressions

439 Monroe Avenue Rochester, NY 14607-3717 1-800-828-9859 (716)271-8960 See description under "Archival Storage"

Salthill Photographic Instruments, Inc.

Wildcat Road Chappaqua, NY 10514 1-800-525-7258 (914)238-1100 Specialty equipment used to process film and paper. Informative catalog.

Summitek

P.O. Box 520011 Salt Lake City, UT 84152 (801)277-4205 Archival print and film washers.

FRAMES

Light Impressions

439 Monroe Avenue Rochester, NY 14607-3717 1-800-828-9859 (716)271-8960 See description under "Archival Storage."

University Products

517 Main Street P.O. Box 101 Holyoke, MA 01041-0101 1-800-628-1912 (413)532-9431 See description under "Archival Storage."

Westfall Framing

P.O. Box 13524 Tallahassee, FL 32317 1-800-874-3164 (904)878-3564 Wood and metal sectional frames and many other supplies for framing. Informative catalog.

Appendix E

Books

The following is a list of worthwhile publications that cover subjects discussed in this book. Although some of these books are no longer in print, many may be found in libraries or used-book stores.

GENERAL

Beyond Basic Photography Horenstein, Henry Boston, MA Little, Brown, 1977 Excellent text covering all aspects of photography.

The Craft of Photography Vestal, David New York, NY Harper and Row, 1975 General-purpose text. Notable for the clearly stated opinions of the author, a thoughtful photographer and experienced teacher.

Eastman Kodak Company Department 454 343 State Street Rochester, NY 14650 Kodak sells (and gives away) a wide range of literature on all aspects of photography. Send for Kodak's Index to Photographic Information (Publication L-1) for a current list.

Exploring Black and White Photography Gassan, Arnold

Dubuque, IA Wm. C. Brown, 1989 One of the best books on basic and intermediate photographic processes (although not the best organized). Contains a practical chapter on photographic aesthetics, unusual for a book of this type.

Into Your Darkroom Step by Step

Curtin, Dennis, and Steve Mussleman Boston, MA Focal Press, 1981 A clearly illustrated review of basic darkroom procedures. Contains many practical suggestions for new workers.

Photographic Possibilities

Hirsh, Robert Boston, MA Focal Press, 1991 A wide-ranging discussion with many specific examples of different photographic techniques and how they might be used creatively.

The Print

Adams, Ansel Boston, MA Little, Brown, 1983 Much of Ansel Adams's writings are rightfully enshrined in the pantheon of technical photographic literature. His volume on printing is a classic, though it is somewhat biased toward a representational approach to photography.

Photographic Printing

Hattersley, Ralph Englewood Cliffs, NJ Prentice-Hall, 1977 Interesting descriptions of a number of pictorial techniques, such as texture screens, print solarization, and something called the Emmerman process.

DARKROOM DESIGN AND CONSTRUCTION

Build Your Own Home Darkroom

Duren, Lista, and Will McDonald Amherst, NY Amherst Media, 1990 A concise, well-written guide to creating a darkroom in a house or apartment. Easy-to-follow instructions.

The Darkroom Builder's Handbook

Hausman, Carl, and Stephen DiRado Blue Ridge Summit, PA TAB Books, 1985 Practical information on the design and construction of darkrooms on a budget. Easy to read and follow. A final chapter on making prints and critiquing images is less useful.

The Darkroom Handbook

Curtin, Dennis, and Joe DeMaio Boston, MA Curtin and London, 1979 A clear and useful text on buying darkroom materials and building darkroom equipment.

Photolab Design

Kodak Publication K-13 Catalog No. 152 7977 Rochester, NY Eastman Kodak Company, 1977 Geared mostly to commercial labs and photographers with a trust fund. Contains a useful section on darkroom floor plans and serves as a wish list of equipment to purchase or to make yourself.

FORMULARIES

150 Do-It-Yourself Black and White Photographic Formulas

Dignan, Patrick, ed. North Hollywood, CA Dignan Photographic, 1977 A chaotic book, mostly concerned with film development. Still, well worth mining for nuggets of valuable information.

PhotoLab Index

Pittaro, Ernest, ed. Hastings-on-Hudson, NY Morgan and Morgan, 1939 The standard reference work for photographic technique. Continually updated, although older editions tend to have a more comprehensive listing of formulas than current editions.

Photographic Facts and Formulas, 4th ed. Wall, E.J., and Franklin I. Jordan Garden City, NY American Photographic Publishing, 1975

A classic formulary, occasionally updated. Although some of the processes in the latest edition haven't been updated to accommodate contemporary materials, this book is still a valuable catalog of formulas not easily available elsewhere.

TECHNICAL

Controls in Black and White Photography, 2d ed. Henry, Richard J. Boston, MA Focal Press, 1988

The published results of exhaustive personal testing by a meticulous worker. This book answers questions most photographers haven't thought of yet.

Photographic Sensitometry Todd, Hollis N., and Richard D. Zakia Hastings-on-Hudson, NY Morgan and Morgan, 1969 This study of tone control in photography relies primarily on data gathered by exposing and processing film. The principles discussed here, however, apply to all photographic emulsions.

ARCHIVAL PROCESSING AND PRESERVATION

American National Standards Institute 1430 Broadway New York, NY 10018 ANSI standards describe performance and test methods for many products, including photographic materials. The 1992 catalog of ANSI standards sells for \$20 plus \$4 for shipping.

Collection, Use, and Care of Historical Photographs
Weinstein, Robert, and
Larry Booth
Nashville, TN
American Association for
State and Local History,
1977

Practical information for the storage and care of photographs as well as restoration of older or damaged images.

Conservation of Photographs

Kodak Publication F-40 Eaton, George T. Rochester, NY Eastman Kodak Company, 1985 Comprehensive work on the various aspects of conserving and collecting photographs. Beautifully reproduced color photographs make the book expensive and less focused on the issues of black-and-white photography.

The Life of a Photograph

Keefe, Laurence E., and Dennis Inch Boston, MA Focal Press, 1990

The Wash Book

Conrad, Roger Newhall, CA Teamworks, 1978

A complete description of archival processing, matting, framing, and storage. Includes both practical and theoretical information.

The published results of personal testing for washing effectiveness and water conservation. Contains practical information about how to wash prints properly.

CONSERVATION

Photogreen

P.O. Box 124 Hampton, NJ 08827 (908)537-7694

The Use of Water in Photographic Processing Kodak Publication J-53 Rochester, NY Eastman Kodak Company, A clearinghouse for information regarding conservation issues related to photography. A periodic newsletter is available.

A short pamphlet discussing the theory of washing, water quality, and how to conserve water during processing.

SAFETY

1978

Making Darkrooms Saferooms

Tell, Judy, ed. Durham, NC National Press Photographers Association, 1989 A variety of essays discussing the practical application of darkroom safety. Available directly from the NPPA (3200 Croasdaile Drive, Suite 306, Durham, NC 27705).

Overexposure: Health Hazards in Photography

Shaw, Susan Carmel, CA The Friends of Photography, 1983 The most comprehensive work available on chemical hazards in photography. Should be part of every photographer's library.

Safe Practices in the Arts and Crafts

Barazani, Gail New York, NY College Art Association, 1978 A general work on safety issues related to all arts materials. Includes a section on photography.

Index

A Accelerator, 39 Agfa 105, developer formula, 138 Agfa 108, developer formula, 138 Agfa 120, developer formula, 135 Agfa Metinol U equivalent, developer formula, 133–134 Agitation, proper methods of, 6	B Backing board, 125 Beers developer, 48, 134, 138, 139, 140 high contrast, 139 low contrast, 138 normal contrast, 134 variable-contrast, 140
Alignment test, enlarger, 127–129 evaluation, 129 procedure, 128 test negative, 128	Black spots on prints, 112–113 Bleach-and-redevelop toner. See Silver conversion toner Books, 153–156
Ansco 135, developer formula, 135 Archival processing, 99–110 development, 101 fixing, 102–104	Burki and Jenny cold-tone developer, 136–137 Burning and dodging, 2–3
film, 102 prints, 102–104 quick, 103–104 residual silver test, 104 testing, 104	C Chemical capacities, 3–4 maintaining even temperatures, 5–6
two-bath, 103 formulas for, 147–149 gold, protective toner, 108 hypo eliminator, 108–109 paper, 100–101	suppliers, 151 temperatures, 4–6 Chemical contamination, storage of negatives and prints, 113– 114
print drying, 109 printing, 100–101 protective coating, 107–108 rinse and washing aid, 105 selenium, protective toner, 108	Chemical fog, 39 Chemical safety, 1–2 while handling prints, 2 Chromium intensification, 142 problem negative, 76–78
standards, 99 stop bath, 101 toner, 107–108 uses of, 99–100 washing, 105–107	procedure, 77–78 test, 78 Cold-color developers, 136–137 Cold-light enlarger, 8 Coloring process, alternative, 97
film, 106 print, 106 washing test, 106–107 water flow, 105–106 water temperature, 105 washing aid, 105	Condenser enlarger, 8 Conservation board, 120 Contact proof, 20–23. See also Proper proof enlarger, 21 evaluation of, 22–23

negative contrast, 22	and print color, 54–55
negative exposure, 22	substituting percentage
procedure, 21	solutions in, 132
standard exposure, 21, 22	Developer testing
standard light intensity, 21	evaluation, 57–58
using, 22–23	materials, 57
Contrast, 26–27. See also Specific	paper, 57–58
type	procedure, 57
defined, 26–28	Developing agent, 5
effect of developing time on, 36	Developing time, effect on
graded paper, 35	contrast, 36
ring-around test, 33	Development
variable-contrast paper, 35	agitation, 6
when to change, 32	for archival processing, 101
Copper brown toner, 93	variables, 35–37
formula, 143	Development decrease, high-
Counter Balance scale, 40	contrast negative, 61-62
,	Diffusion enlarger, 8
D	Direct toners, 87
Dark detailed shadow, 30	Documentation, 113
Dark gray shadow, 29–30	Dodging, 2–3
Darkroom	Dry mounting, 121, 122
reviewing fundamentals, 1–10	DuPont 54-D, developer formula,
supplies, 151–152	136
Defender 57-D, developer formula,	Dye toner, 88, 94–95
139	formulas, 143-144
Dehardening solution, formula, 148	procedure, 94–95
Developer	mordant, 88
capacity, 3–4	
creating, 41–48	E
equal amounts of metol and	Edwal 120, developer formula,
hydroquinone print, 47	139–140
evaluation, 44-48	Edwal T.S.T., developer, 68
increasing restrainer content, 69	Elon, 38. See also Metol
test materials, 41–42	Emulsion speed, 23–24
more hydroquinone than metal	testing, 23–24
print, 47, 48	Enlarger. See also Specific type
more metol than hydroquinone	contact proof, 21
print, 47–48	fundamentals, 8–9
test procedure, 42-44	Enlarger alignment, 9, 127–131
reducing agent, preservative,	alignment test, 127-129
accelerator, and restrainer	evaluation, 129
print, 46	procedure, 128
reducing agent and preservative	test negative, 128
print, 45	correcting misalignment, 129-
selection, 58–59	131
test setup, 42	baseboard leveling, 129–130
timing, 6	checking, 127–129
Developer chemicals, 38-40. See	lens board leveling, 130
also Specific type	negative stage leveling, 130
measuring, 40-41	tools, 129
mixing, 41	Exposure
obtaining, 40	finding correct, 13-17
Developer formulas, 132–140	and highlights, 11–24

mechanism, 11–12 relative effect on print tones,	Glassine negative envelope, 115 Glazing, 125
11	Gold protective toner, 93–94, 145
ring-around test, 33–35 variables, 35–37	Gold toner, 93–94
zone system, 12	archival processing, 108
Exposure and development	formulas, 144–145 Graded paper, defined, 27
variables test, 36–37	contrast, 35
arrangement order, 36	printing paper, 27
evaluation, 36–37	Gray card, 52
Exposure test	Gray Cara, 52
determining exposure, 17	Н
evaluation, 16–17	Hand-applied toner, 95
exposing test strips, 15-16	High-contrast developers, 138–140
preparation, 15	used with low-contrast
procedure, 14–17	negative, 68–69
processing test strips, 16	High-contrast negative, 26
Expressive print, xi	how to print, 60–67
F	and decreased development, 61- 62
Farmer's reducer, 83–84, 85	low-contrast developer, 62-63
DuPont 1-R (subtractive), 141-	combined, 67
142	low-contrast paper, 61–62
DuPont 1a-P (proportional), 142	print flashing, 63–65
local application, 85	exposure threshold, 63
Film base plus fog, 21	flash exposure, 63
Fix	flash exposure calculation,
capacity, 4	64–65
timing, 7	main exposure calculation,
Fixer test, formula, 147–148 Fixing, archival processing,	65 printing 60, 67
102–104	printing, 60–67 water bath development, 65–67
film, 102	High-contrast paper, defined, 31
prints, 102–104	Highlight
quick, 103–104	blank white, 12, 13
residual silver test, 104	darker, 13, 14
testing, 104	exposing for, 11–24
two-bath, 103	first appearance of gray, 12, 13
Formalin supplementary	identifying, 12–13
hardener, 142–143	identifying most important, 12
Framing	print tone, 52
print, 124–125	textured, 13, 14
backing board, 125	Humidity, storage, 114–115
frame materials, 124-125	Hydroquinone, 38, 47–48
glazing, 125	Hypo eliminator
vapor barrier, 125	archival processing, 108-109
supplies, 152	formula, 148
G	I
GAF 113, developer formula, 134	Ilford ID-3, developer formula,
GAF 120, developer formula, 137	137–138
GAF 130, developer formula,137	Ilford ID-20, developer formula,
Gevaert G.262, developer	133
formula,136	Image color, print color, 54-55

Intensifier, 30 formulas, 141–143 for negatives, 75–78 for prints, 82–83 Iron blue toner, 93 formula, 145–146 K Kodak 18% reflectance card, 52 Kodak Blue Toner, 94 Kodak D-52, developer formula, 134–135 Kodak D-72, developer formula, 133 Kodak F-24, fixer formula, 147 Kodak FT-1, fixer test formula, 147–148	Maximum black shadow, 28–29 Medium dark shadow, 30 Metol, 38, 45, 47–48 Middle tones, 52–53 gray card, 52 Kodak 18% reflectance card, 52 print tone, 52–53 Mordant, for dye toners, 88 Mount board, 119–120 Mounting materials, 118–121 print size and position, 120–121 techniques, 121–124 Multiple toning, 95–97 experiments, 96–97 Museum board, 120 N
for negatives, 75–78 for prints, 82–83 Iron blue toner, 93 formula, 145–146 K Kodak 18% reflectance card, 52 Kodak Blue Toner, 94 Kodak D-52, developer formula, 134–135 Kodak D-72, developer formula, 133 Kodak F-24, fixer formula, 147 Kodak FT-1, fixer test formula,	Metol, 38, 45, 47–48 Middle tones, 52–53 gray card, 52 Kodak 18% reflectance card, 52 print tone, 52–53 Mordant, for dye toners, 88 Mount board, 119–120 Mounting materials, 118–121 print size and position, 120–121 techniques, 121–124 Multiple toning, 95–97 experiments, 96–97 Museum board, 120
for prints, 82–83 Iron blue toner, 93 formula, 145–146 K Kodak 18% reflectance card, 52 Kodak Blue Toner, 94 Kodak D-52, developer formula, 134–135 Kodak D-72, developer formula, 133 Kodak F-24, fixer formula, 147 Kodak FT-1, fixer test formula,	Middle tones, 52–53 gray card, 52 Kodak 18% reflectance card, 52 print tone, 52–53 Mordant, for dye toners, 88 Mount board, 119–120 Mounting materials, 118–121 print size and position, 120–121 techniques, 121–124 Multiple toning, 95–97 experiments, 96–97 Museum board, 120
Iron blue toner, 93 formula, 145–146 K Kodak 18% reflectance card, 52 Kodak Blue Toner, 94 Kodak D-52, developer formula, 134–135 Kodak D-72, developer formula, 133 Kodak F-24, fixer formula, 147 Kodak FT-1, fixer test formula,	gray card, 52 Kodak 18% reflectance card, 52 print tone, 52–53 Mordant, for dye toners, 88 Mount board, 119–120 Mounting materials, 118–121 print size and position, 120–121 techniques, 121–124 Multiple toning, 95–97 experiments, 96–97 Museum board, 120
formula, 145–146 K Kodak 18% reflectance card, 52 Kodak Blue Toner, 94 Kodak D-52, developer formula, 134–135 Kodak D-72, developer formula, 133 Kodak F-24, fixer formula, 147 Kodak FT-1, fixer test formula,	Kodak 18% reflectance card, 52 print tone, 52–53 Mordant, for dye toners, 88 Mount board, 119–120 Mounting materials, 118–121 print size and position, 120–121 techniques, 121–124 Multiple toning, 95–97 experiments, 96–97 Museum board, 120
K Kodak 18% reflectance card, 52 Kodak Blue Toner, 94 Kodak D-52, developer formula, 134–135 Kodak D-72, developer formula, 133 Kodak F-24, fixer formula, 147 Kodak FT-1, fixer test formula,	print tone, 52–53 Mordant, for dye toners, 88 Mount board, 119–120 Mounting materials, 118–121 print size and position, 120–121 techniques, 121–124 Multiple toning, 95–97 experiments, 96–97 Museum board, 120
Kodak 18% reflectance card, 52 Kodak Blue Toner, 94 Kodak D-52, developer formula, 134–135 Kodak D-72, developer formula, 133 Kodak F-24, fixer formula, 147 Kodak FT-1, fixer test formula,	Mordant, for dye toners, 88 Mount board, 119–120 Mounting materials, 118–121 print size and position, 120–121 techniques, 121–124 Multiple toning, 95–97 experiments, 96–97 Museum board, 120
Kodak 18% reflectance card, 52 Kodak Blue Toner, 94 Kodak D-52, developer formula, 134–135 Kodak D-72, developer formula, 133 Kodak F-24, fixer formula, 147 Kodak FT-1, fixer test formula,	Mount board, 119–120 Mounting materials, 118–121 print size and position, 120–121 techniques, 121–124 Multiple toning, 95–97 experiments, 96–97 Museum board, 120
Kodak Blue Toner, 94 Kodak D-52, developer formula, 134–135 Kodak D-72, developer formula, 133 Kodak F-24, fixer formula, 147 Kodak FT-1, fixer test formula,	Mounting materials, 118–121 print size and position, 120–121 techniques, 121–124 Multiple toning, 95–97 experiments, 96–97 Museum board, 120
Kodak D-52, developer formula, 134–135 Kodak D-72, developer formula, 133 Kodak F-24, fixer formula, 147 Kodak FT-1, fixer test formula,	materials, 118–121 print size and position, 120–121 techniques, 121–124 Multiple toning, 95–97 experiments, 96–97 Museum board, 120
134–135 Kodak D-72, developer formula, 133 Kodak F-24, fixer formula, 147 Kodak FT-1, fixer test formula,	print size and position, 120–121 techniques, 121–124 Multiple toning, 95–97 experiments, 96–97 Museum board, 120
Kodak D-72, developer formula, 133 Kodak F-24, fixer formula, 147 Kodak FT-1, fixer test formula,	techniques, 121–124 Multiple toning, 95–97 experiments, 96–97 Museum board, 120
133 Kodak F-24, fixer formula, 147 Kodak FT-1, fixer test formula,	Multiple toning, 95–97 experiments, 96–97 Museum board, 120
Kodak F-24, fixer formula, 147 Kodak FT-1, fixer test formula,	experiments, 96–97 Museum board, 120
Kodak FT-1, fixer test formula,	Museum board, 120
Kodak FT-1, fixer test formula,	
	N
	N
Kodak GP-1, toner, 93–94,	
formula, 145	Negative
Kodak HE-1, hypo eliminator	for printing test, 55–56
formula, 148	storage, 115–117
Kodak HT-2, residual hypo test	transmission density, 50, 51
formula, 148–149	Negative contrast, 26–27
Kodak Polycontrast filter	in contact proof, 22
equivalents, 9	defined, 26
Kodak SH-1, hardener formula, 148	Negative exposure, in contact
Kodak ST-1, residual silver test	proof, 22
formula, 149	Negative intensifier, 75-78
Kodak T-8, toner formula, 146	preparing for intensification, 75
Kodak T-21, toner, 94, formula, 145	Negative reducer, 78–81
	Negative viewing, transmitted
L	light, 50, 51
Local reduction	Nelson gold toner, 94, 145
on prints, 85–86	Neutral-color developers, 133-134
procedure, 85	Nonhardening fix, 147
testing, 85–86	Normal-contrast negative, defined,
Locally applied developer, 81-82	27
Low-contrast developers, 137	Normal-contrast paper, defined, 31
used with high-contrast	
negative, 62–63	0
Low-contrast negative, defined, 26	Oxidation, in developers, 39
used with high-contrast	
developer, 68-69	P
printing, 67–69	Paper
Low-contrast paper	archival processing, 100-101
used with high-contrast	developer testing, 57–58
negative, 61–62	selection, 58–59
defined, 31	Paper color, print color, 54
,	Paper grades, effect on print
M	contrast, 30–32
Masking, used with toners, 95–96	Paper surface
Matte surface, effect on viewing	print viewing, 51, 52
prints, 52	reflected light, 51, 52

Paper testing, 55–58	Print intensifier, 82–83
evaluation, 56-57	Print position, mounting, 120–121
materials, 56	Print reducer, 83–86
methods, 55-58	procedure, 83
procedure, 56	Print statement, xi
Phenidone, 81–82	Print tones
Pinholes, 112–113	highlights, 52
Point-source enlarger, 8	middle tone, 52-53
Polysulfide toner, 92-93, 146	separation, 52–54
Potassium bromide, 39	shadow, 53–54
Presentation of prints, 111-126	Print tongs, using, 2
Preservation of negatives and	Print viewing
prints, 111–126	paper surface, 51, 52
Preservative in developers, 39	physics of, 50–51
Print	reflected light, 51
framing, 124-125	Print washing apparatus, 107
backing board, 125	Printing
frame materials, 124-125	archival processing, 100–101
glazing, 125	high-contrast negative, 60–67
vapor barrier, 125	low-contrast negative, 67–69
local reduction, 85–86	Printing paper
ordering by print color, 58	brand, 35
ordering by tonal separation, 58	graded paper, 27
reflection density, 51	variable-contrast paper, 27
salvage techniques, 81-86	Printing test, negative, 55–56
storage, 117–118	Problem negatives
surface treatment, 113	categories, 60
Print color, 54–55	chromium intensification of, 76–
developer formula, 54–55	78
image color, 54–55	contrast solution, 60–73
ordering by, 58	salvage techniques, 74–81
paper color, 54	selenium intensification, 75–
psychology, 55	75, 77
relative differences, 55	Proper proof, 20–23
Print contrast	Proportional intensifier, 75
customizing, 69-72	Proportional reducer, 80–81, 84
defined, 27	procedure, 80
high-contrast paper, 31	test, 80–81, 84
low-contrast paper, 31	Protective coating, of prints, 107–
normal-contrast paper, 31	108
and paper grades, 30–32	Pyro-based developer, 54
split tray development, 70–71	Publications, 153–156
low-contrast image, 71	i delications, 100 100
procedure, 70	R
very high contrast image, 71	Red toner, formula, 146
Print drying, 109	Reducer. See Farmer's reducer
Print finishing, 111–113	Reducing agent, 38
Print flashing, for high-contrast	for negatives, 78–81
negatives, 63–65	for prints, 83–86
exposure threshold, 63	Reduction, defined, 74
flash exposure, 63–65	formulas, 141–143
flash exposure calculation, 64–	for negatives, 78–81
65	for prints, 83–86
	1

paper surface, 51, 52	procedures, 92
print viewing, 51	Shadow, print tone, 53-54
Reflection density, print, 51	Shadow tones, 28-30
Relative differences, print color,	Signing and documentation, 113
55	Silver conversion toners, 87–88
Residual hypo test, formula,	Sodium carbonate, 39
148–149	conversion table, 132–133
Residual silver test, formula, 149	Sodium sulfite, 39
Restrainer, 39	forms, 39
Ring-around test, 33–35	conversion table, 132-133
arrangement order, 35	Sodium thiosulfate, conversion
contrast, 33	table, 141
evaluation, 34–35	Split filter exposure, variable-
exposure, 33	contrast paper, 71–72
preparation, 33	materials, 71–72
procedure, 34	procedure, 72
Rinse and washing aid, archival	Split toning, with selenium toner,
processing, 105	91
	Split tray development, effect on
S	print contrast, 70-71
Safelight	used with low-contrast image,
placement, 19	71
wattage, 19	procedure, 70
Safelight dimmer, 20	used with very high contrast
Safelight filter, 19	image, 71
Safelight fog, 17–20	SpoTone, 111
Safelight test, 18–20	Spotting, 111–113
analysis, 19–20	Standard black and white patches,
procedure, 18–19	20
suitable negative, 18	Stop bath
Safety	archival processing, 101
general, 1–2	capacity, 4
special precautions for toners,	timing, 6–7
88	Storage, 113–118
during print processing, 2	chemical contamination,
Salvage techniques, 74–86 locally applied developer,	113–114
	conditions, 114–115
81–82	humidity, 114–115 for negatives, 115–117
print, 81–86	
problem negative, 74–81 selection, 74	for prints, 117–118 supplies, 150
Selection, 74 Selection, 74 Selection, 74	Subtractive reduction, 79–80
Selenium toner used in archival	procedure, 79
processing, 108	test, 79–80
Selenium intensification	Superproportional reducer, 79
negatives, 75–76, 77	Supplies, 150–152
procedure, 76	chemicals, 151
test, 76	darkroom equipment, 151–152
Selenium/sulfide toner, 92	framing, 152
as a resist, 96	storage, 150
Selenium toner, 90–92, 108	Surface treatment, print, 113
procedure, 90–91	cannot treatment, print, 110
split toning, 91	Т
Sepia toner, 91–92	Temperature for chemicals, 4–5
formula, 146–147	maintaining even range, 5–6

Test strips, 14, 15, 16	Variable-contrast paper
set, 16	contrast, 35
Timing processes, 6–7	printing paper, 27
developer, 6	split filter exposure, 71–72
fix, 7	materials, 71–72
stop bath, 6-7	procedure, 72
washing, 7	•
washing aid, 7	W
Toned print	Warm-color developers, 134-136
dye toner, 97	Washing, 105–107
partially redeveloping, 97	archival processing, 105-107
removing silver, 96-97	film, 106
Toner	prints, 106
archival processing, 107-108	washing test, 106-107
formulas, 143–147	water flow, 105-106
hand-applied, 95	water temperature, 105
safety precautions, 88	timing, 7
testing, 89–90	Washing aid
order, 90	archival processing, 105
procedure, 89–90	capacity, 4
types, 87–88	formula, 148
Toning, 87–98	timing, 7
multiple, 95–97	Water
print preparation, 88-89	in developers, 39-40
Touchrite, 111	flow rate in washing, 105-106
Transmission density,	Water bath development,
negative, 50, 51	high-contrast negative, 65-67
Transmitted light,	Window matting, 121, 122-124
negative viewing, 50, 51	floating window, 122-123
Triple-beam balance, 40	mounting corners, 123
	overlapping window, 122-123
V	
Varnishing prints, 113	X
Vapor barrier, 125	Xerox HD-6, developer formula,
Variable-contrast filters, 8–9	135

Photo Credits

Cover Tim Barnwell from the Figure 3-2 Wm. E. Davis series on rural Appalachian Cotton Gin: Arkansas lifestyles Figure 3-4 Judith Canty Figure 2-2 Judith Canty Figure 3-5 Max Belcher Figure 2-3 Sharon L. Fox Mars House Porch, Figure 2-4 Wm. E. Davis Paynesville, Liberia San Xavier del Bac Church Figure 3-9 Judith Canty Dome: Arizona Figure 4-3 Judith Canty Figure 2-5 Judith Canty Figure 5-4 Judith Canty Figure 2-8 Judith Canty Figure 7-5 Nancy Roberts Figure 2-9 Judith Canty Color 8-1 Judith Canty Figure 3-1 Wm. E. Davis Color 8-2 Nancy Roberts Urns on Porch Railing: Color 8-5 Ann Kurutz Montana Old Orchard Beach, Maine

			*

		* *		